PLAYGROUND

FOR QUINN & ZEB

PLAYGROUND

JAMES MOLLISON

aperture

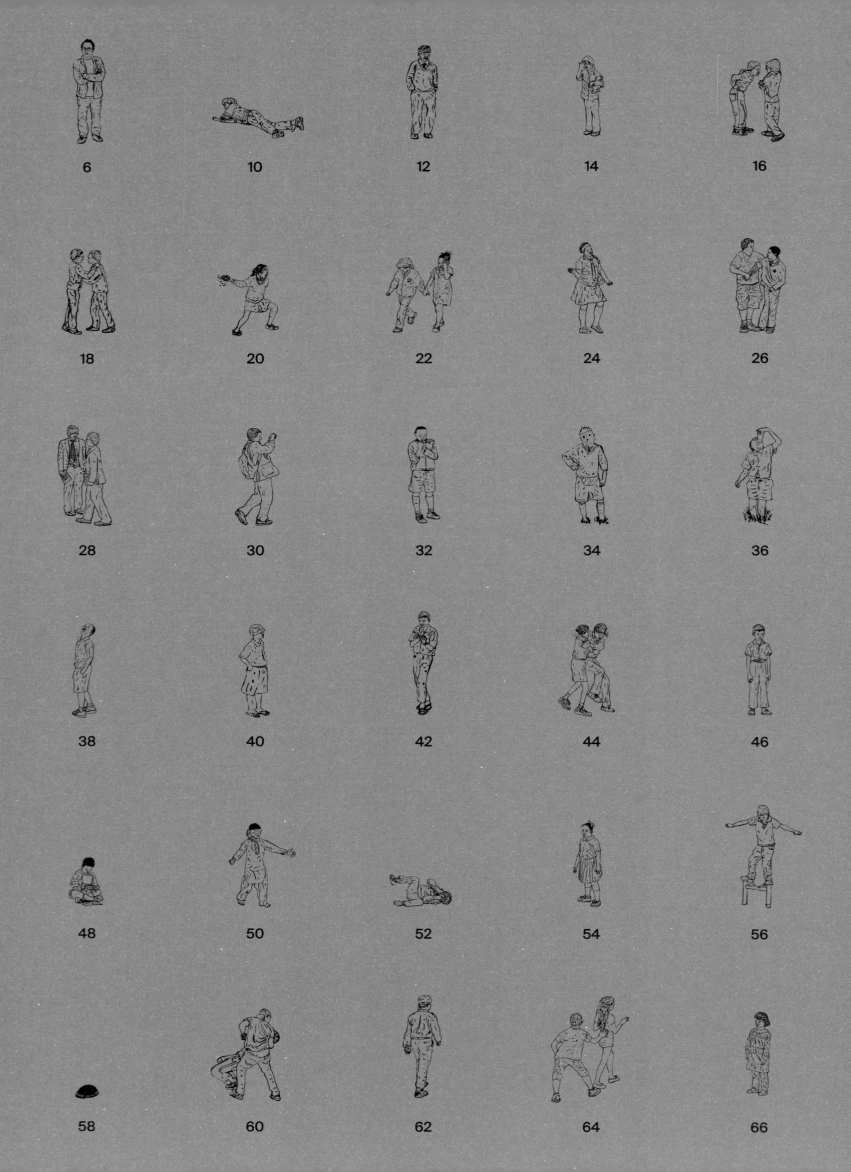

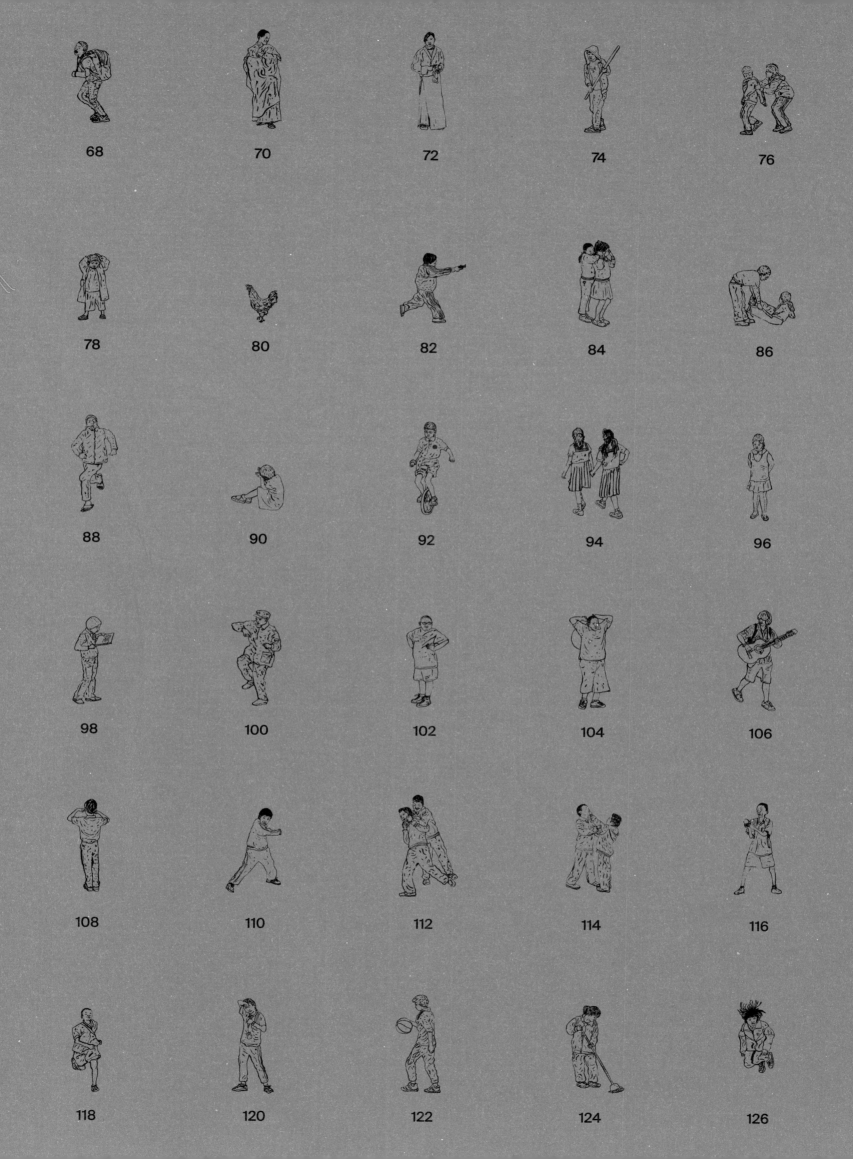

68

70

72

74

76

78

80

82

84

86

88

90

92

94

96

98

100

102

104

106

108

110

112

114

116

118

120

122

124

126

Foreword
Jon Ronson

James Mollison's *Playground* photographs are fantastically complicated and ambitious. They're as fun as a *Where's Wally* (*Where's Waldo* in North America) book and as chilling as my own school playground memories. Which really are chilling. I'll pluck up the nerve to detail them below.

James and I meet at a bar in New York City. He tells me how the photographs were a bureaucratic nightmare to pull off. Most of the schools he approached said no. One (British) school had a security guard accompany him everywhere. The children aimed footballs at James's head, and cheered when one missed him and scored a direct hit on the security guard. They wobbled James's tripod and called him a pervert. Why else would he want to photograph children, if he wasn't a pervert?

Personally, I'm happy to hear these terrible stories. It's always nice to know that someone has worked ridiculously hard on a project, gone to crazy lengths. If we expect people to pay good money for our books, our discomfort is the least we can offer in return.

I find myself more interested in the uncanny similarities within these photographs than the outrageous inequalities. But before I explain why, here are some of the peculiar differences James noticed: at an American private school, cartwheels and handstands are banned for health and safety reasons (a ban that is widely ignored, James is relieved to tell me). In the unsupervised playgrounds of Kenya, a popular game is "urr-up," which involves children throwing each other several feet into the air. In Norway, the kids are forced to play outside even in polar conditions. At a fancy futuristic school in Japan, the playground has an electronic roof that plays music as it closes.

"There are darker sides," James says. "One head teacher of a slum primary school told me she'd check to see if her pupils walked strangely, as this was often a sign that they had been sexually abused."

The school James visited in Bethlehem used to have a view of Israel but now only has a view of the dividing wall and the army turrets. There's a mural painted on the wall of two soldiers dragging away a blindfolded man. The head teacher told James that the wall serves as a constant reminder to the children "of the humiliation we have to suffer."

When James recounts this sad conversation, I remember the work of the American psychiatrist James Gilligan, who—after decades spent interviewing violent prisoners inside Massachusetts maximum-security prisons—concluded that the cause of all violence is humiliation, violence being an attempt to replace shame with self-esteem. I suppose some of the playground fighters captured in this book will grow up to be actual fighters.

And while we're on the topic of shame and humiliation....

My playground memories are as bad as they get. Once when I was fifteen or sixteen, I was blindfolded and stripped and thrown into the schoolyard. Kids would spit in my food. I was thrown into a lake. And this was not a lake with lovely crystal waters; it was a polluted lake full of crap. All this happened at Cardiff High School, in Wales, between 1983 and 1985.

I console myself with the thought that it's exactly the sort of childhood a journalist ought to have: forced to the margins, suspicious of the elite, and unwelcomed by them anyway. But I'd rather be a journalist with a happier childhood, frankly. No matter how great one's subsequent life turns out to be, memories like that will follow you around, like the cloud of dirt that follows Pig-Pen in the *Peanuts* cartoons. Playground experiences can mold a lifetime.

This is why I don't see this book as a record of adorable rough-and-tumble and hijinks. Other people will see it that way, but not me. I see it as a book of horror photographs. Wherever in the world the playground is, you notice it: little flashes of violence and cruelty. My eyes skip past the comfortable little cliques and the best friends holding hands to the outcasts, the pariahs, the ones protecting their faces from the blows. For instance: what's that happening at the Thako Pampa School in Bolivia? Bottom right-hand corner. That looks like an assault. If those people were adults they'd be in prison for that. Or maybe they're just playing. I don't know. Look at that little girl sitting on the immaculate lawn of the Seishin School in Tokyo. She's covering her eyes.

What's happened to her? Is she going to be okay? Norway seems especially brutal. It might be a trick of perspective, but that boy lying facedown on the ground at the Gomalandet School in Kristiansund looks like he's about to get his head kicked in, while a hooded child stalks toward him wielding a large stick. That's very Cardiff High.

When I meet James, I tell him how pitiless Norway looks from his photographs.

"Oh, no," he replies, surprised. "No! I was really impressed by Norway. They have these back-to-nature areas, with rocks and sticks, where kids are encouraged to climb trees."

"But what about that boy about to stamp on that other boy's head?" I say.

"He was jumping over him," James replies.

"And the hooded kid looming toward them with the big stick?"

"He was building something," James says. "It definitely wasn't an act of nastiness."

James says that one country stood out as having by far the nastiest playground behavior. It wasn't Kenya—although Kenya was rough. Bolivia was rough, too, but it wasn't Bolivia. It wasn't Los Angeles either, despite James's preconceptions of the place from listening to NWA albums. The LA kids were polite and enthusiastic, James says, even though all those clichés of American high school tribes turned out to be true: the jocks, the cheerleaders, the stoners, the feared goths.

It wasn't Kenya or Bolivia or LA.

It was Britain.

In the bar, James gets out his laptop and shows me something I hadn't noticed. It's an altercation unfolding in a British playground. I feel bad about pointing out exactly which photograph it is, so I won't. But you'll find it if you look hard enough.

It's a boy and a girl. A few moments before James took the photograph, the girl had shouted at the boy, "You're a queer."

The boy replied, "I'm not, I'm not."

The girl yelled, "Yeah, you are."

"And then he just lost it," James says. "He started shaking. And he hit her. He couldn't control it. He just slapped her. Then she was effing and blinding even more. Suddenly the whole playground focused in on it. All the kids standing around were totally thrilled. He was in this moment of complete humiliation. I really felt for him. The sheer enjoyment that everyone else was getting. One kid started taking a video. The other kids were winding the situation up. Some were shouting, 'You can't hit a girl.' Others were shouting at her, 'You can't take that.' Then I had the teachers run up to me. They thought I had somehow instigated it. They said, 'What are you doing? Did you start this?' I said, 'No. It just happened.'" James pauses. "This project really put me off living in London. The kids were just so . . . lippy."

A few years ago I attended my high school reunion. Something happened there that took me aback. My former classmates already knew I was annoyed with them about the lake incident because I'd written a column about it in the *Guardian*:

I wake up in the middle of the night. I find I'm still angry with the boys who threw me into Roath Park Lake in Cardiff in the summer of 1983 when I was sixteen. I log onto Friends Reunited. I find one of them, and e-mail him to inform him that I'm now a bestselling author.

He e-mails me back. He says that the reason why they threw me in the lake was because I was a pain in the arse. He adds that the tenor of my e-mail leads him to suspect that I haven't changed, and that throwing me in the lake again today would be an appropriate response.

I e-mail him back to tell him that I earn more money than he does.

He has not yet e-mailed me back.

Touché.

The school reunion was held at a pub where we used to drink underage. Midway through the night one of the men who had thrown me into the lake staggered over to me, drunk. He's an archaeologist now, with his own plane. I always imagined—and, in fact, used to tell my son—that bullies grow up to have disappointing lives. But the archaeologist seemed to be having a great life, annoyingly.

"You've got it all wrong," he told me. "The lake incident. You've remembered it all wrong."

"How so?" I asked him.

"We all went down to the lake and jumped in together," he said.

"That's how you remember it?" I said.

"Yeah!" he said.

"We all jumped in together, like in a kind of joyous, youthful frenzy?" I said.

"Yeah," he said.

I recall that day perfectly. He was wrong. I think this nice archaeologist simply couldn't allow himself to remember that he'd been a bully. It was too painful for him, too guilt-inducing, so he'd blocked it out.

James lived in Kenya until he was five, and then his family moved to Oxford, where he spent the remainder of his childhood. James's school, like mine, was a mix of posh kids and estate kids—kids who brought guns in, kids who died of heroin overdoses, kids who went on to be academics, or successful photographers. James is goodlooking, tall, nice, and a little nerdy. I try and picture schoolboy James. I bet he was one of the lucky ones: not quite nerdy enough to be bullied, not quite sporty enough to be a thug.

"Were you ever picked on?" I ask him.

"I remember a group in my class turning on me," he says.

"They trapped me in the toilets. I was in there sobbing. It was terrifying. Those raw emotions that you feel as a kid—that up and down . . ."

"Did you do it to other people?" I ask.

There's a pause. "Who knows," he replies.

"You say, 'Who knows,'" I say.

James swallows. "My sister is in touch with someone in the class who says I really upset her," he says. "I wasn't particularly aware of it. I did tease her. But I thought it was joking, banter . . ." He trails off, and looks a little sad.

I feel bad about how much of the introduction to this beautiful book has focused on the sad, painful, angry moments captured in James's photographs, when in fact there's an awful lot of happiness here. The hula hooping and skipping girls in LA and Tokyo, the Bedouin boys climbing in the West Bank: all over the world, children are smiling, and very often not for mean reasons.

And in fact I know right away what my favorite photograph of all is here. It's the leaf-throwing contest taking place in the field at Thornton College in Buckinghamshire. It's so familiar and so lovely, so British and autumnal. Those faces!

"They organized it themselves," James says. "They'd spent fifteen minutes collecting leaves, and they just suddenly broke out into this moment. It was brilliant."

"I forgot that playgrounds were that fun," I say.

"That moment when the lesson is over and you just run," James says.

"The sheer excitement of it. The lesson ends. And you just explode out into the playground, and you're just running . . . "

Pilgrims School,
Winchester, UK

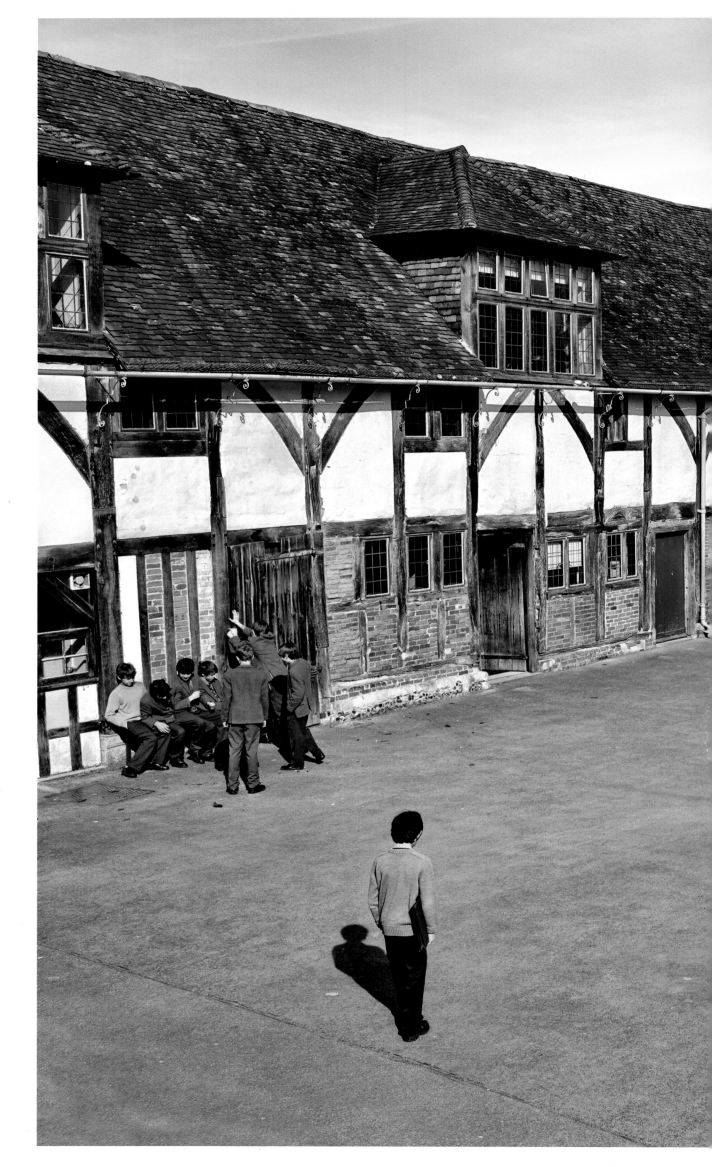

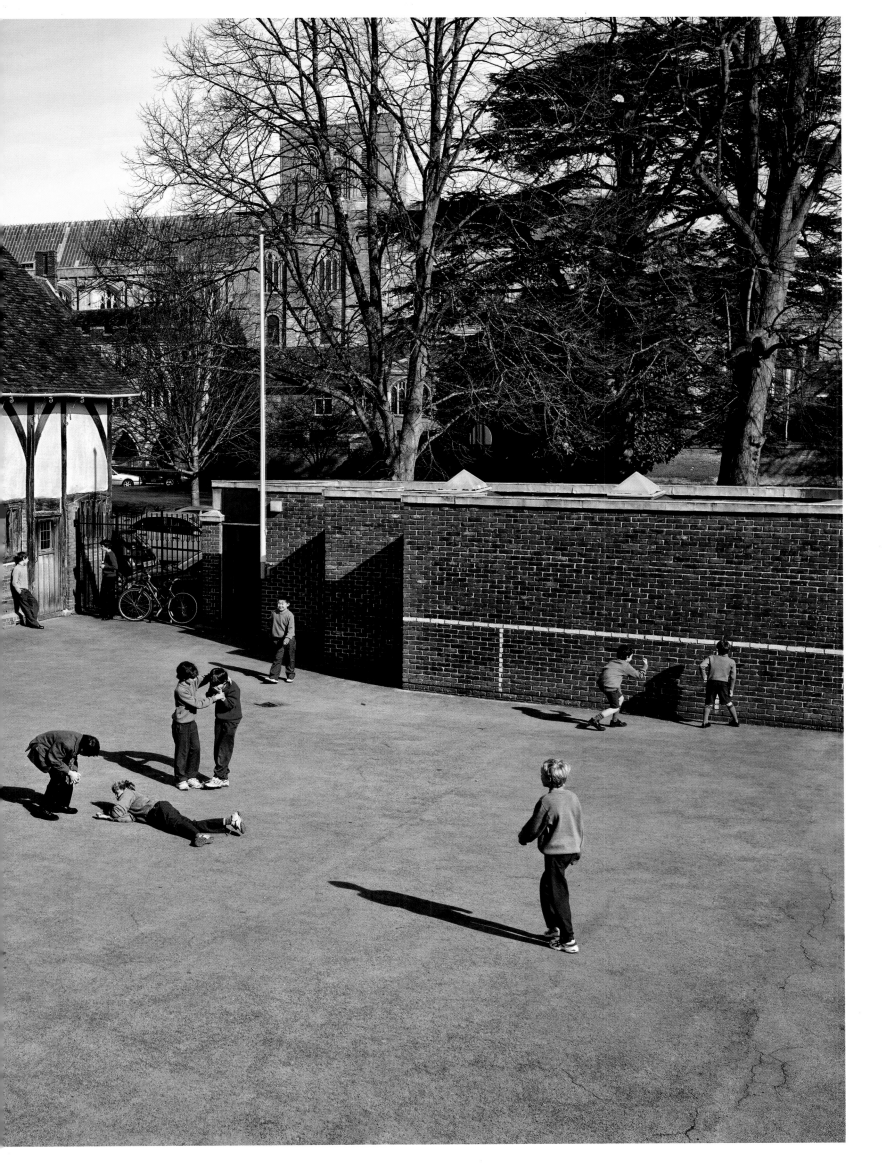

Stonyhurst College,
Lancashire, UK

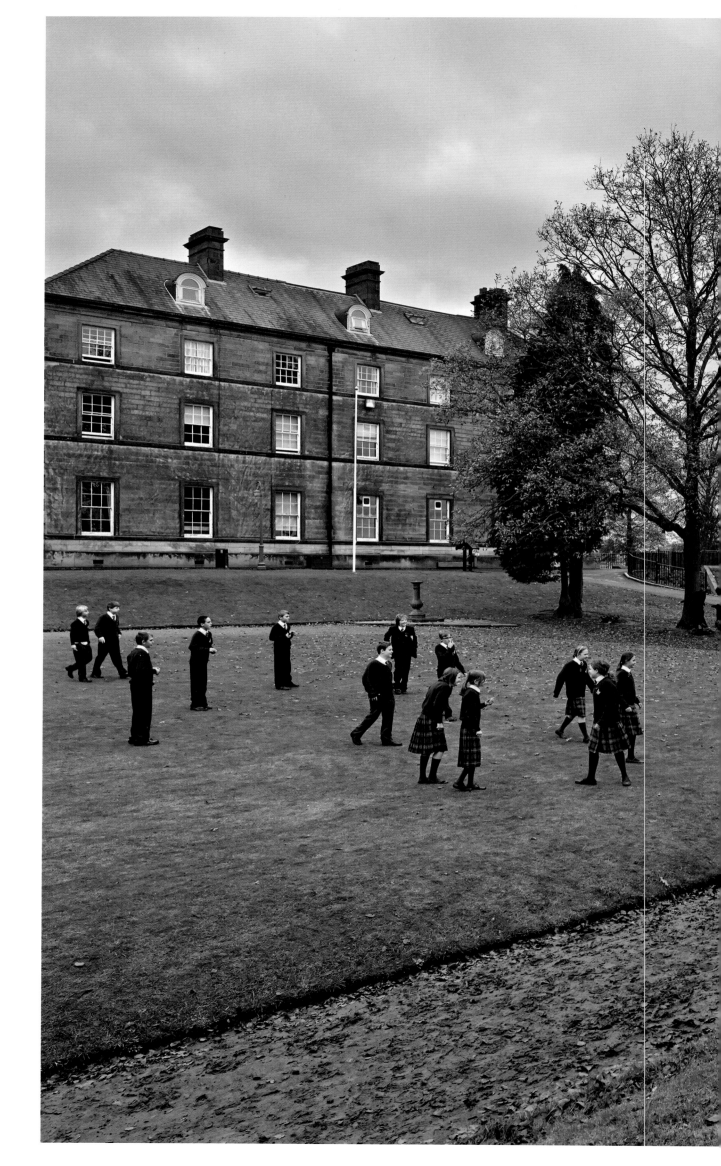

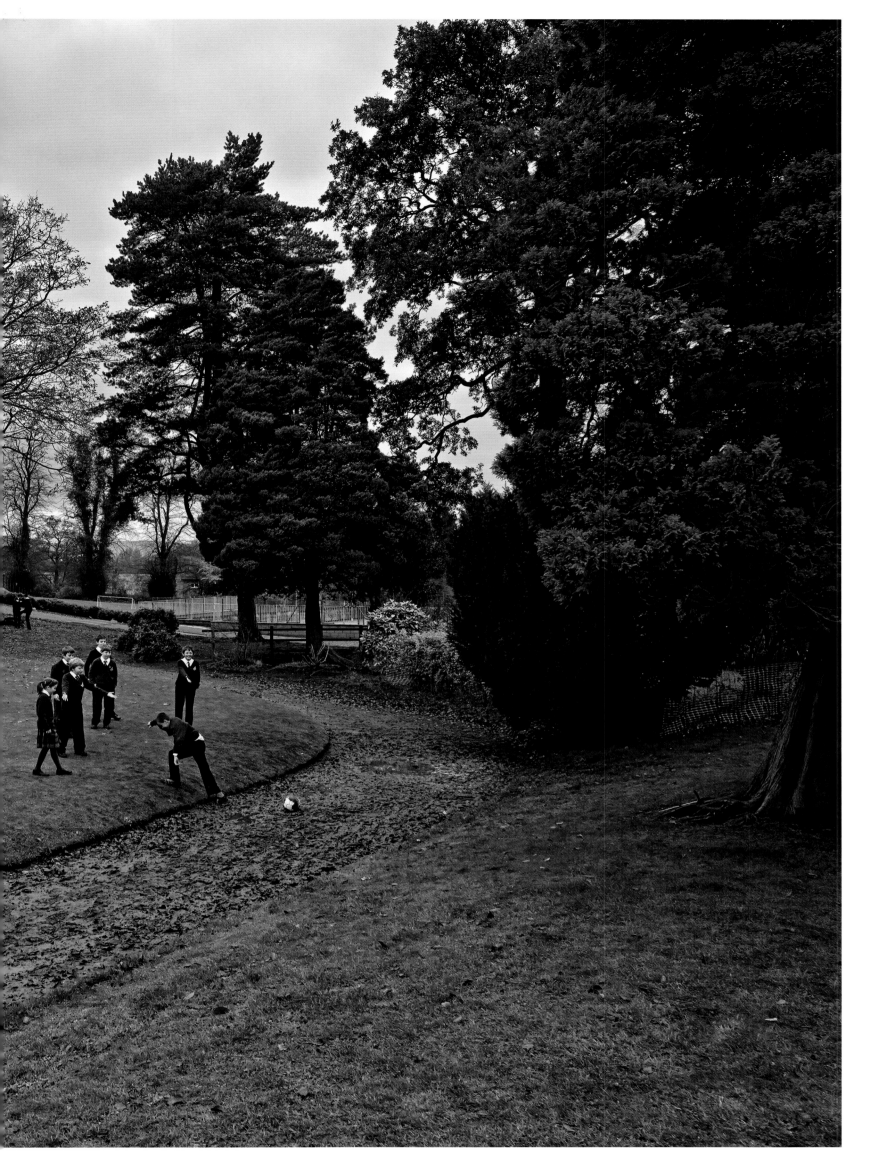

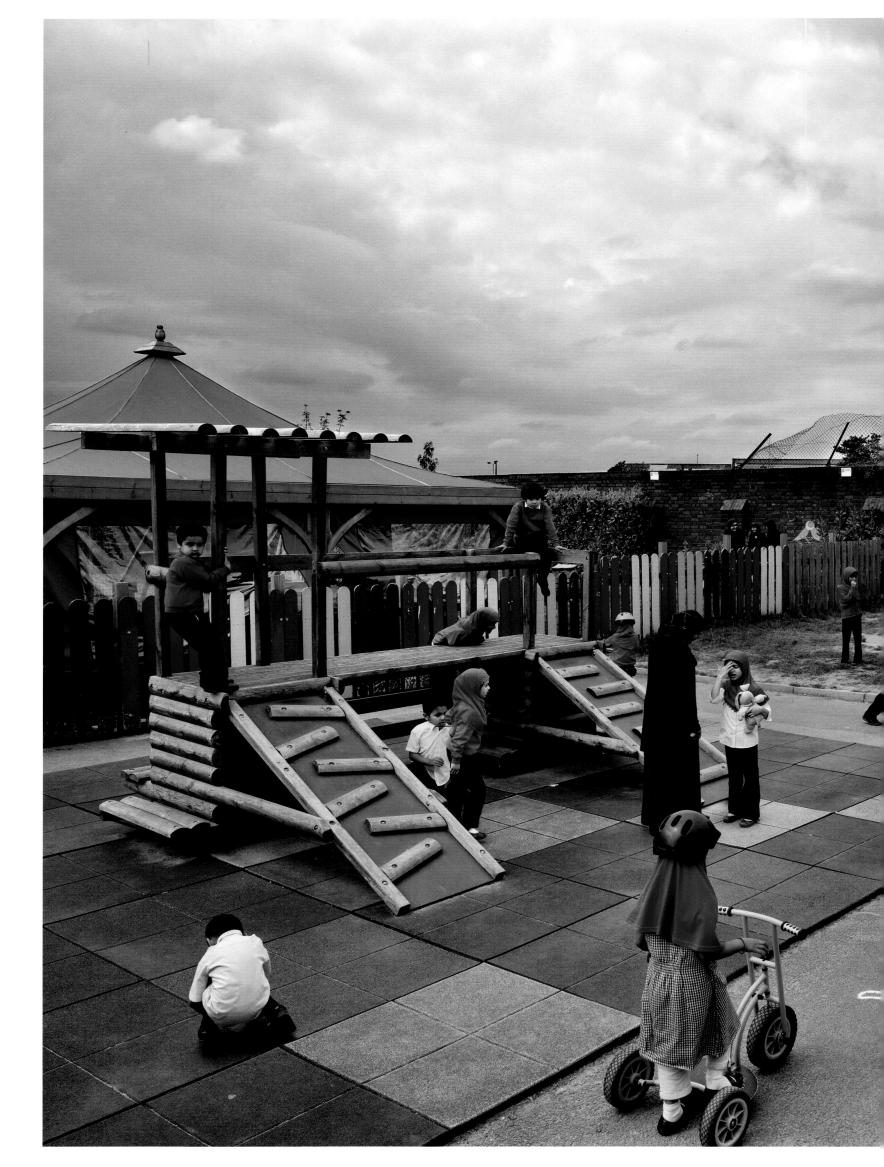

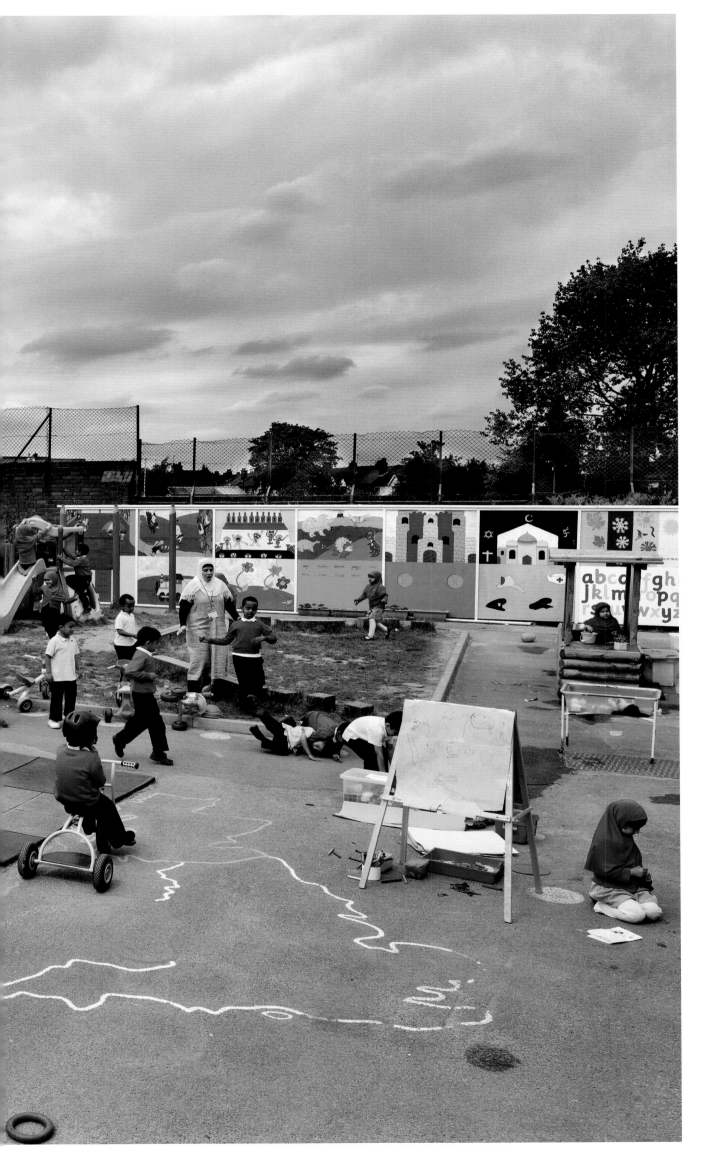

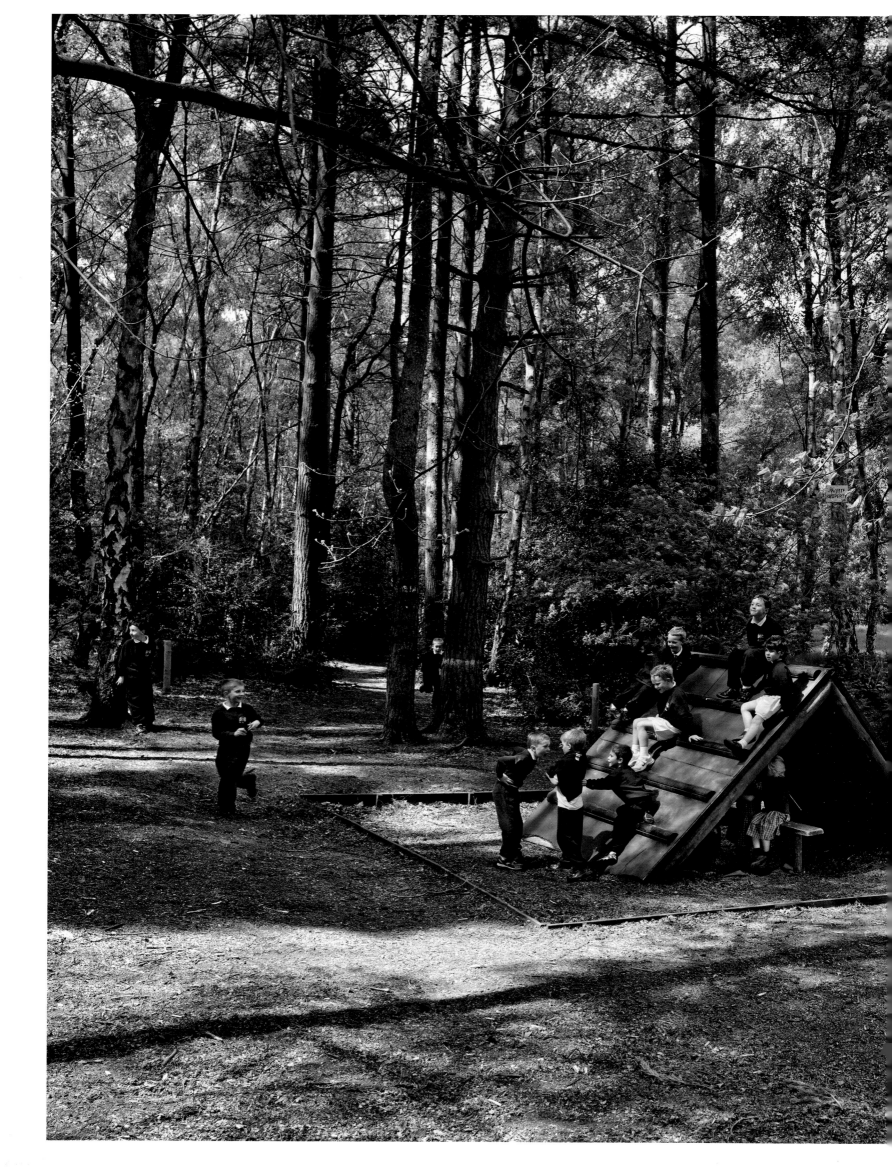

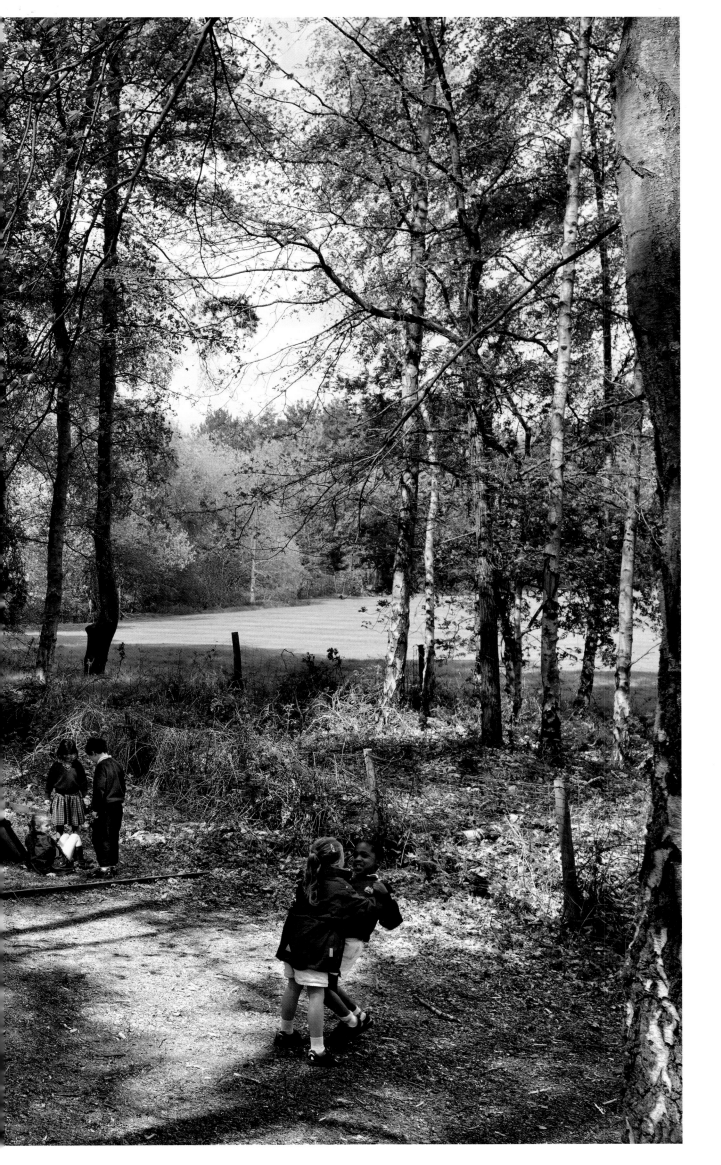

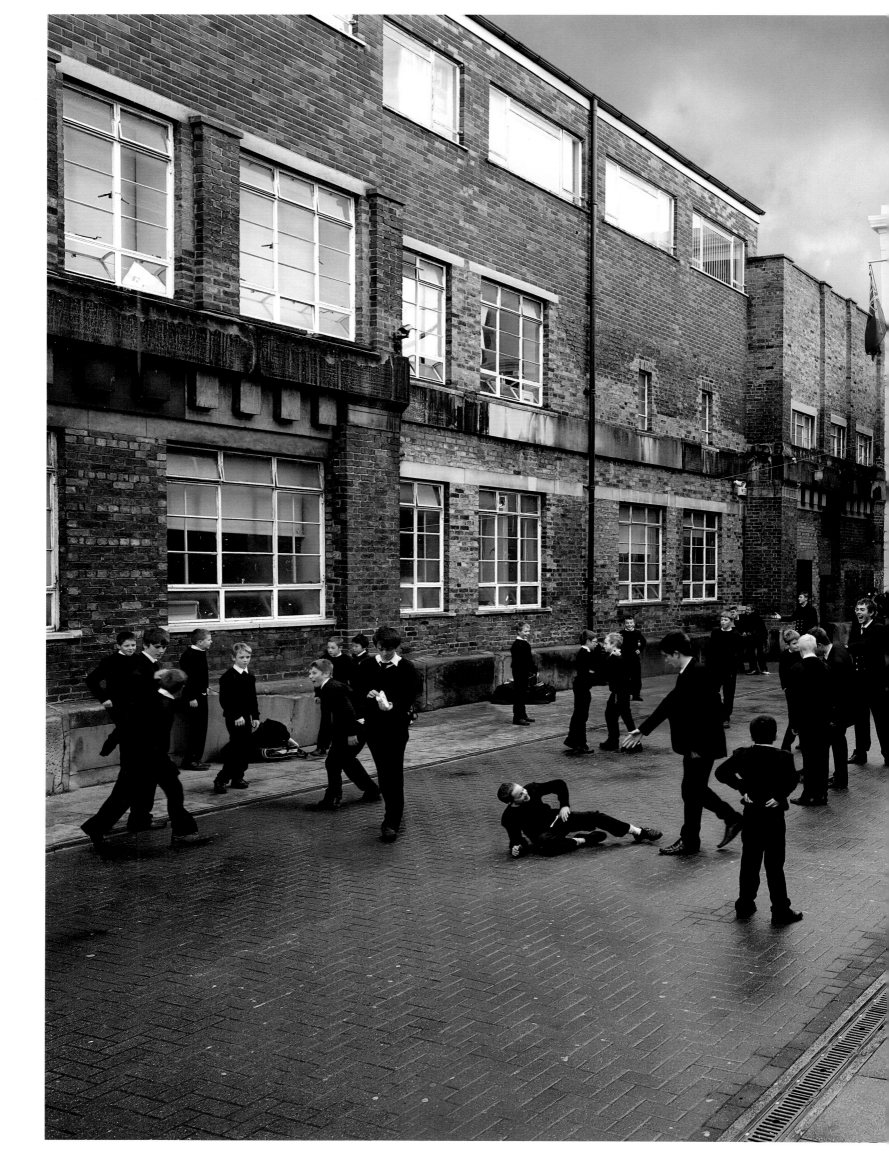

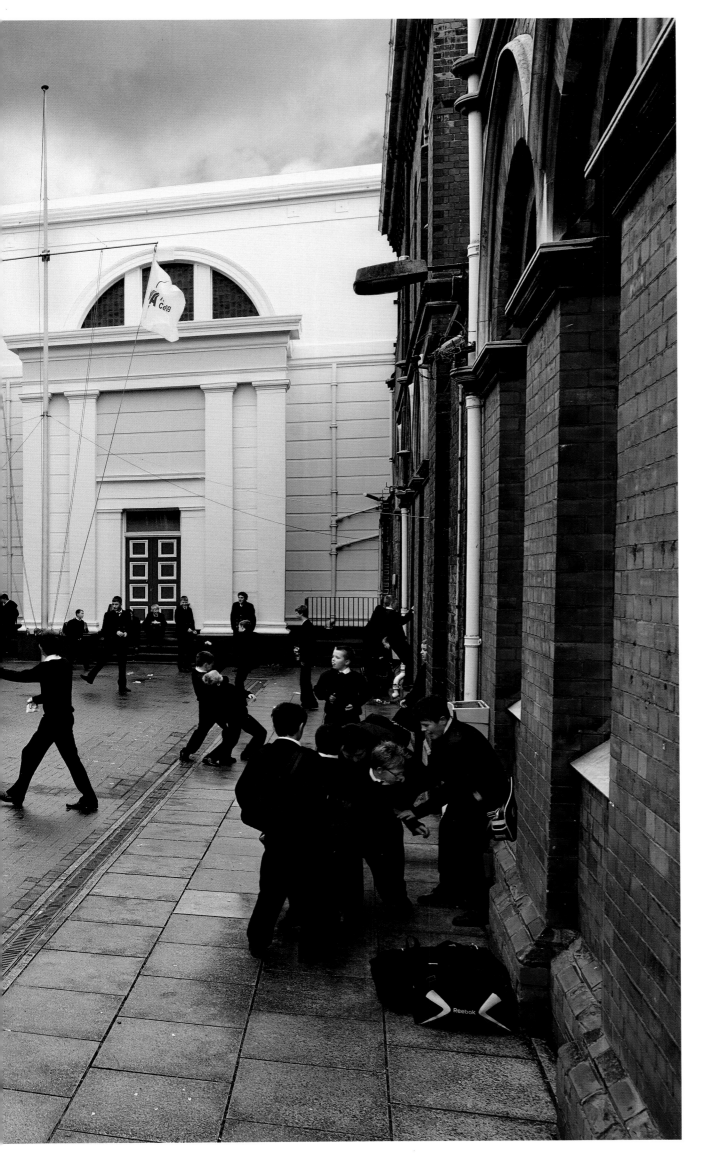

Thornton College
Convent of Jesus
and Mary,
Thornton, UK

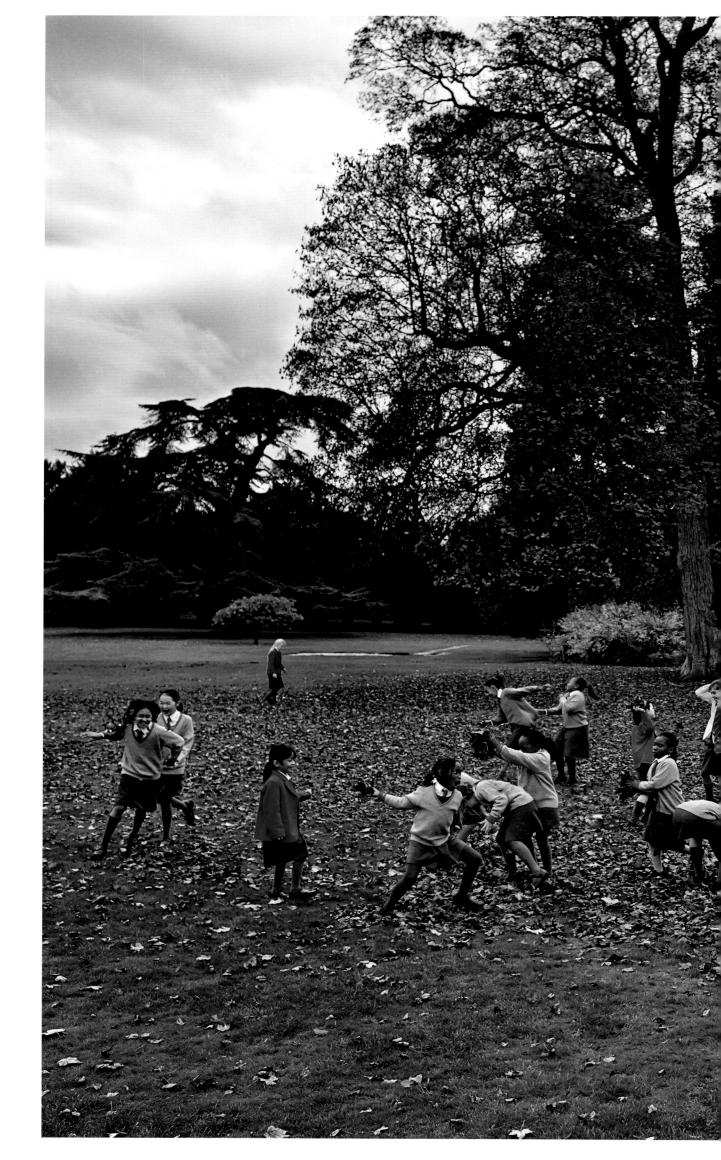

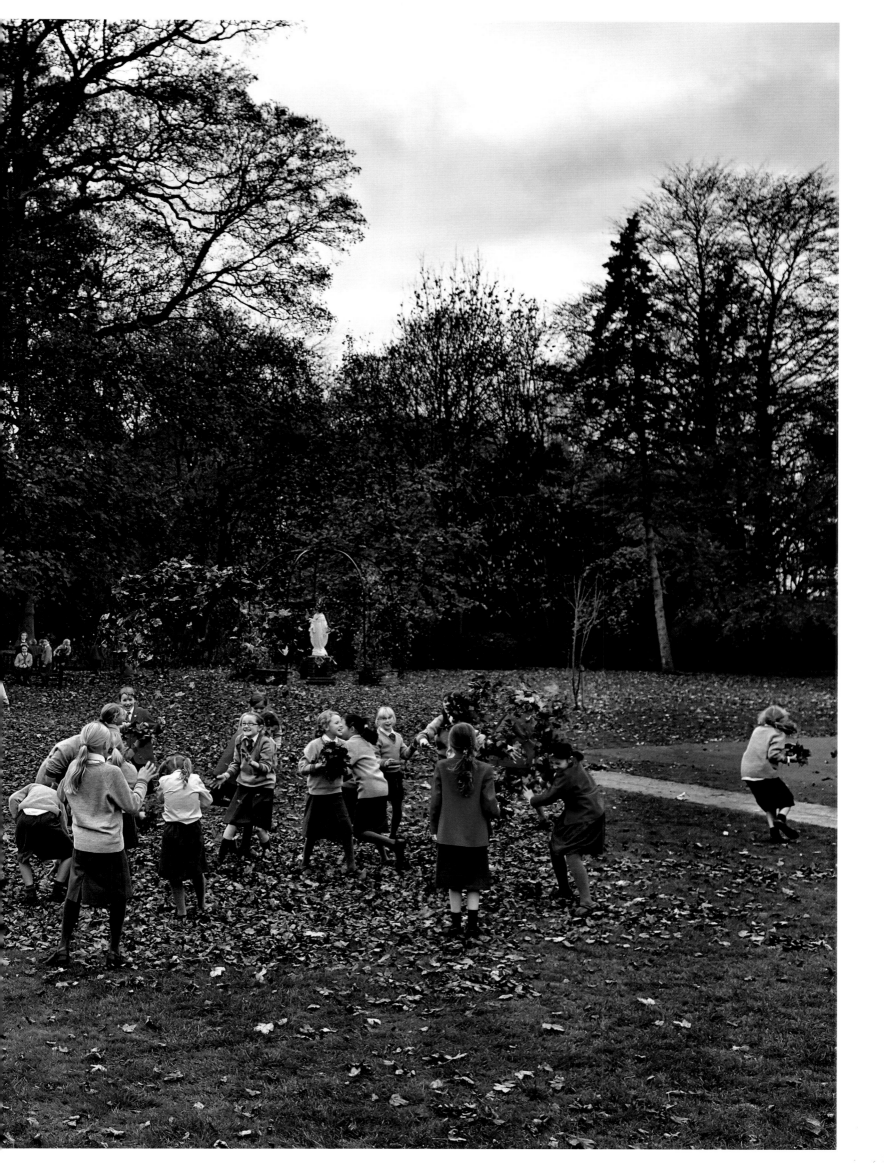

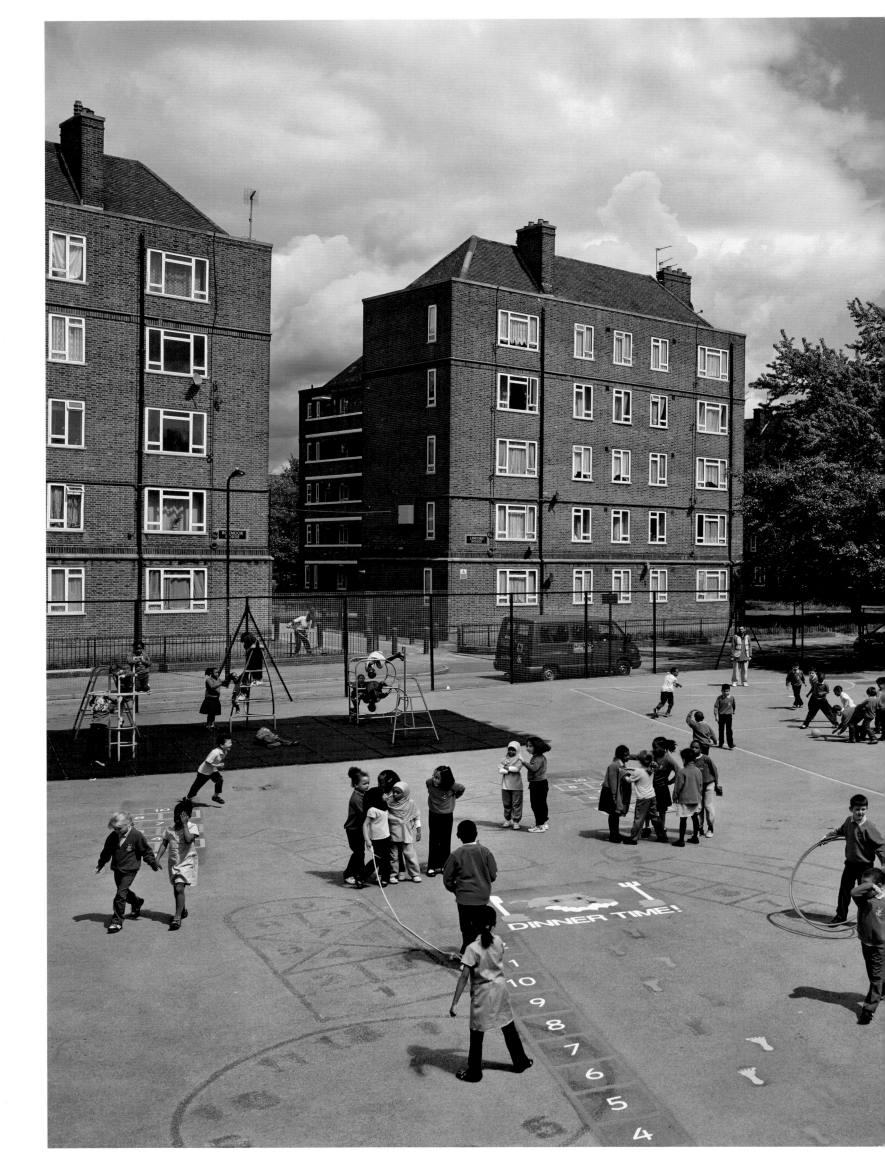

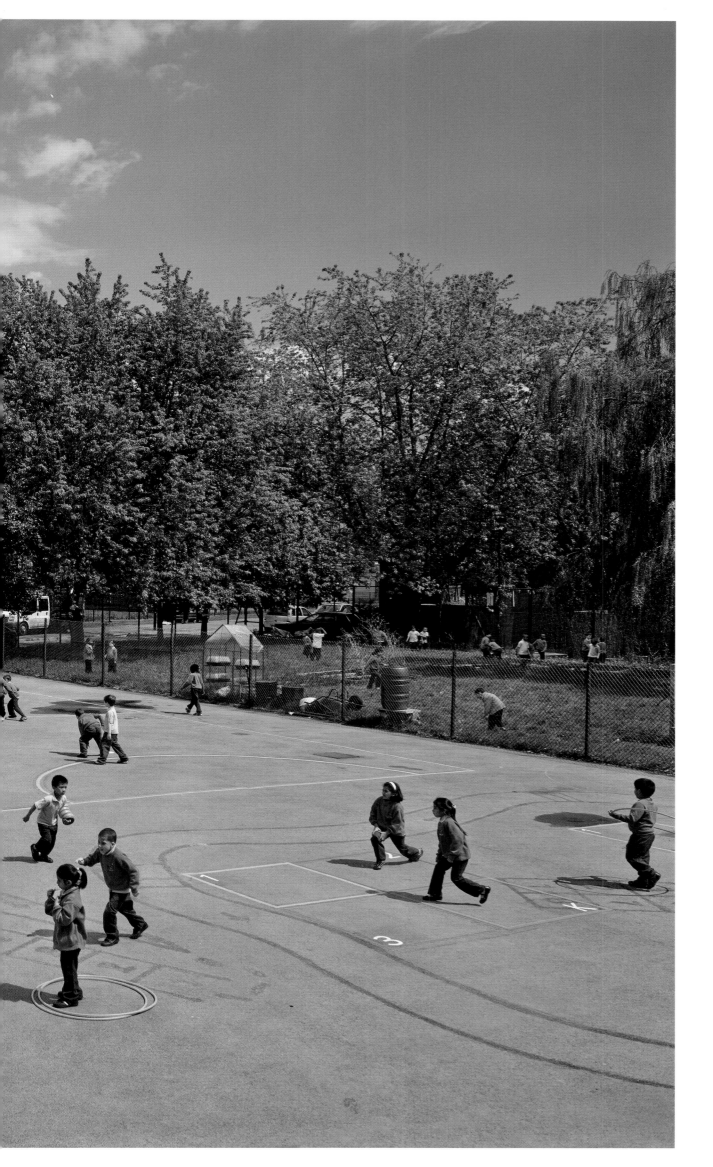

Hampstead School,
London

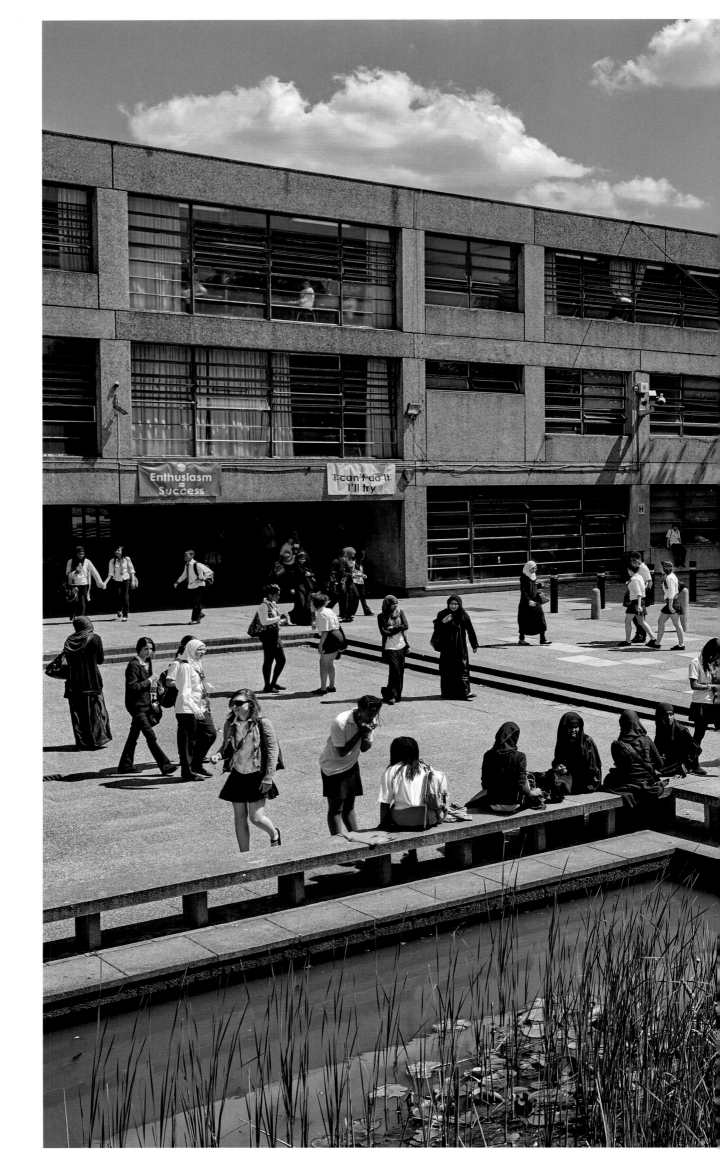

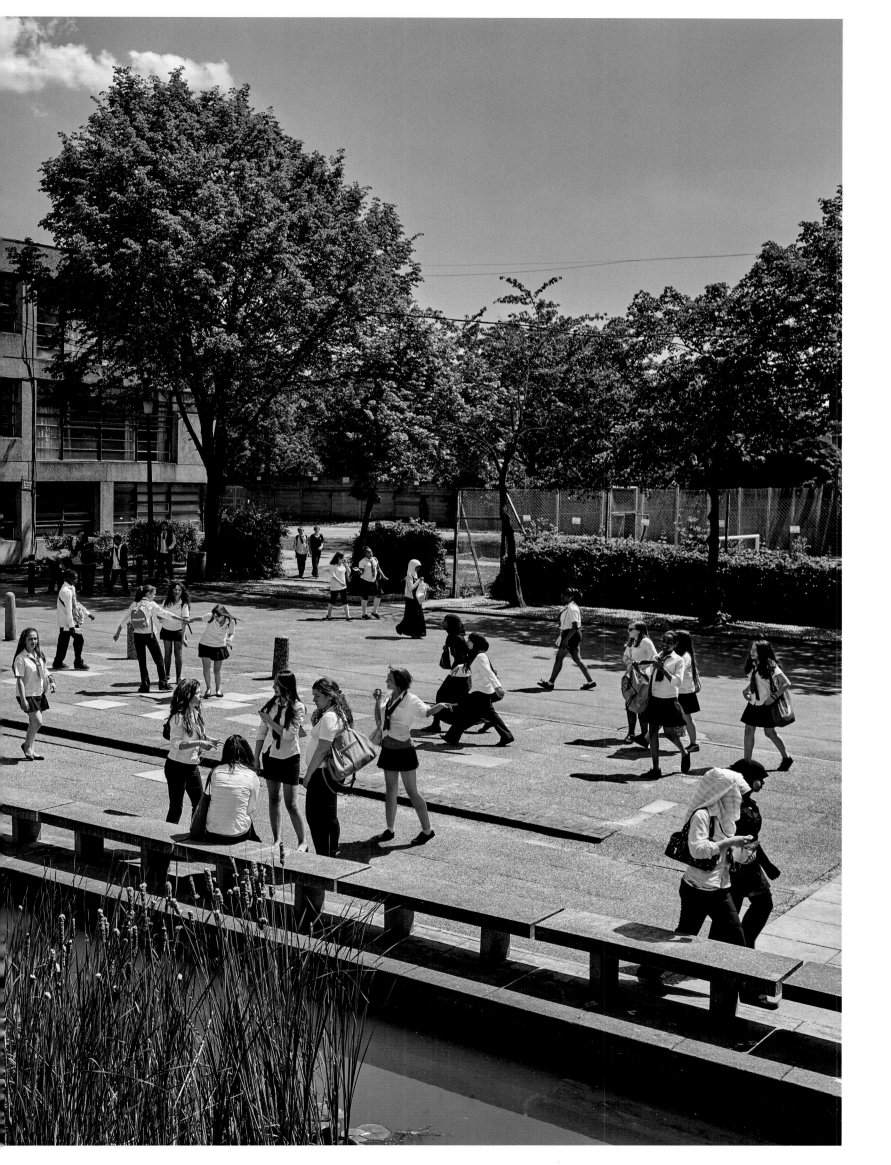

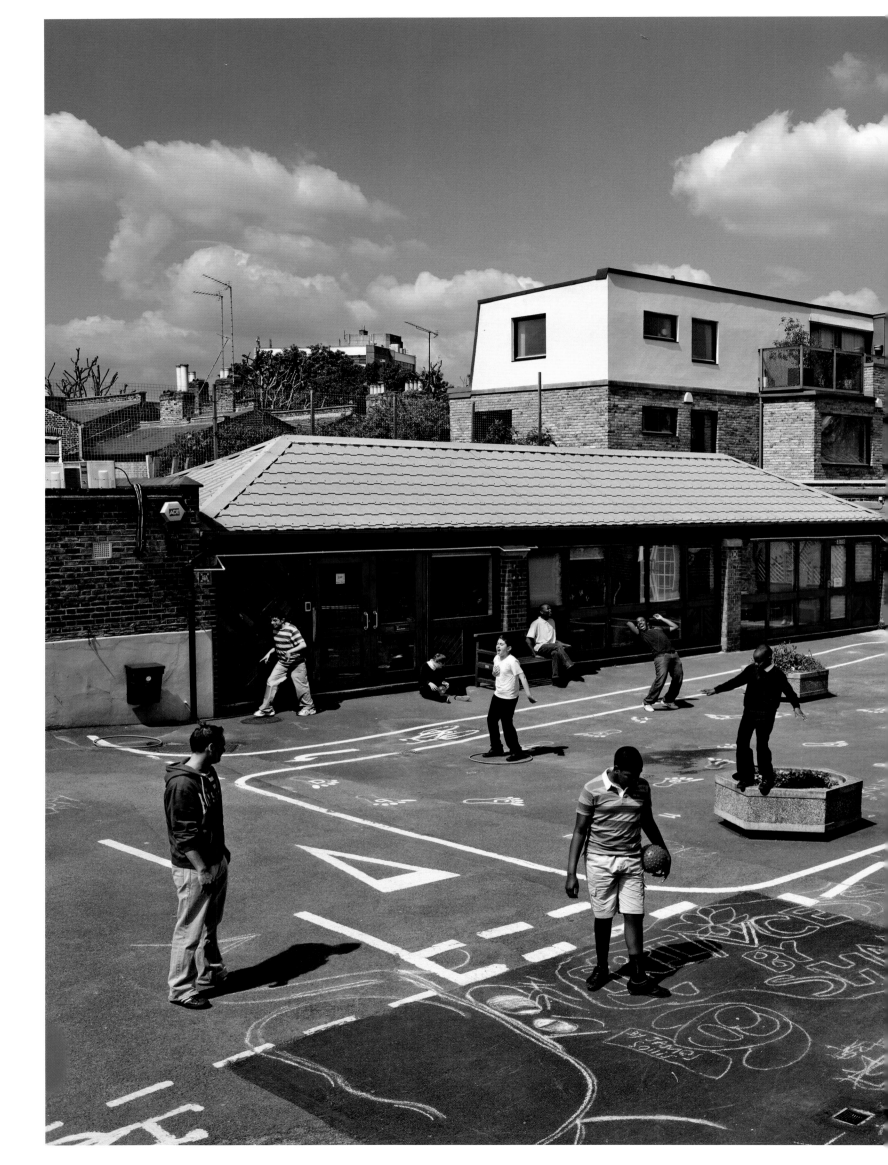

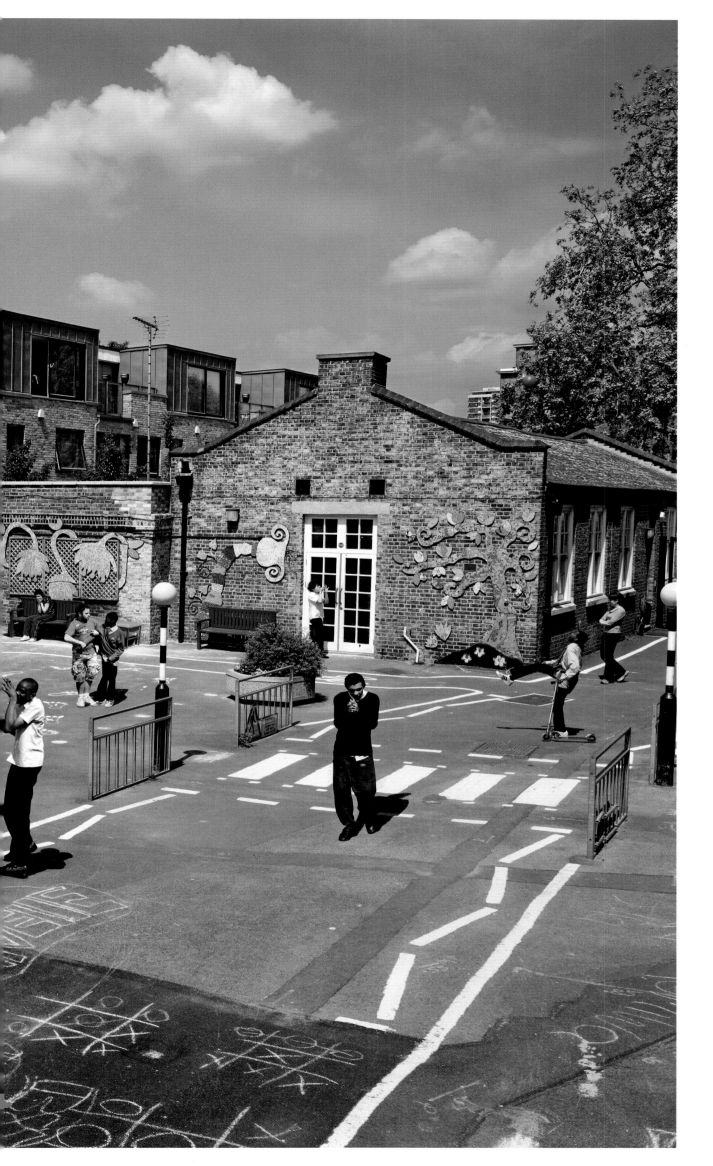

Westminster School,
London

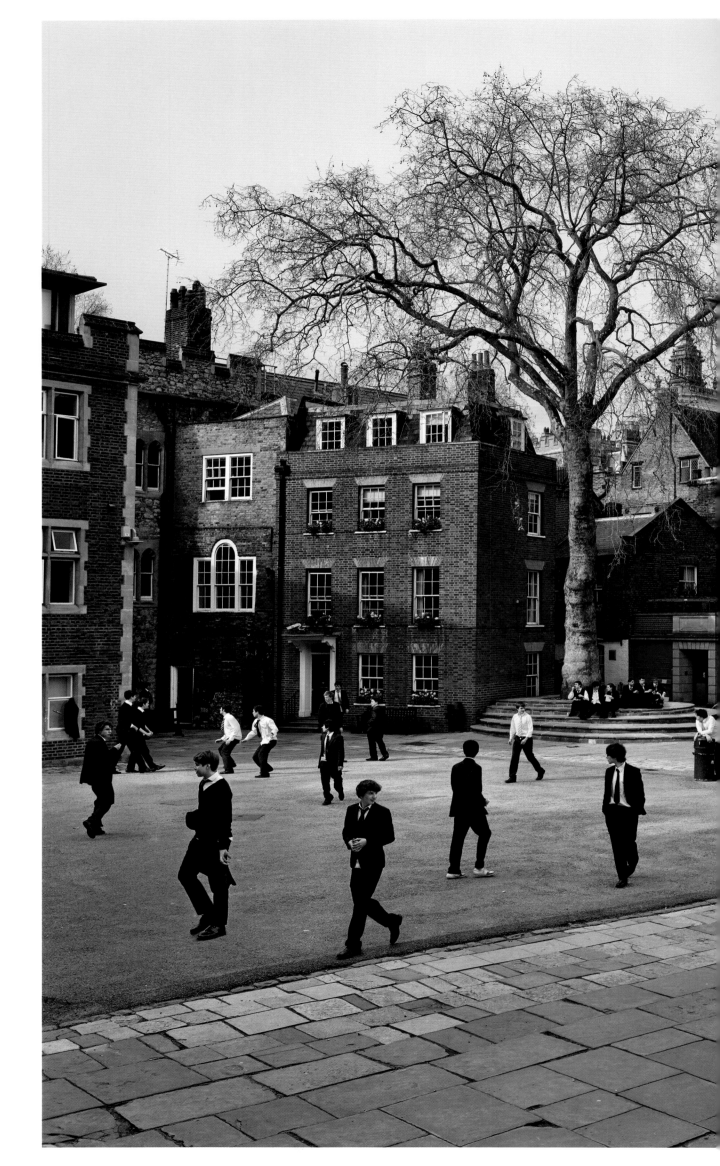

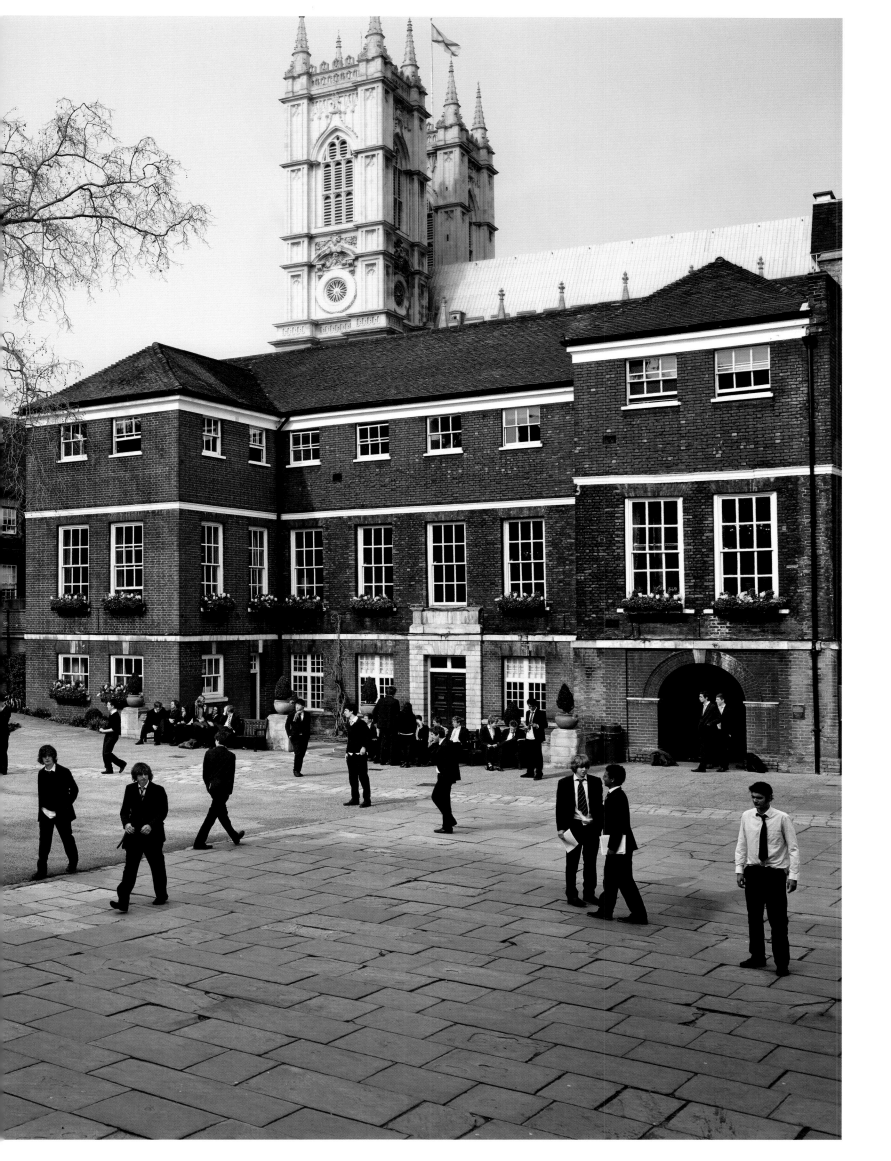

Sacred Heart
Catholic Secondary
School, London

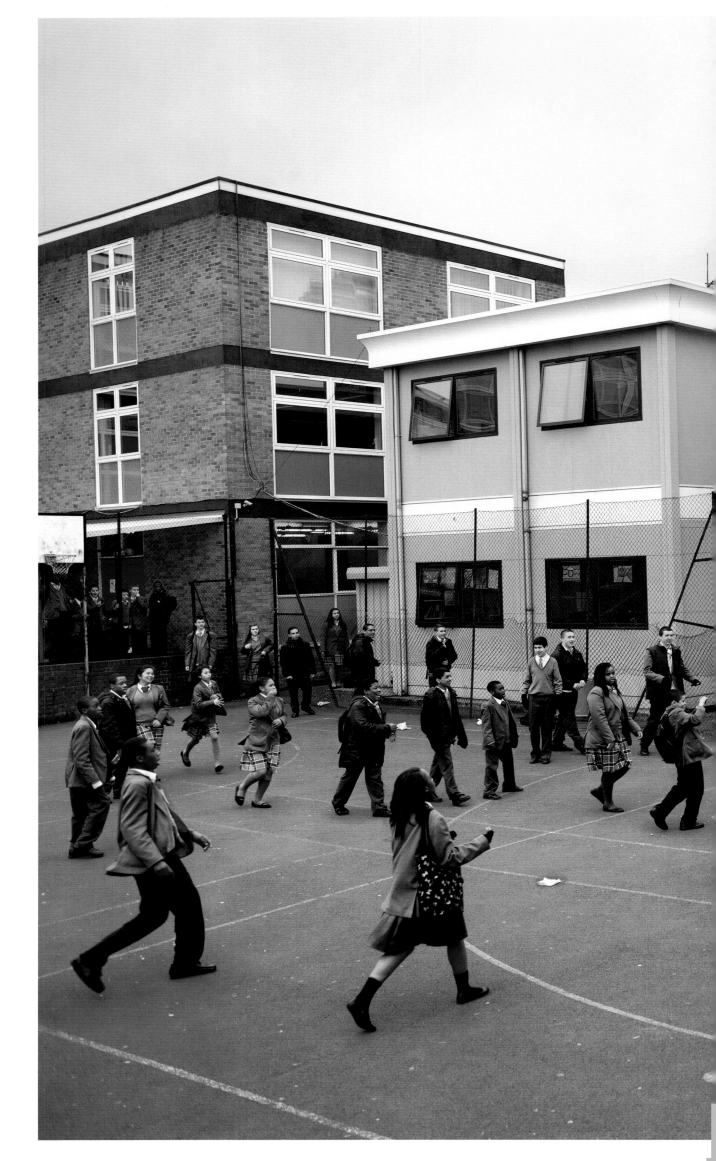

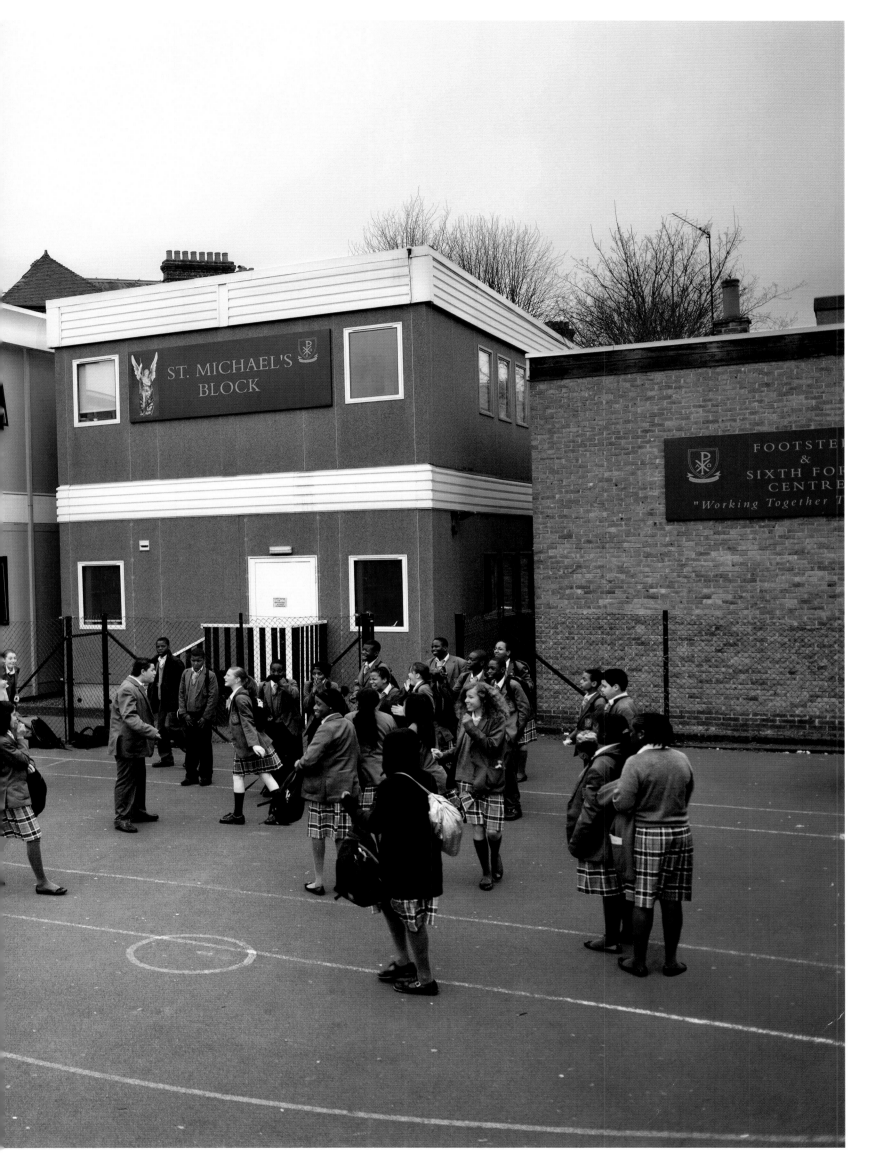

Valley View School,
Mathare, Nairobi,
Kenya

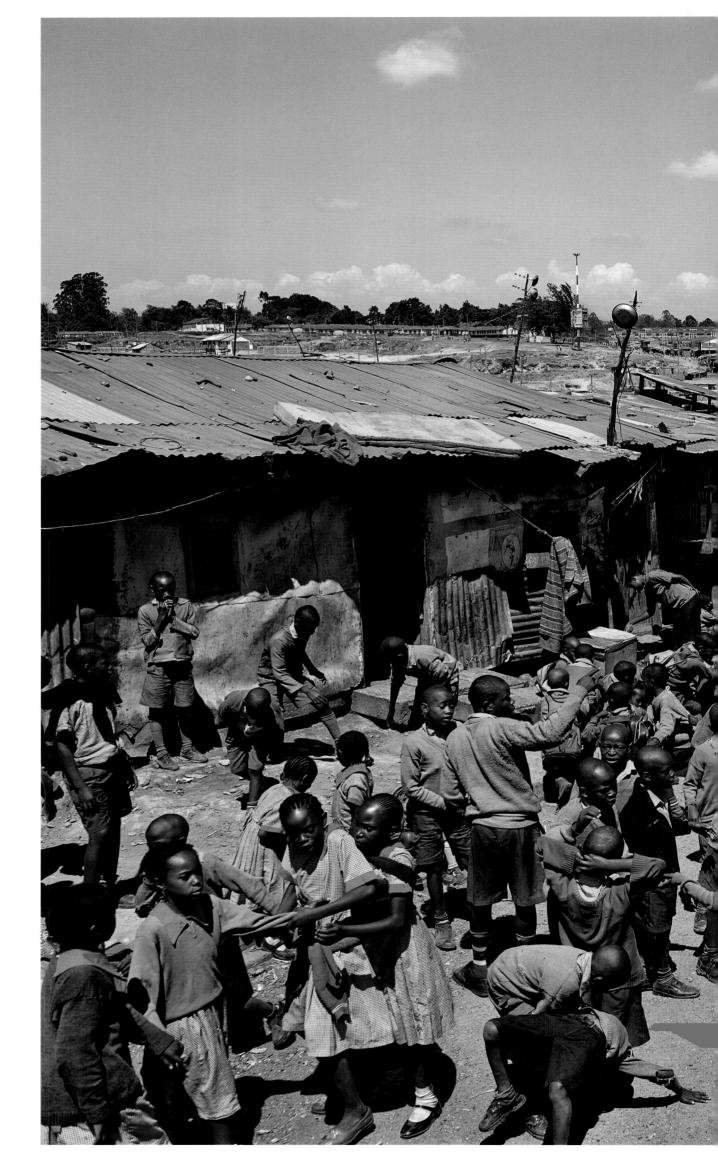

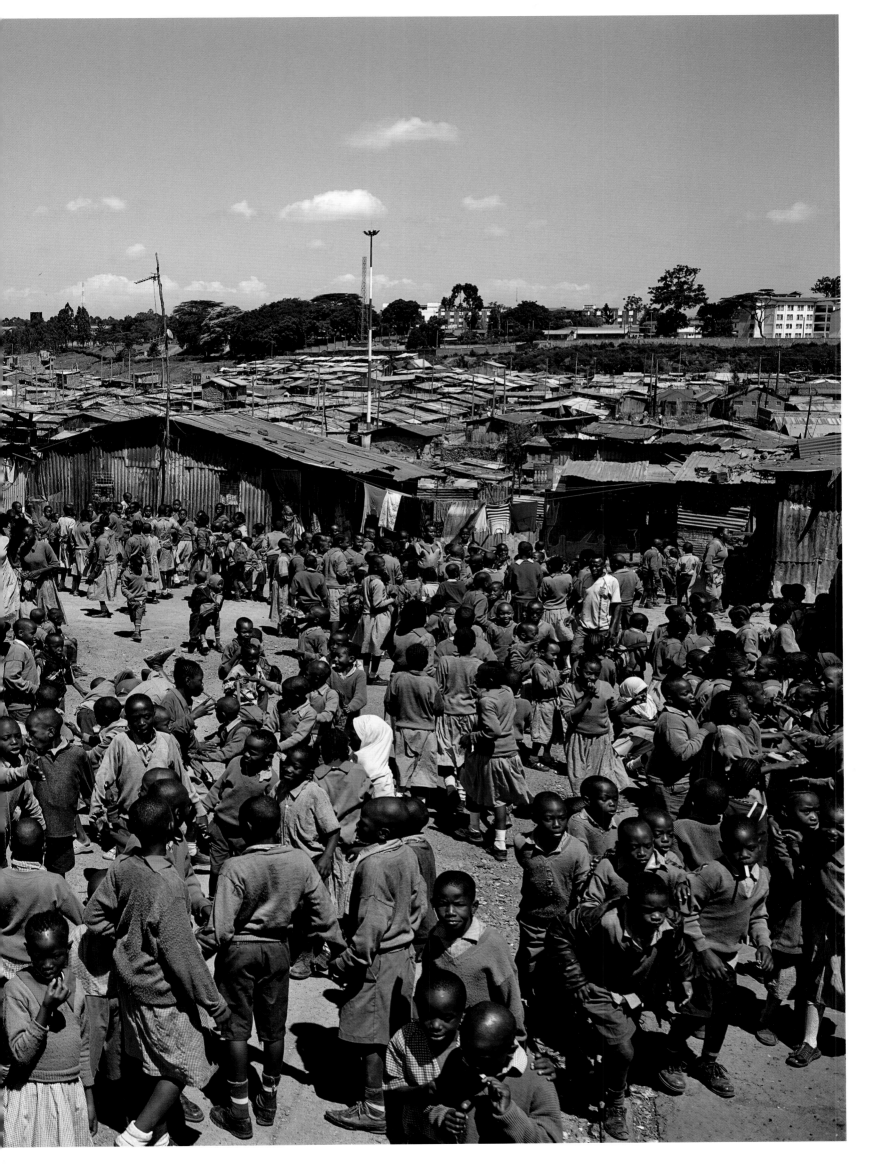

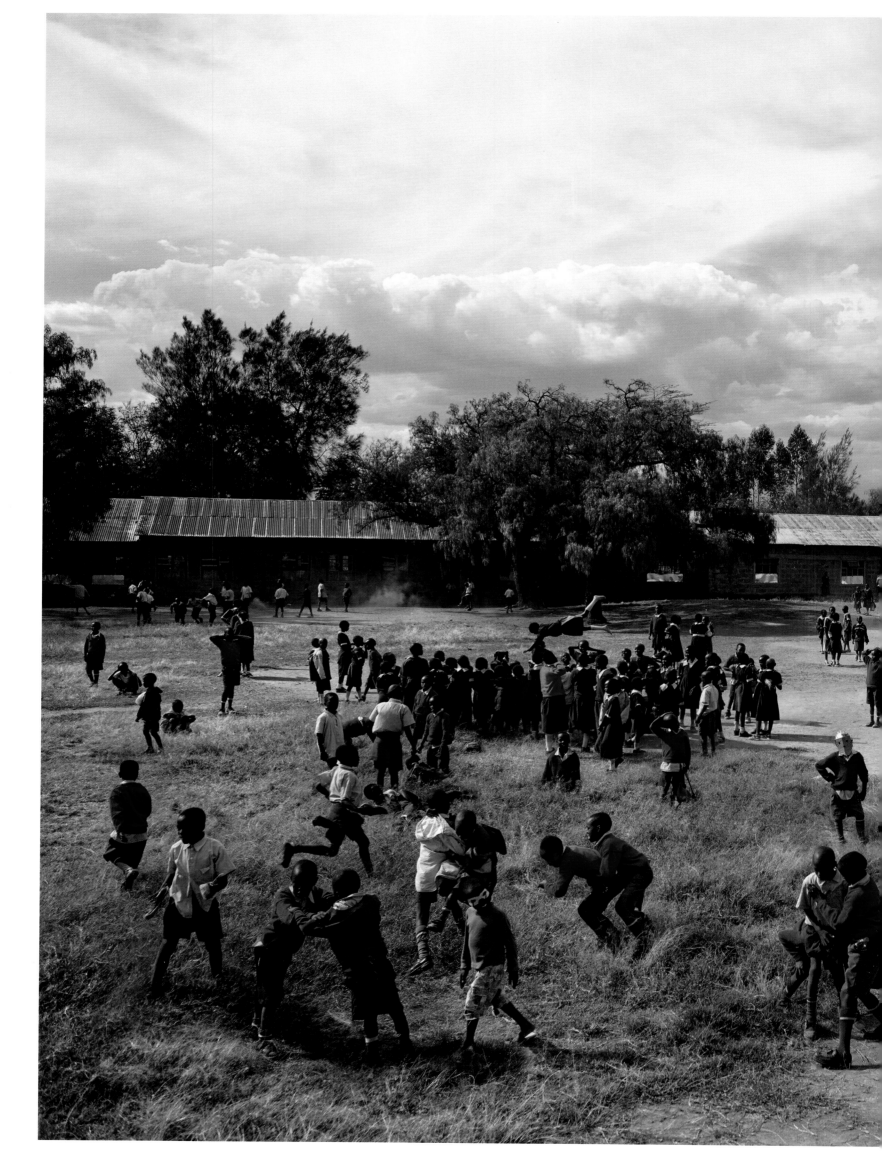

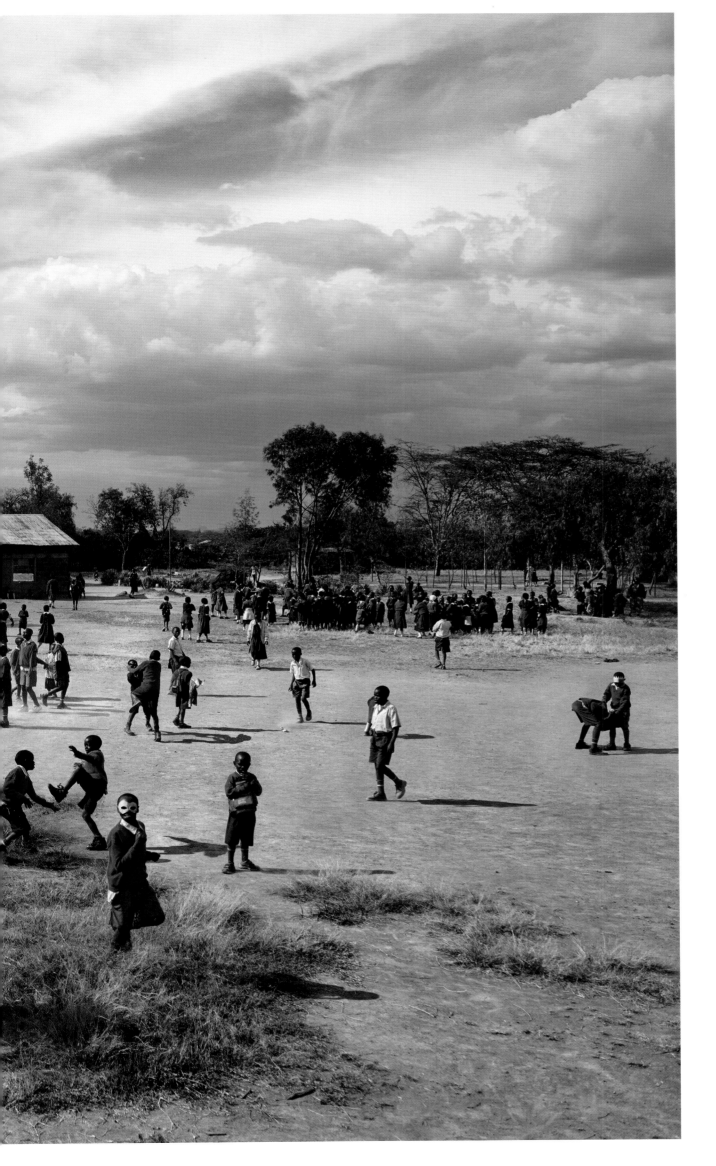

Manera Primary
School, Naivasha,
Kenya

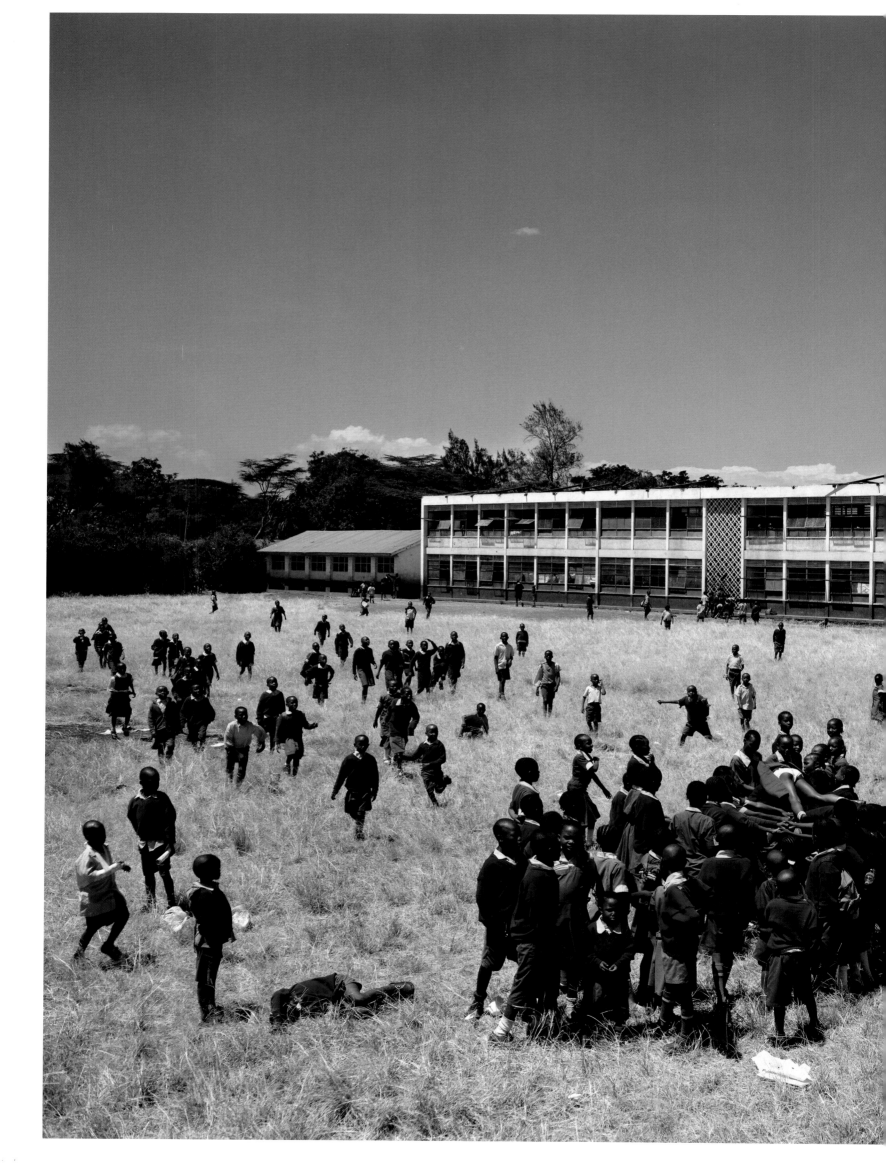

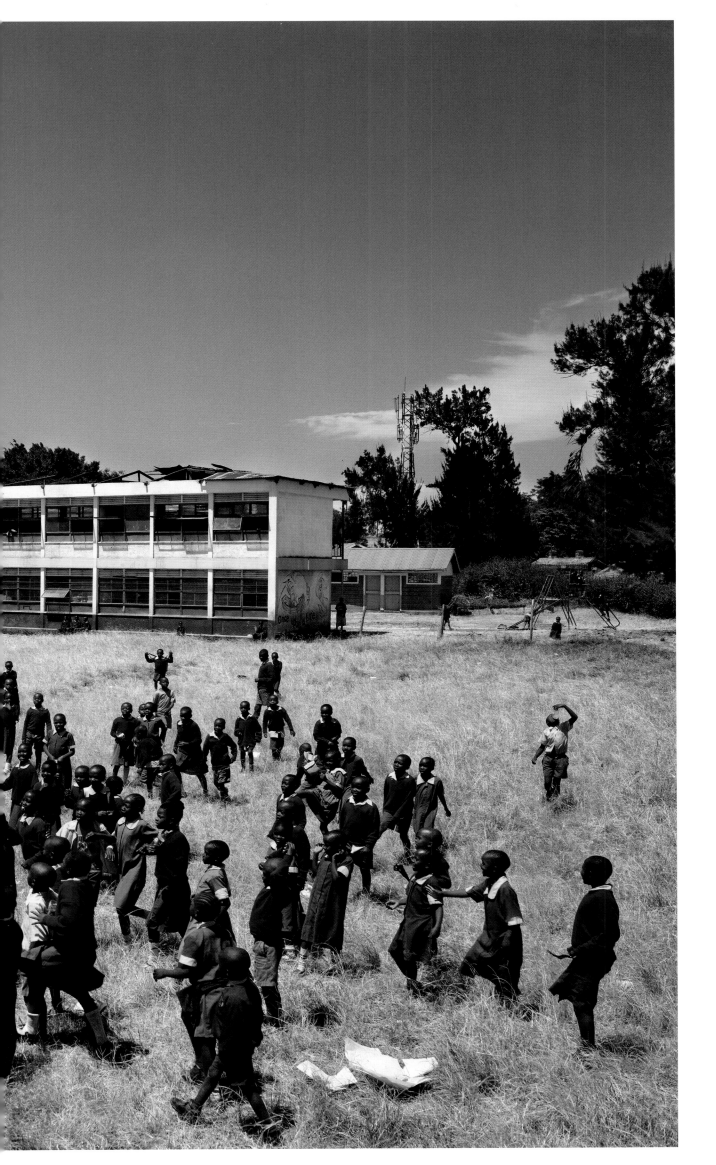

Kaloleni School,
Nairobi, Kenya

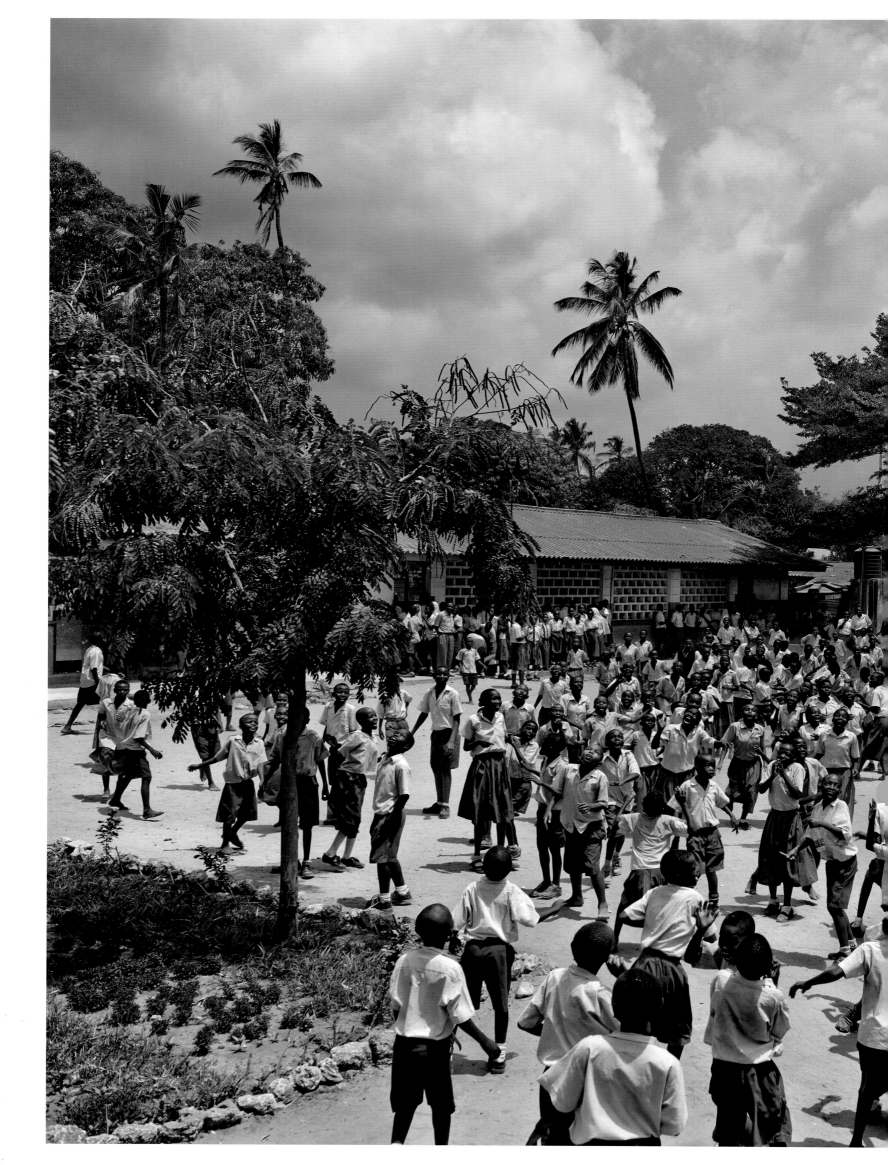

Freretown
Community Primary
School, Mombasa,
Kenya

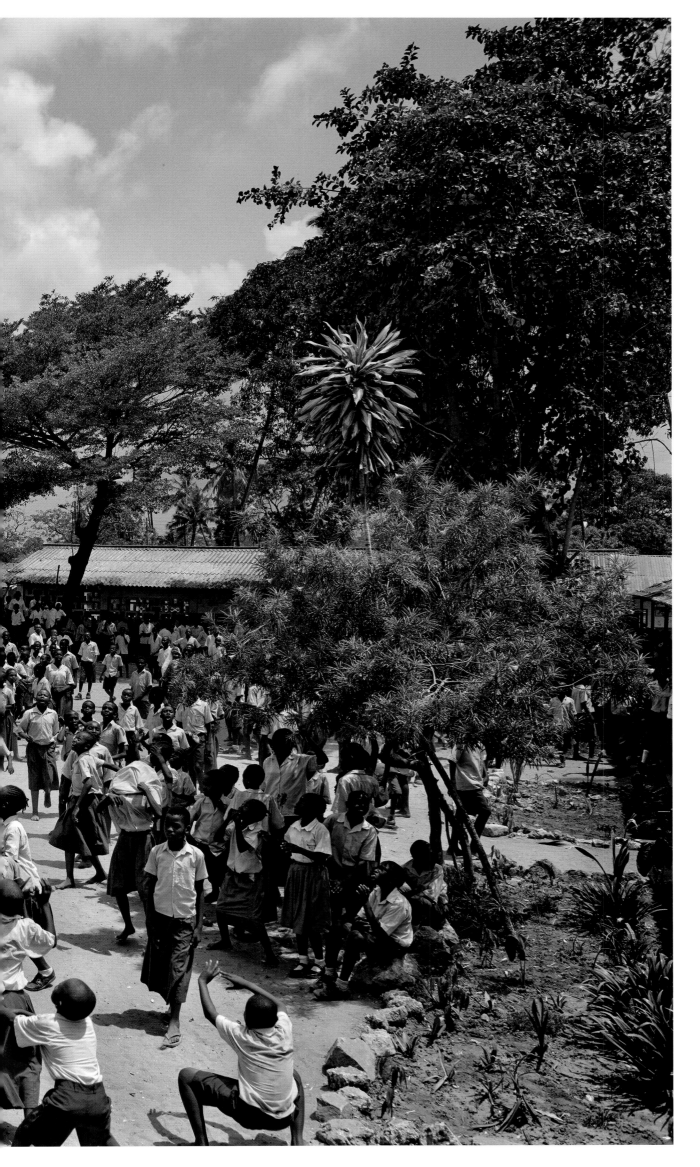

Likoni School for
the Blind, Mombasa,
Kenya

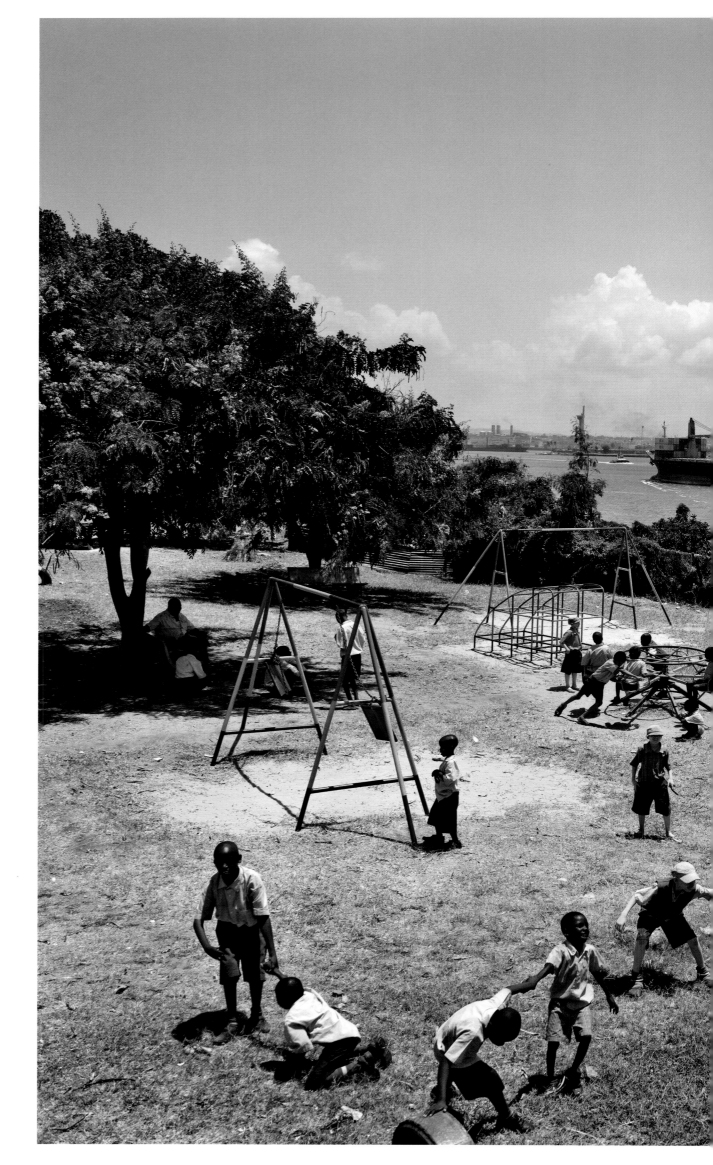

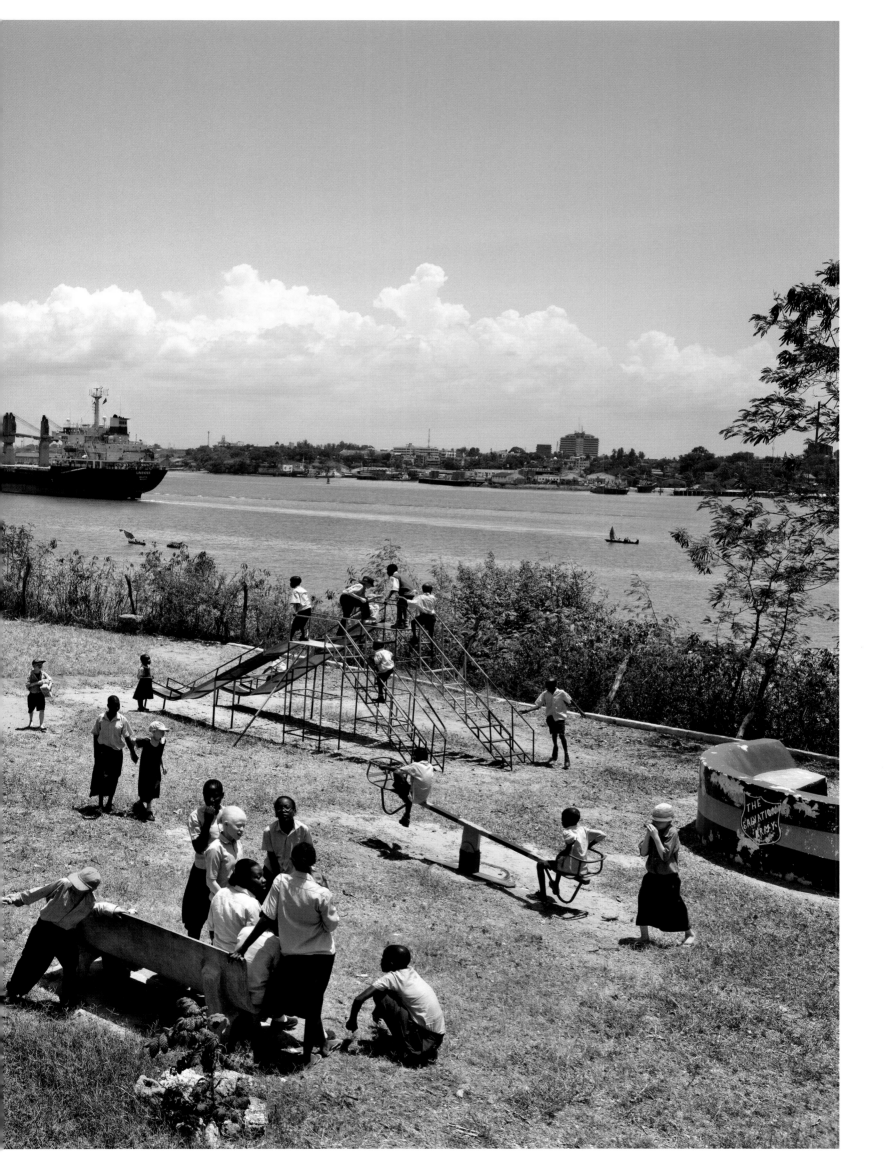

Virani Deaf and
Dumb School,
Rajkot, Gujarat, India

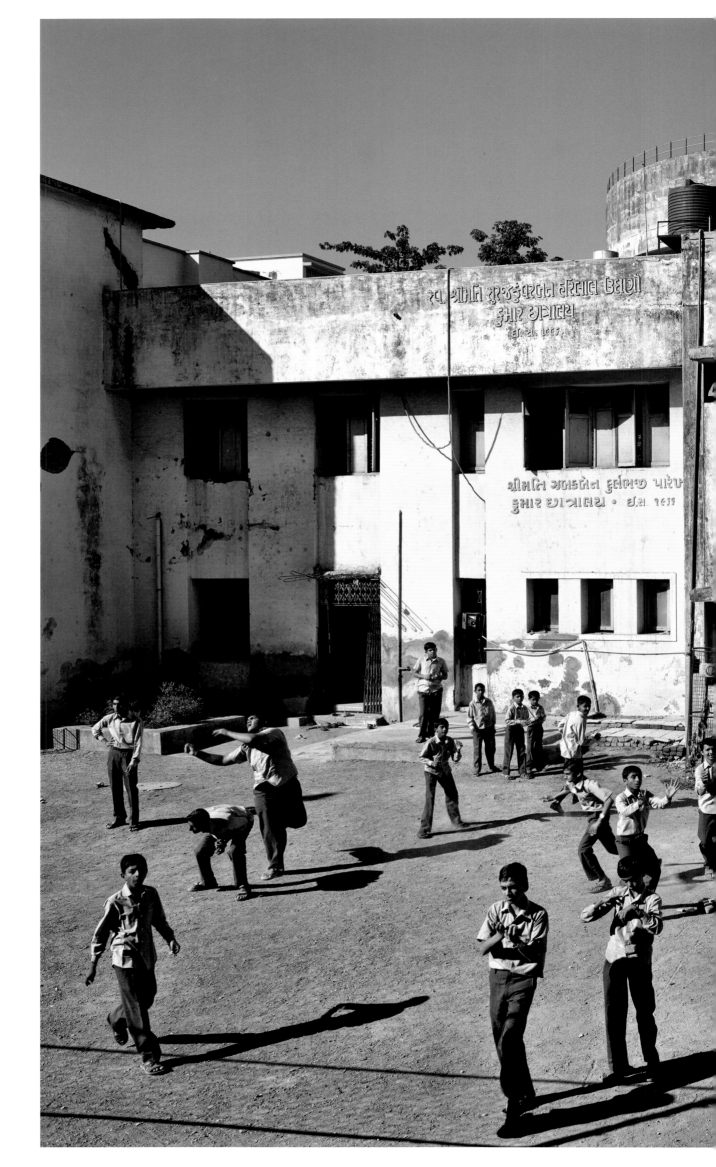

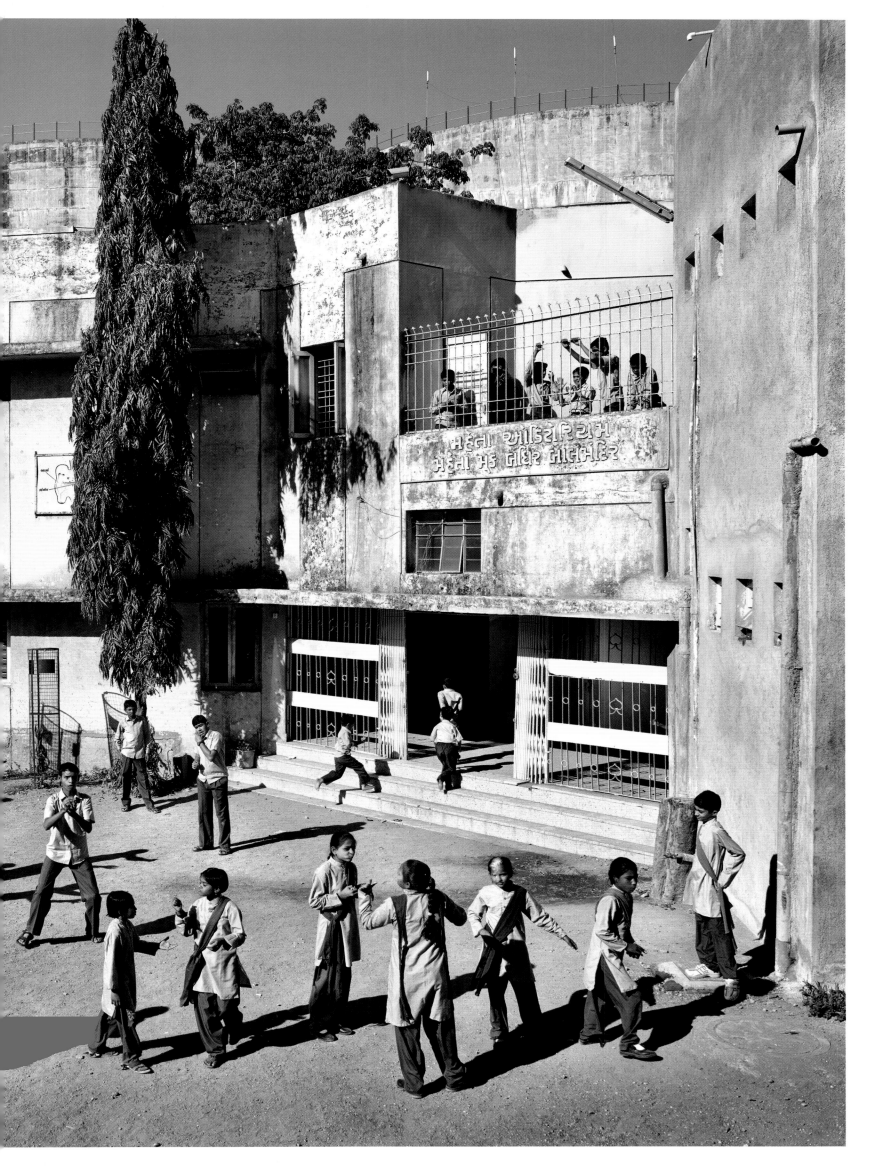

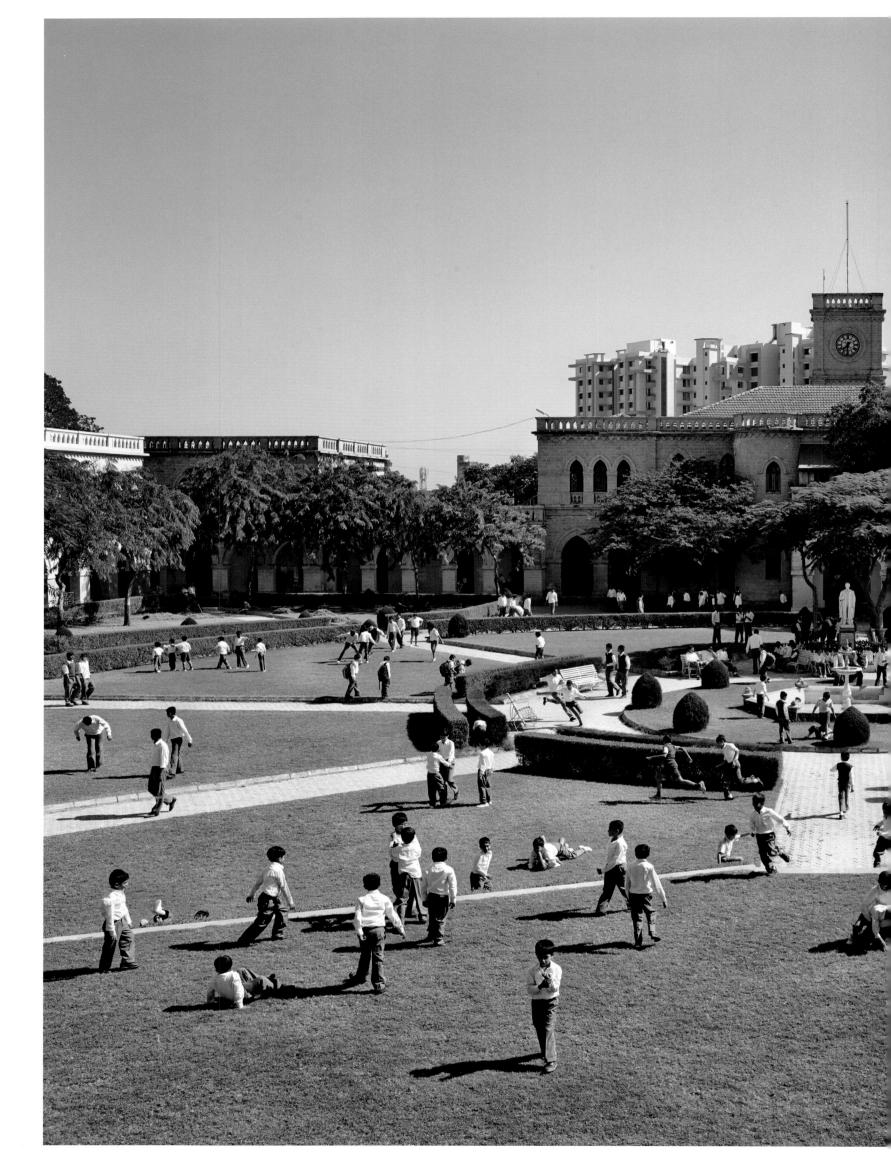

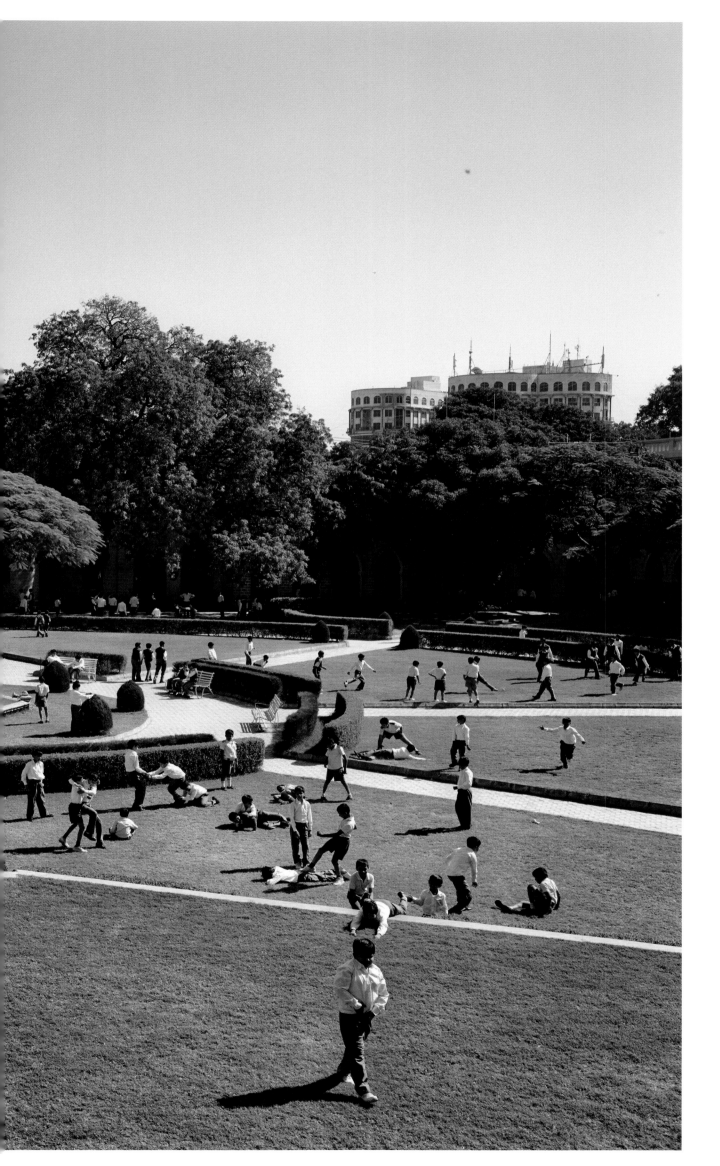

SDCCL Public
School, Sikka,
Gujarat, India

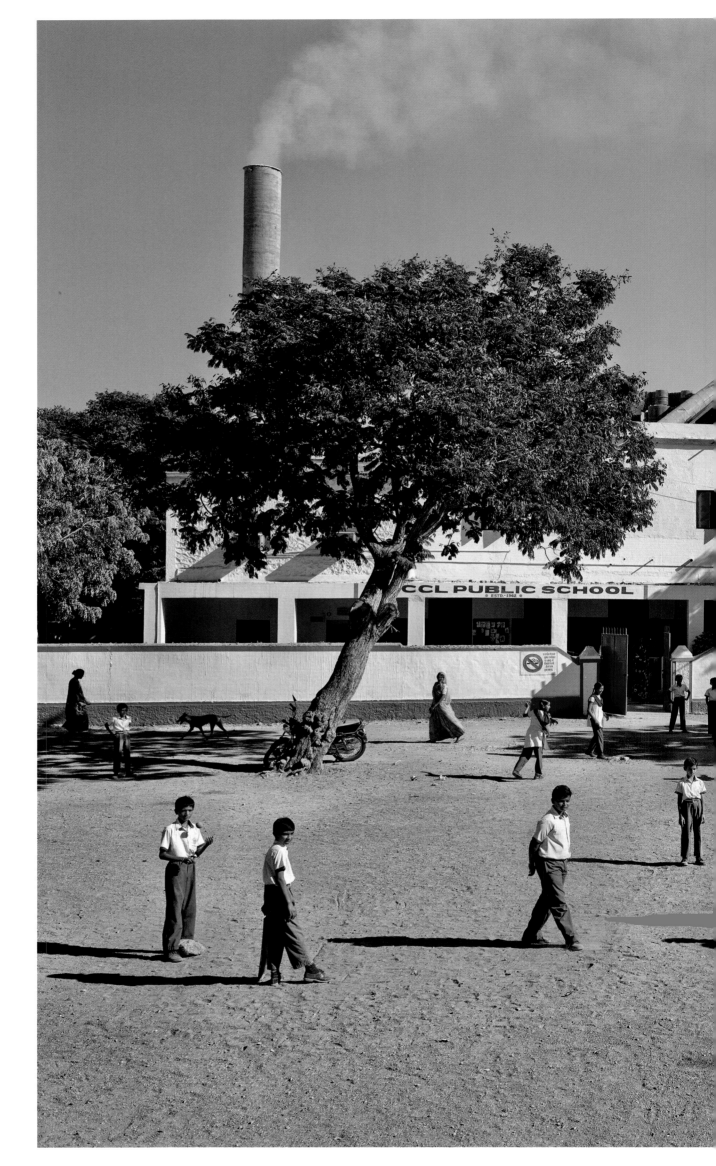

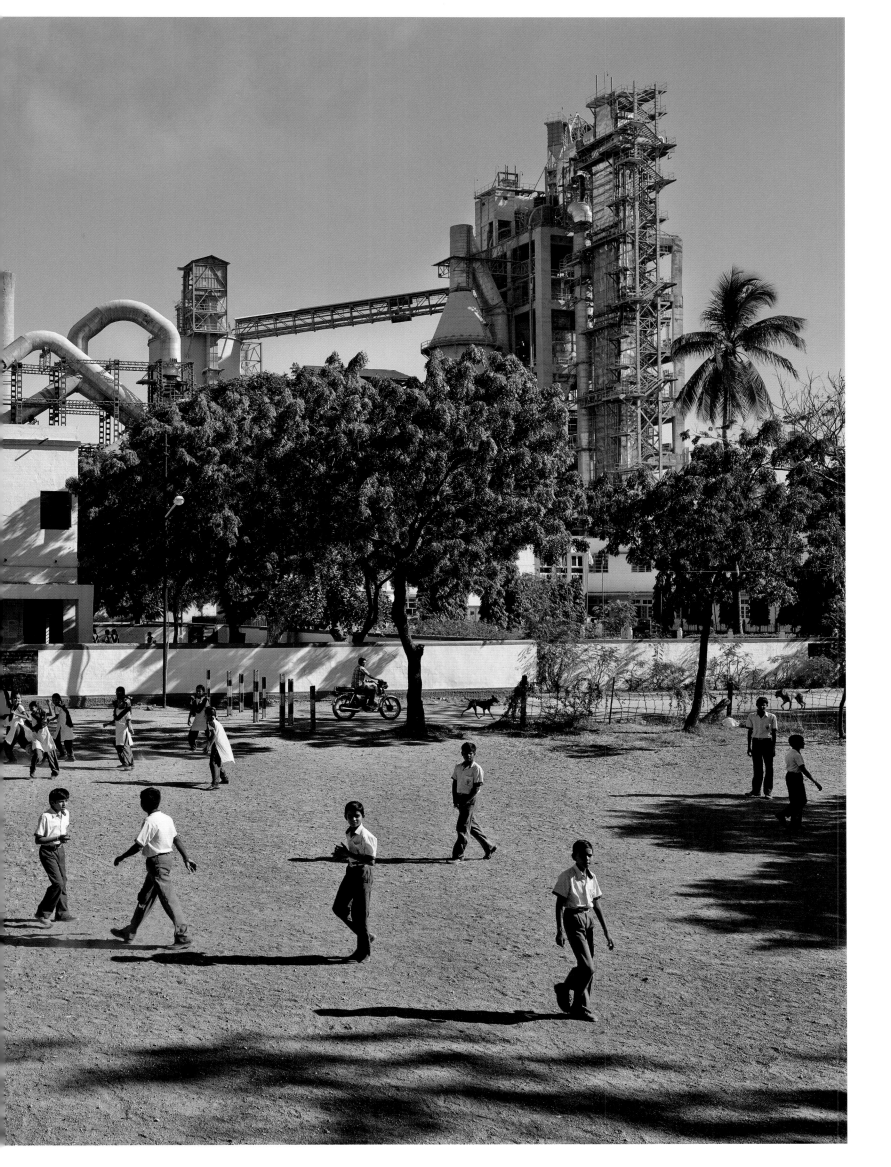

KD Ambani School,
Jamnagar, Gujarat,
India

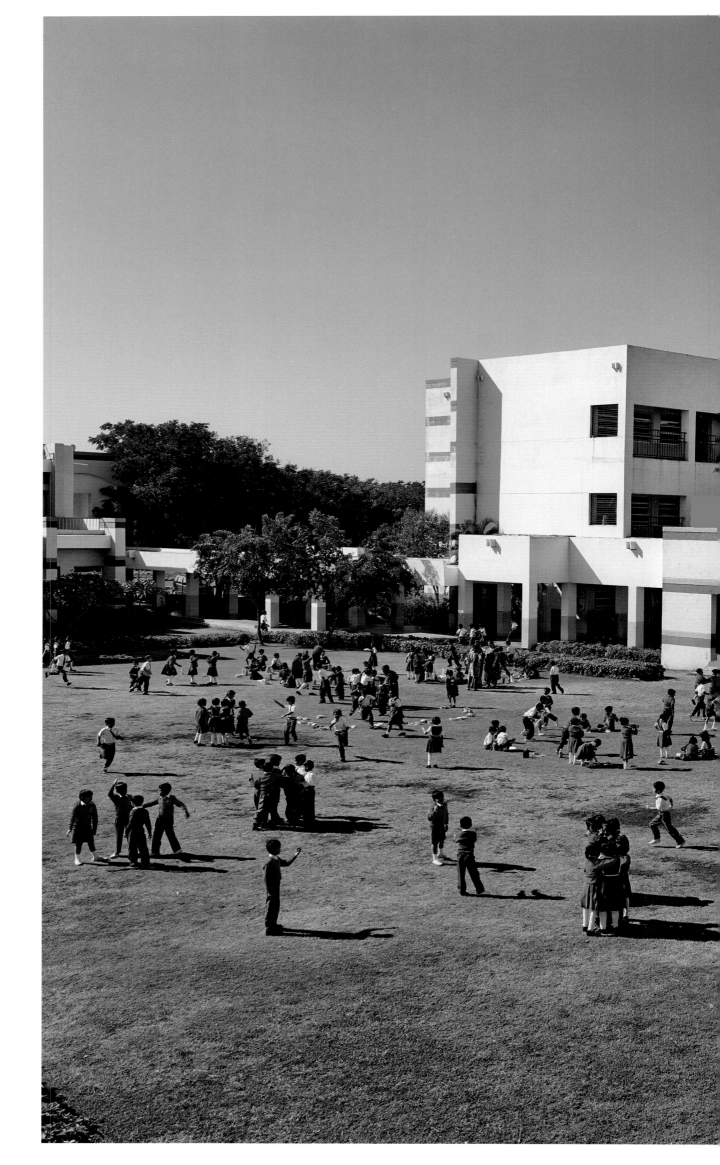

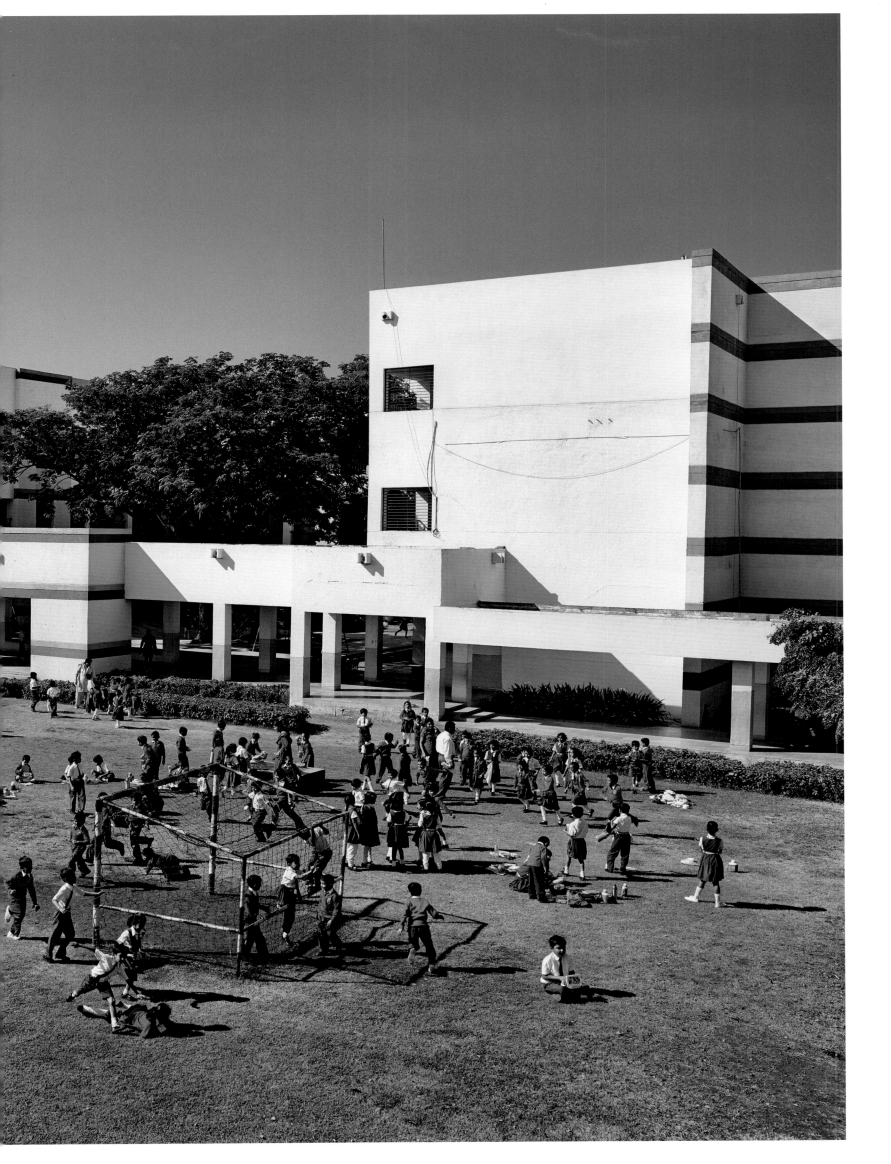

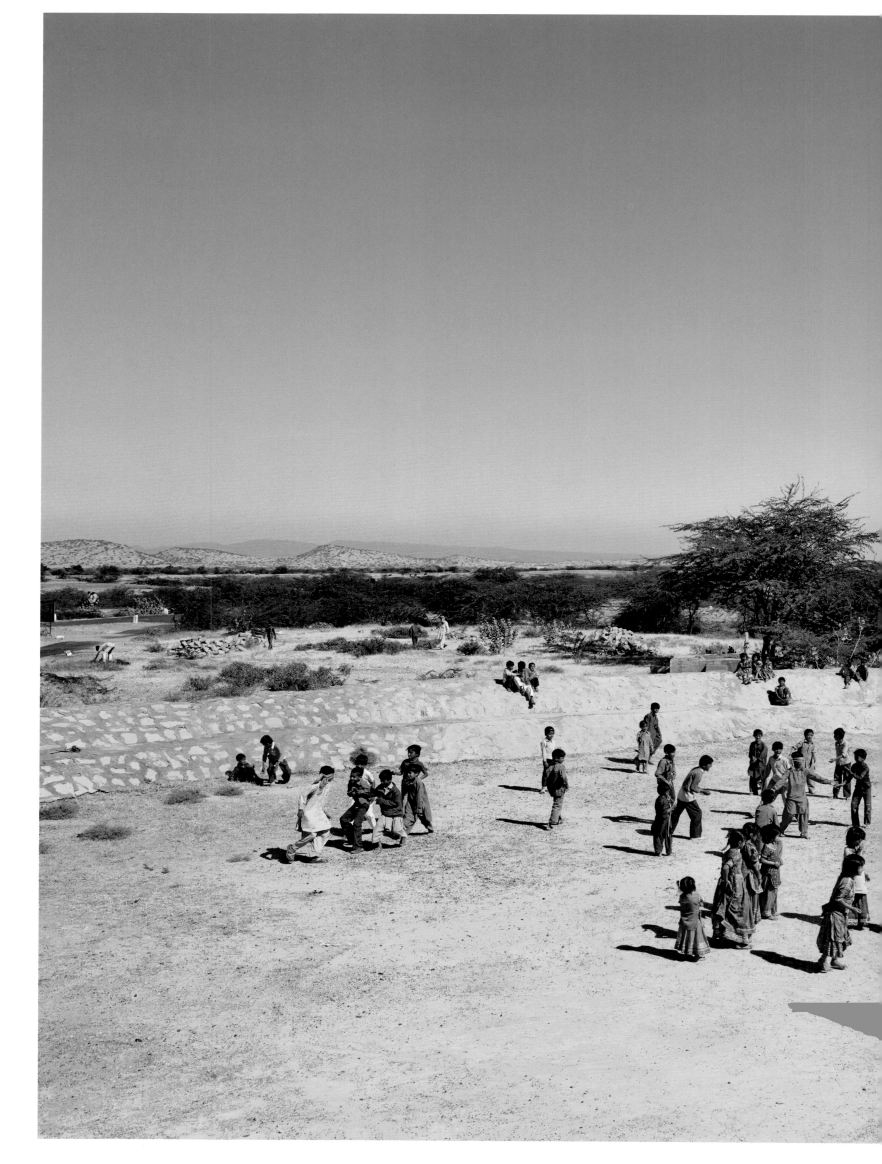

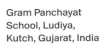

Gram Panchayat
School, Ludiya,
Kutch, Gujarat, India

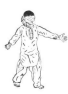

Ugo Foscolo
Elementary School,
Murano, Venice

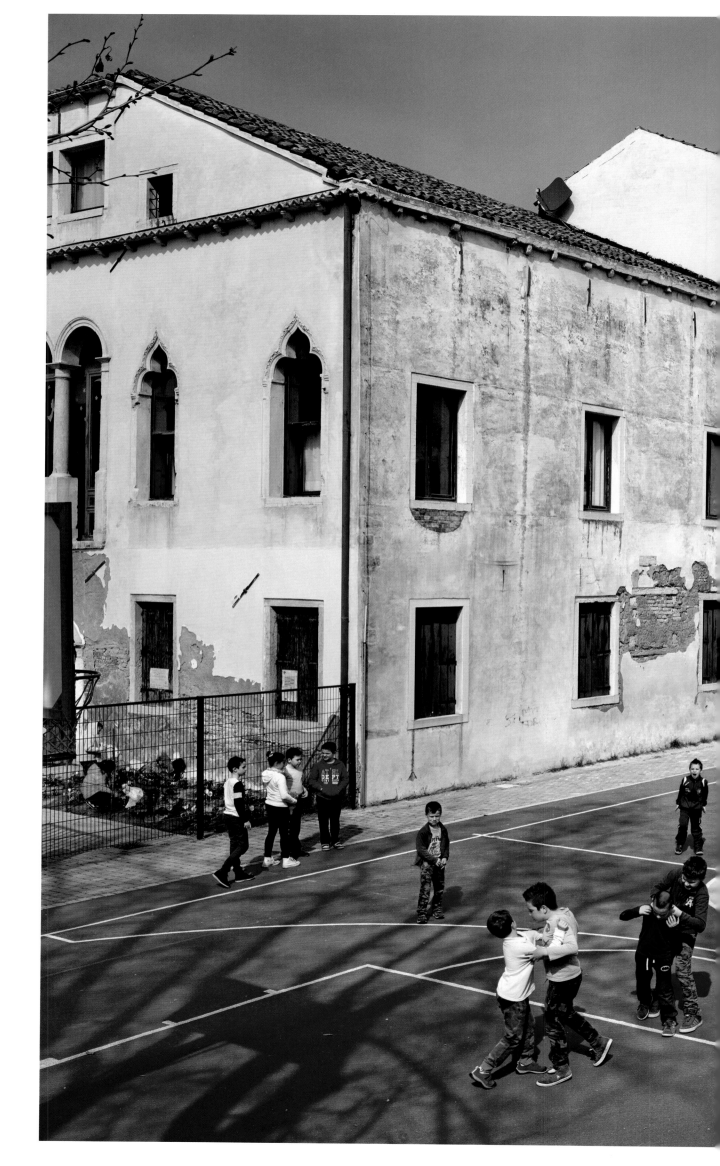

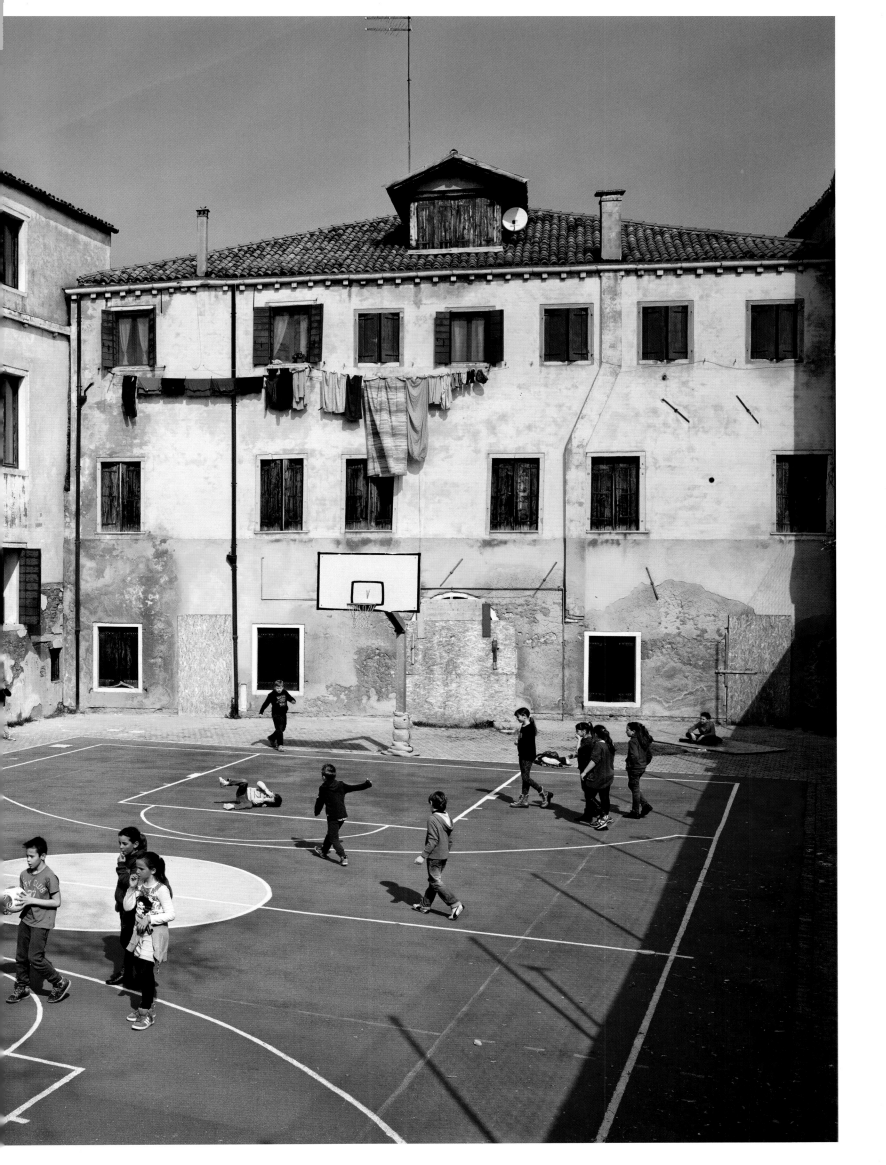

St. Augustine
Roman Catholic
School, Palm Loop,
Montserrat

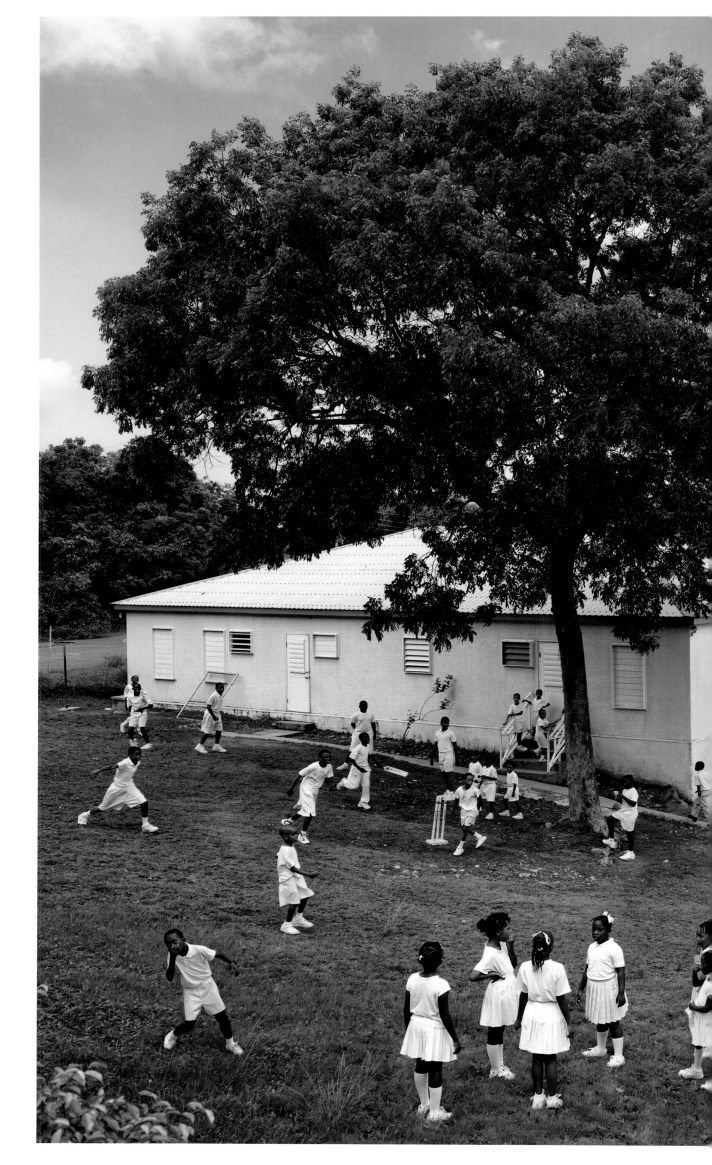

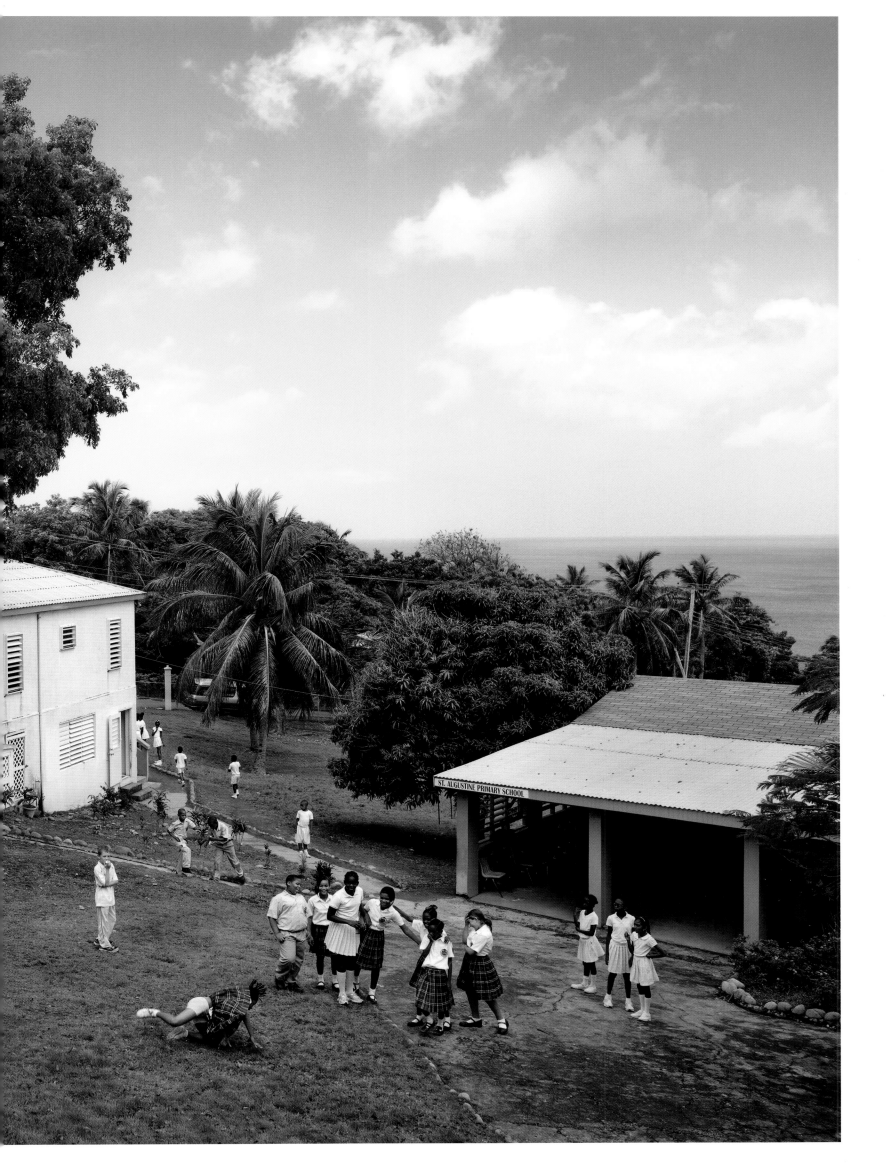

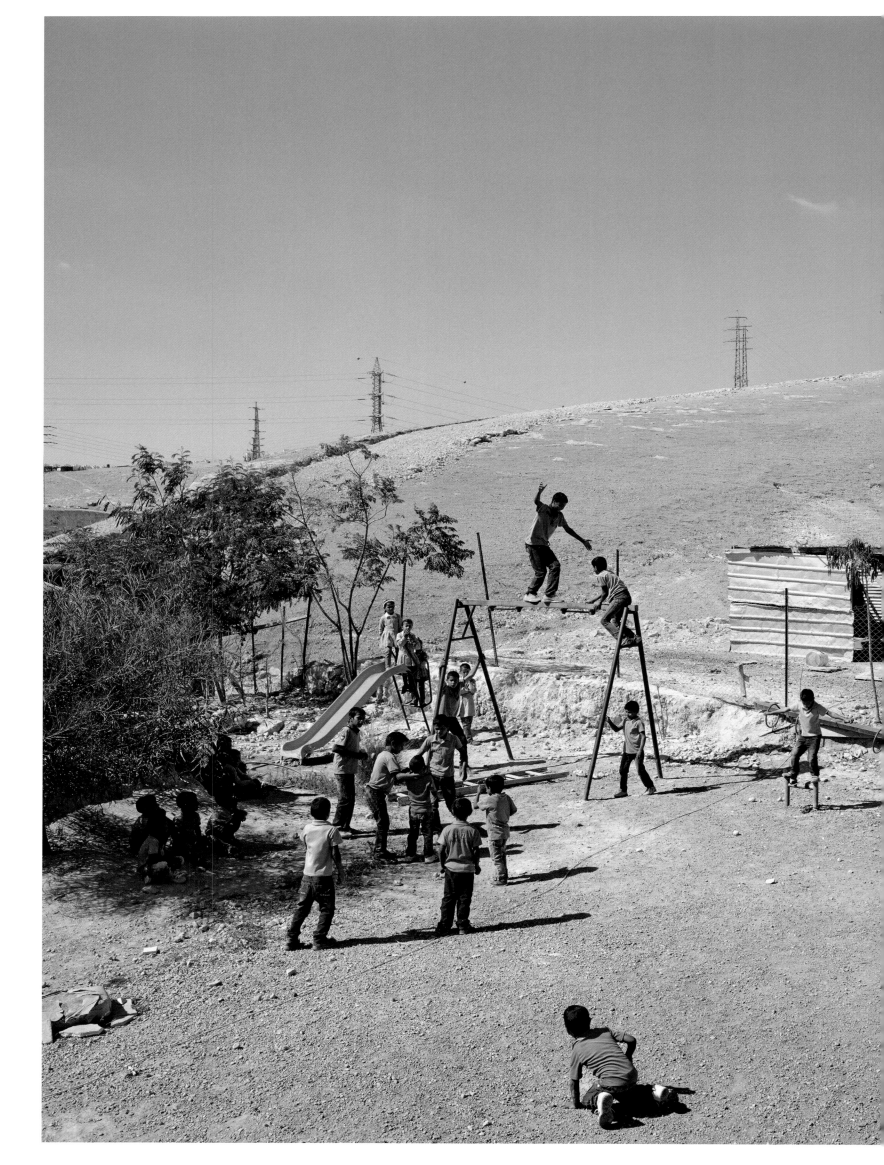

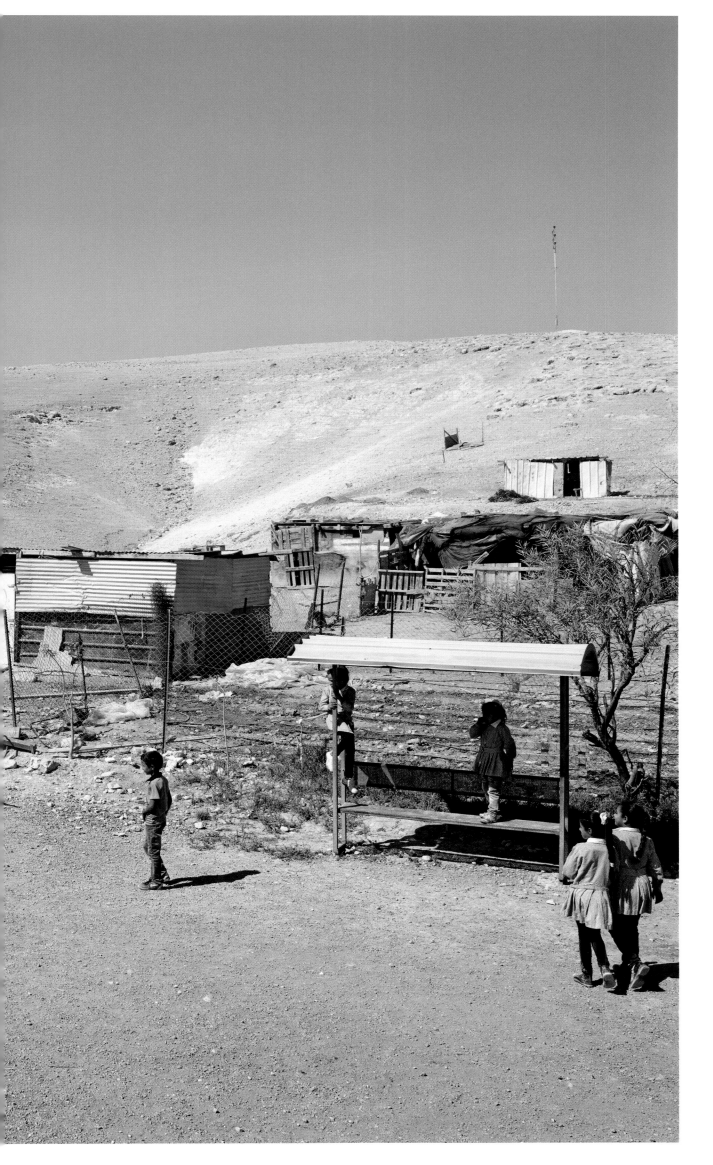

Al Khan Al Ahmar
Primary School,
Area C, Jericho,
West Bank

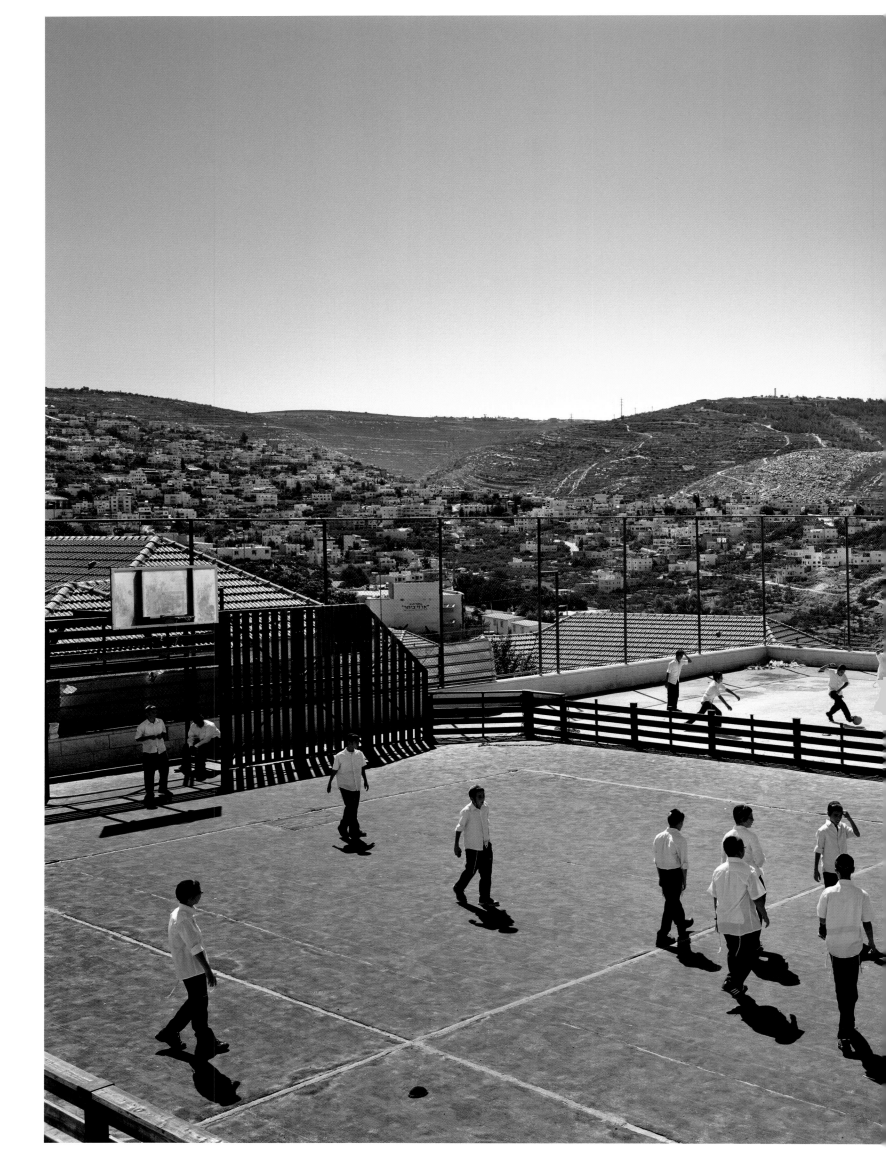

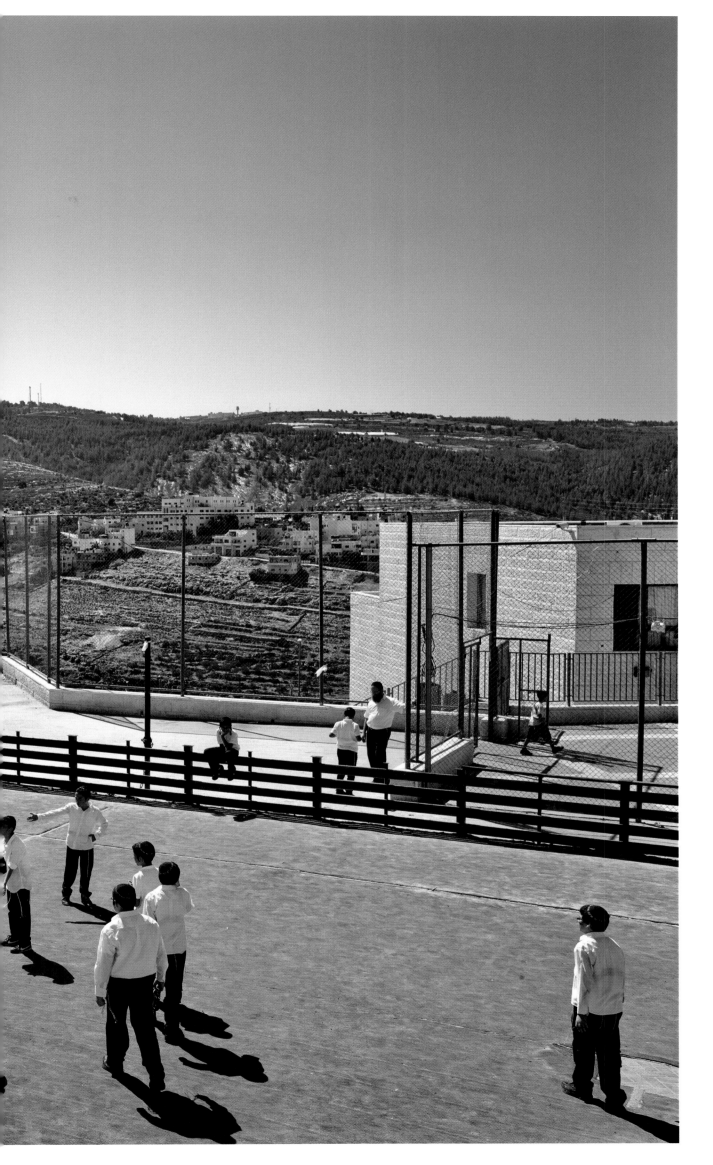

Aida Boys School,
Bethlehem,
West Bank

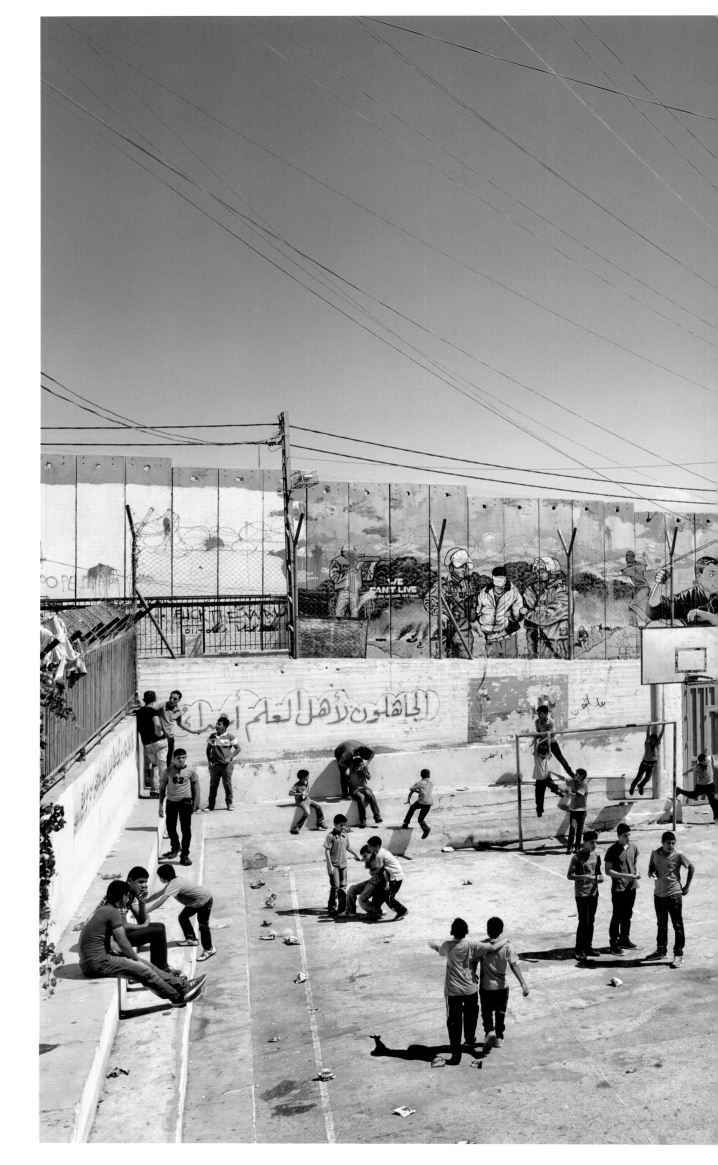

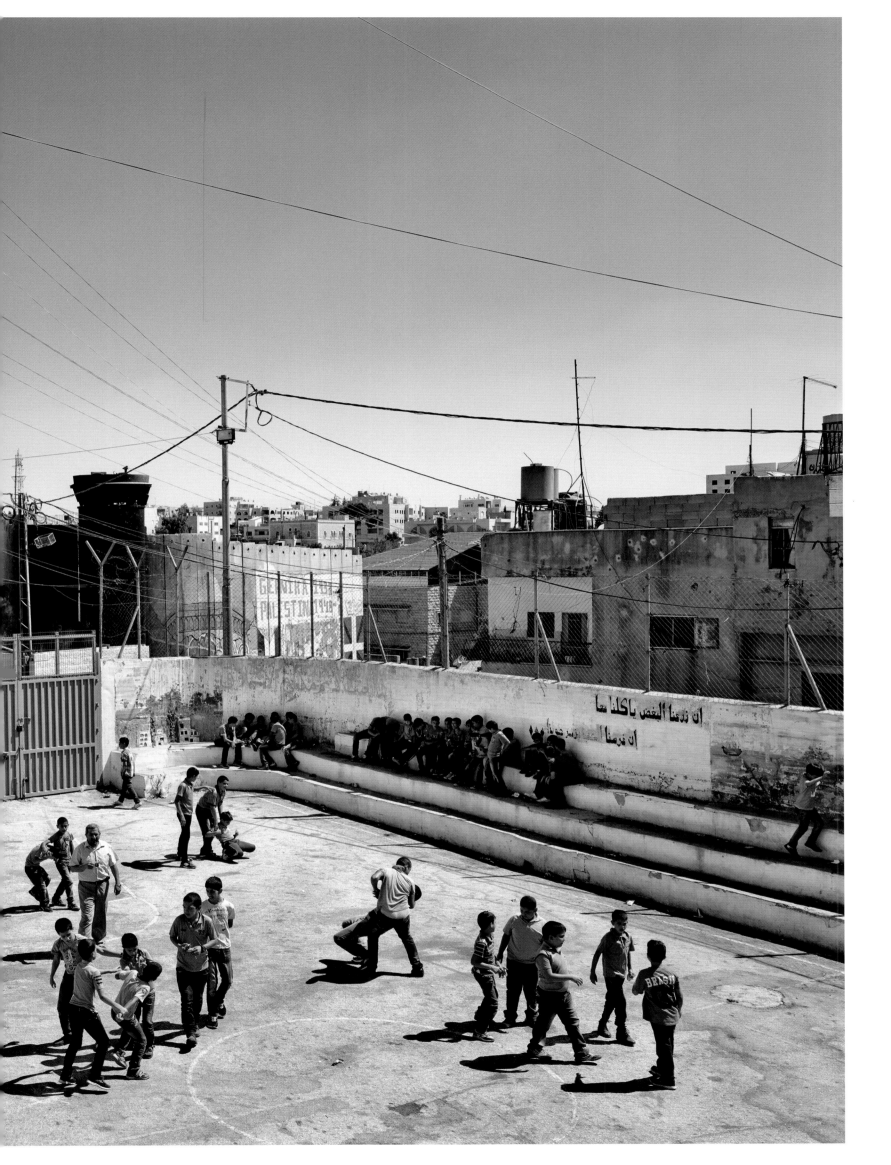

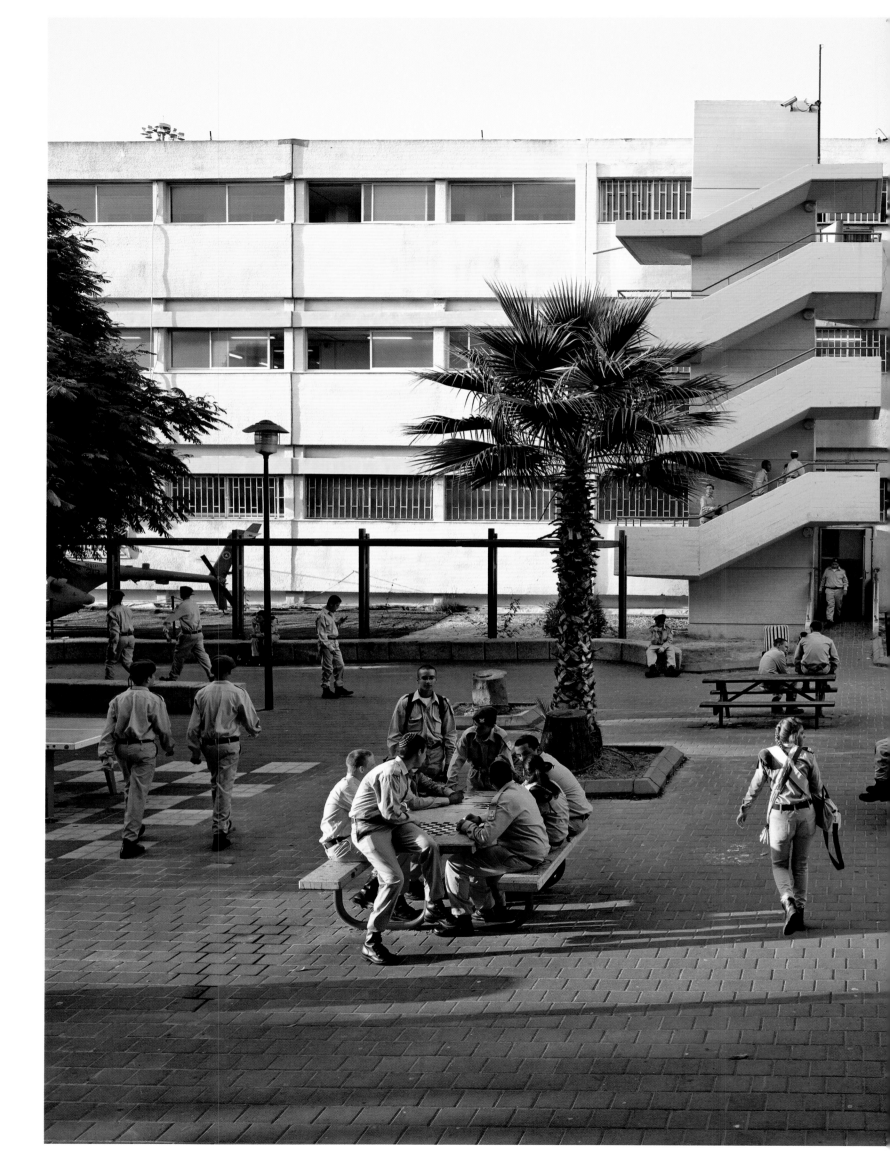

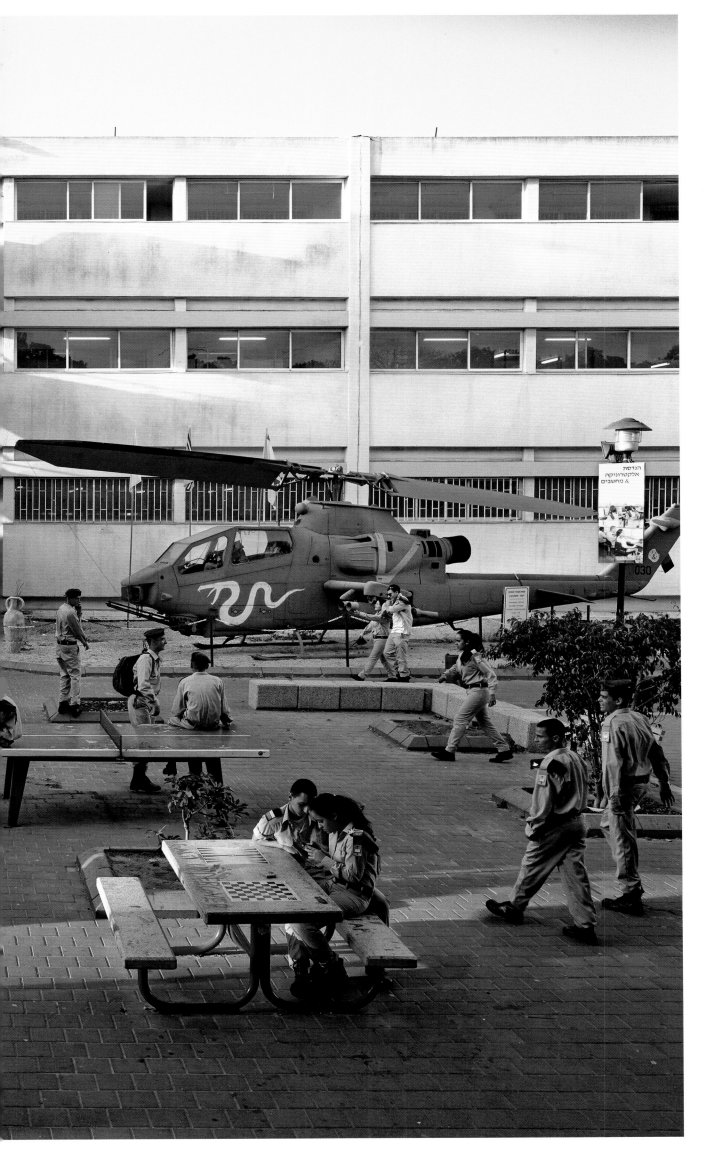

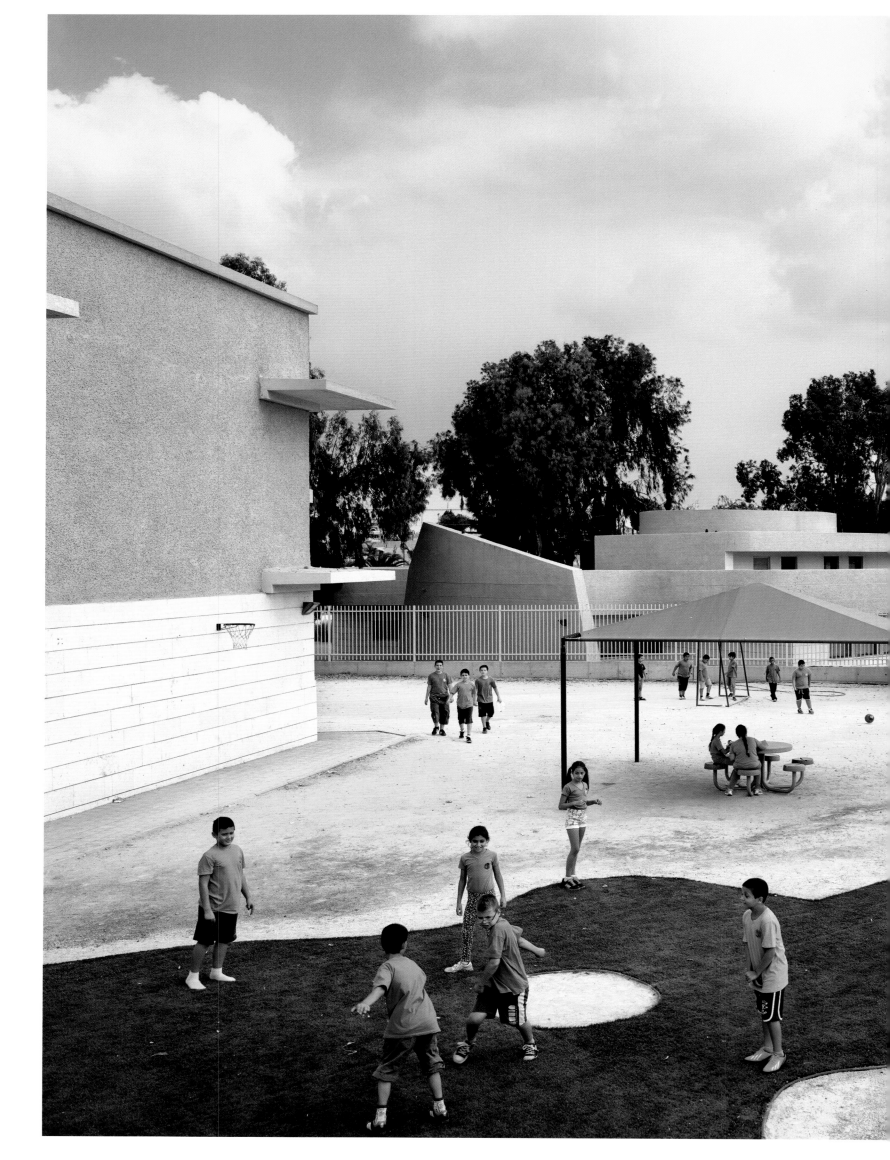

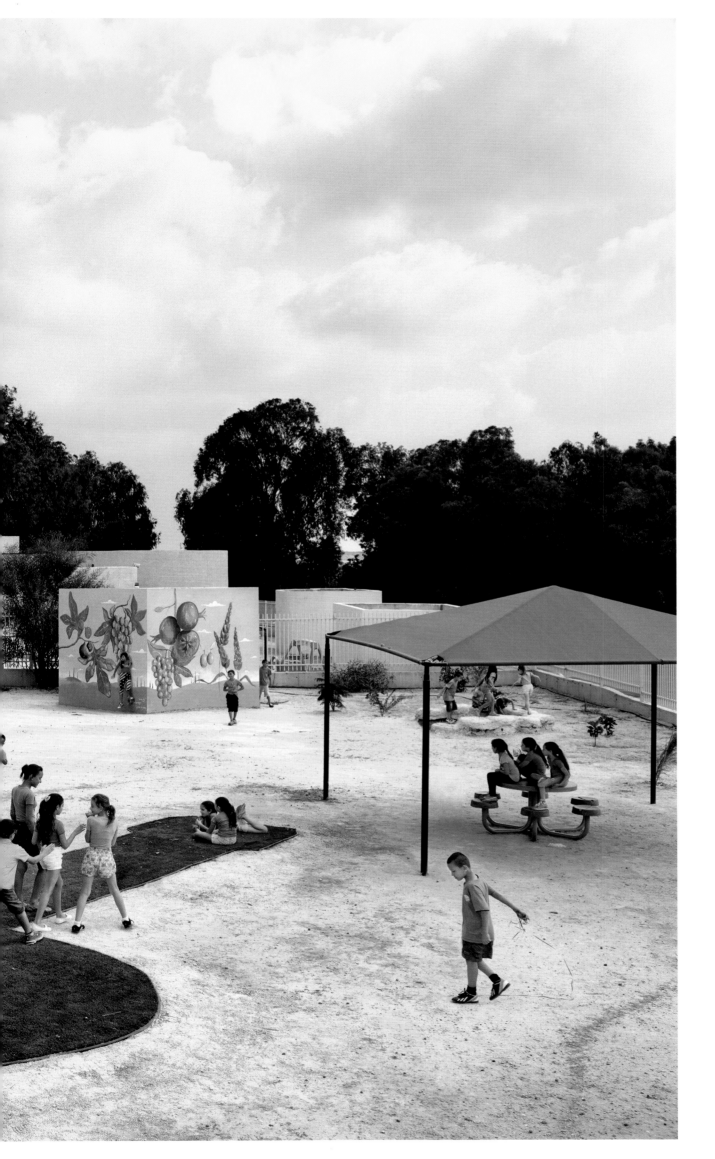

Shikim Maoz
School, Sderot,
Israel

Maamounia
Elementary,
Rhimal Area,
Gaza City, Gaza

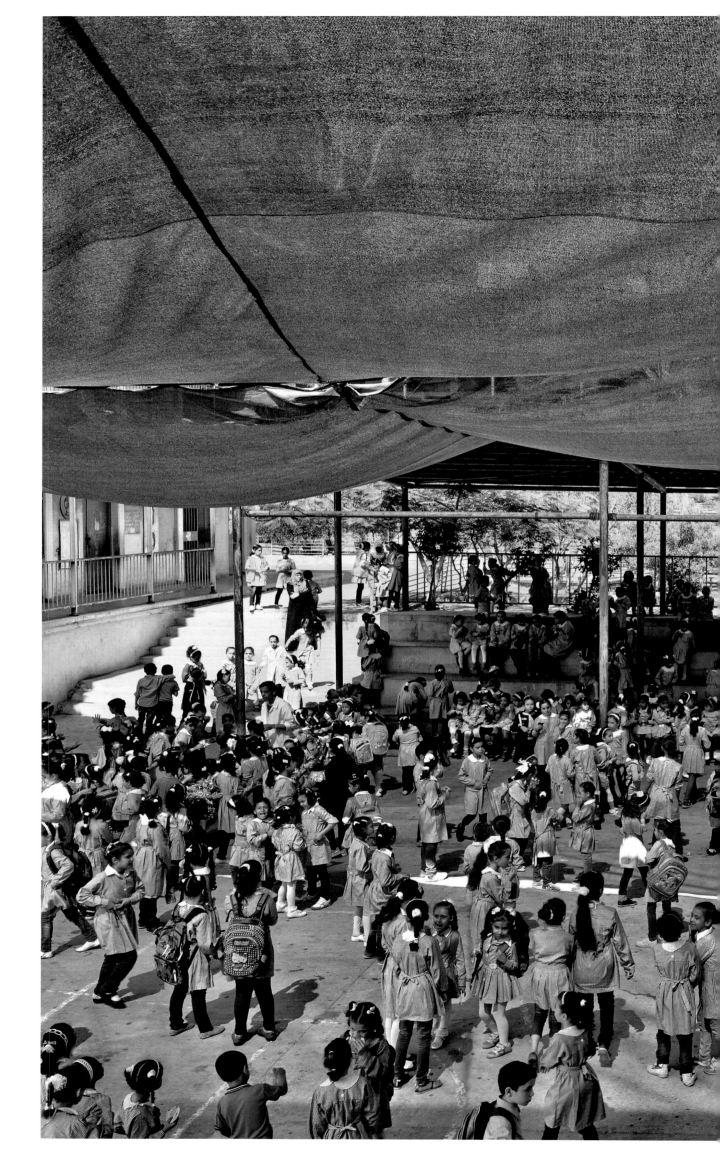

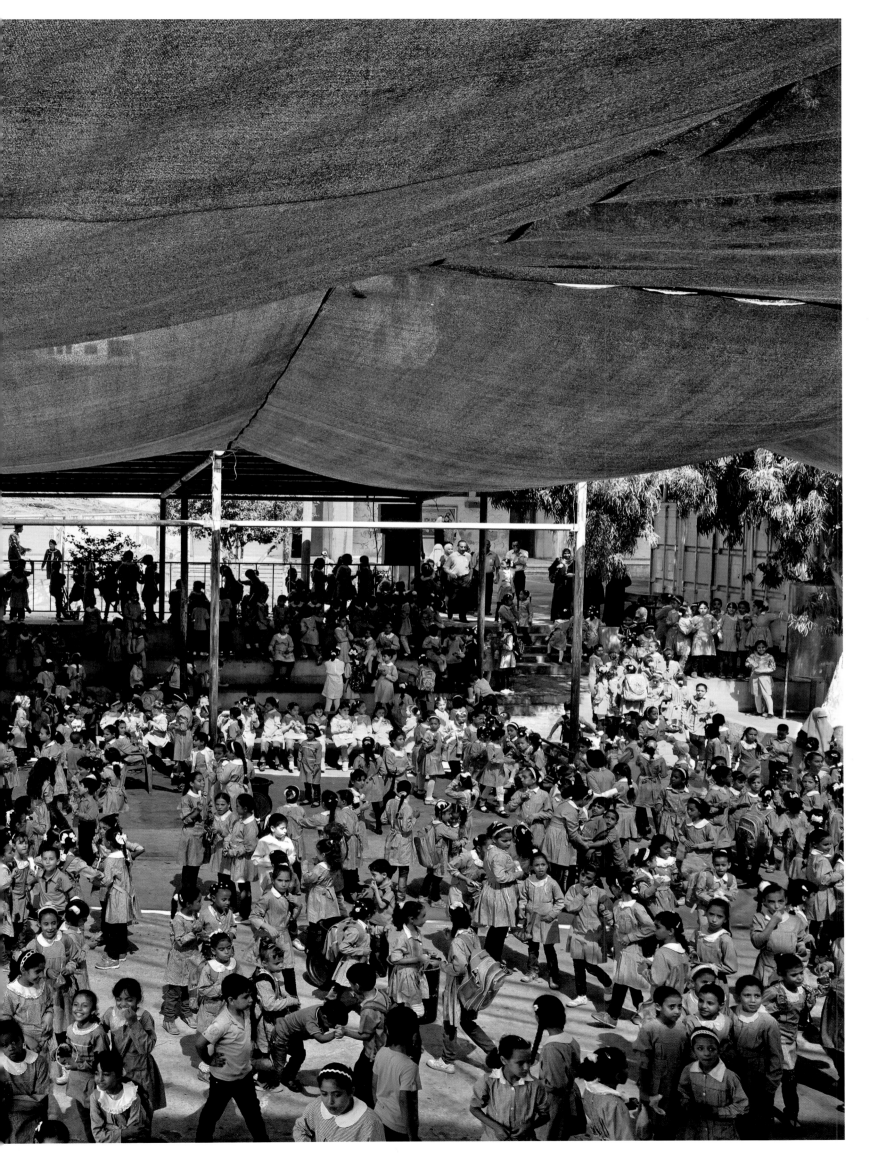

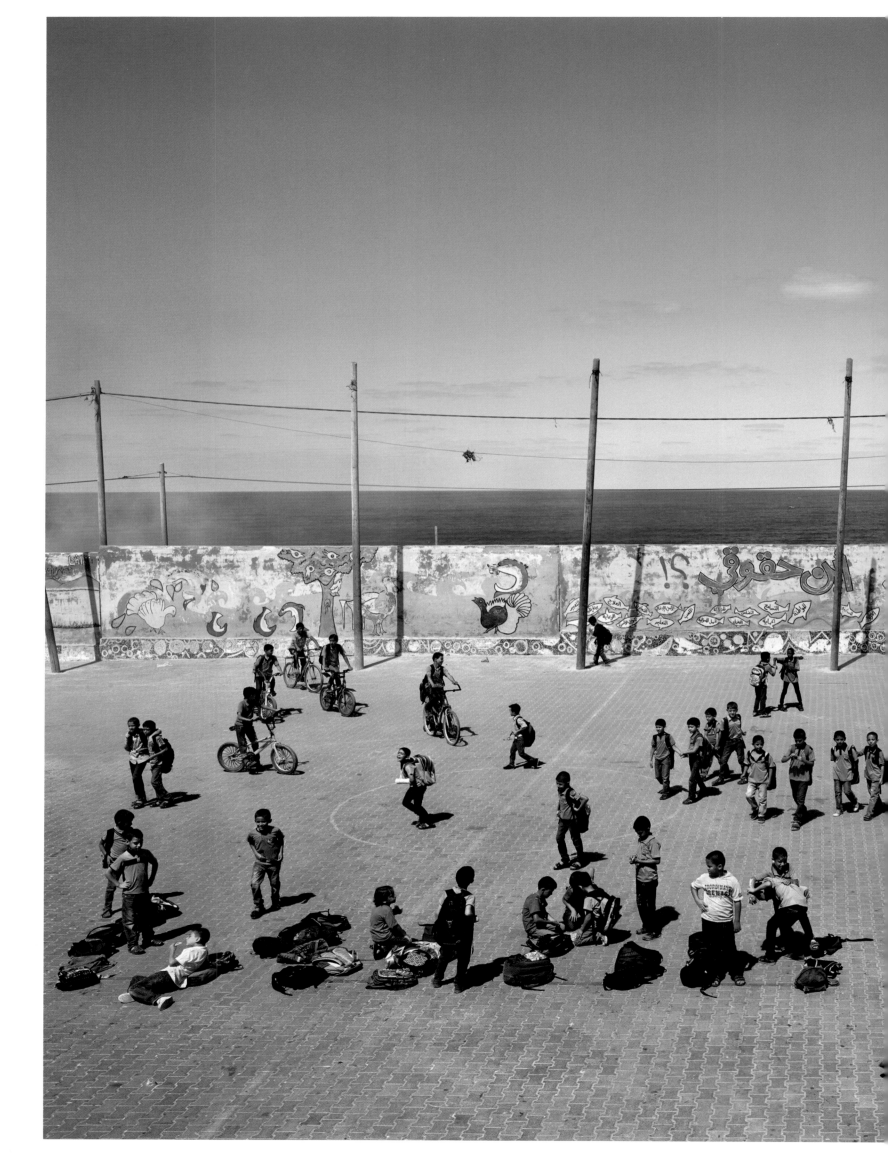

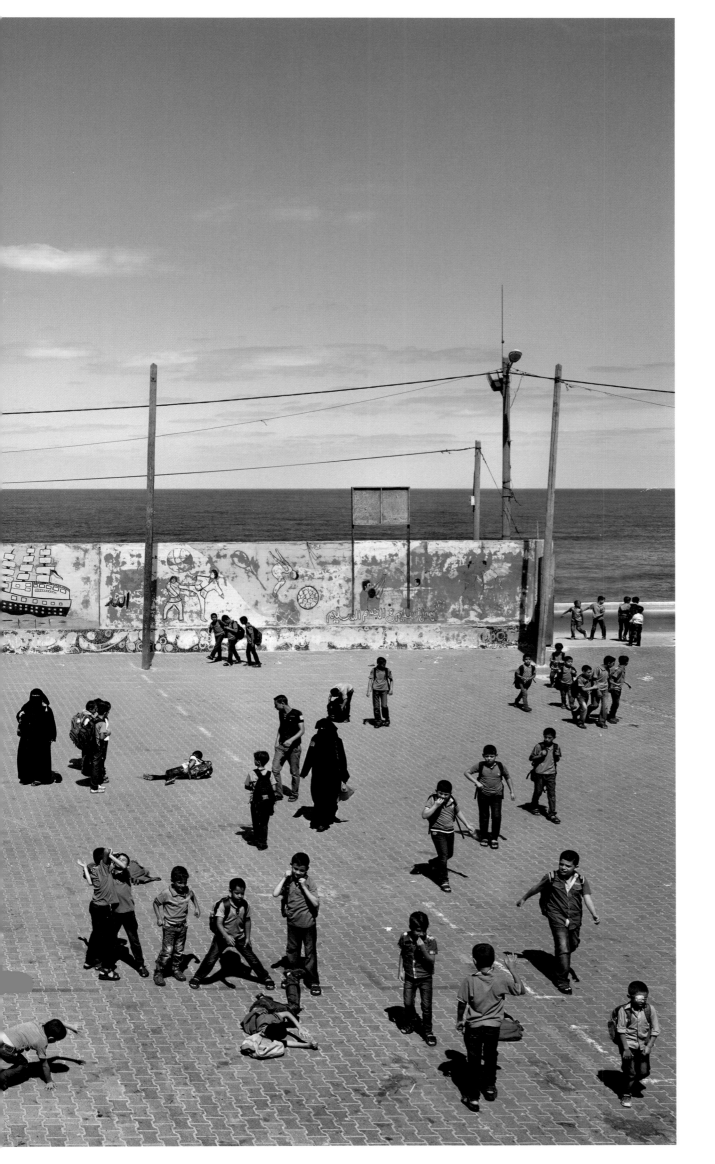

Deir al-Balah
Boys' Elementary,
Middle Area, Gaza

Dechen Phodrang,
Thimphu, Bhutan

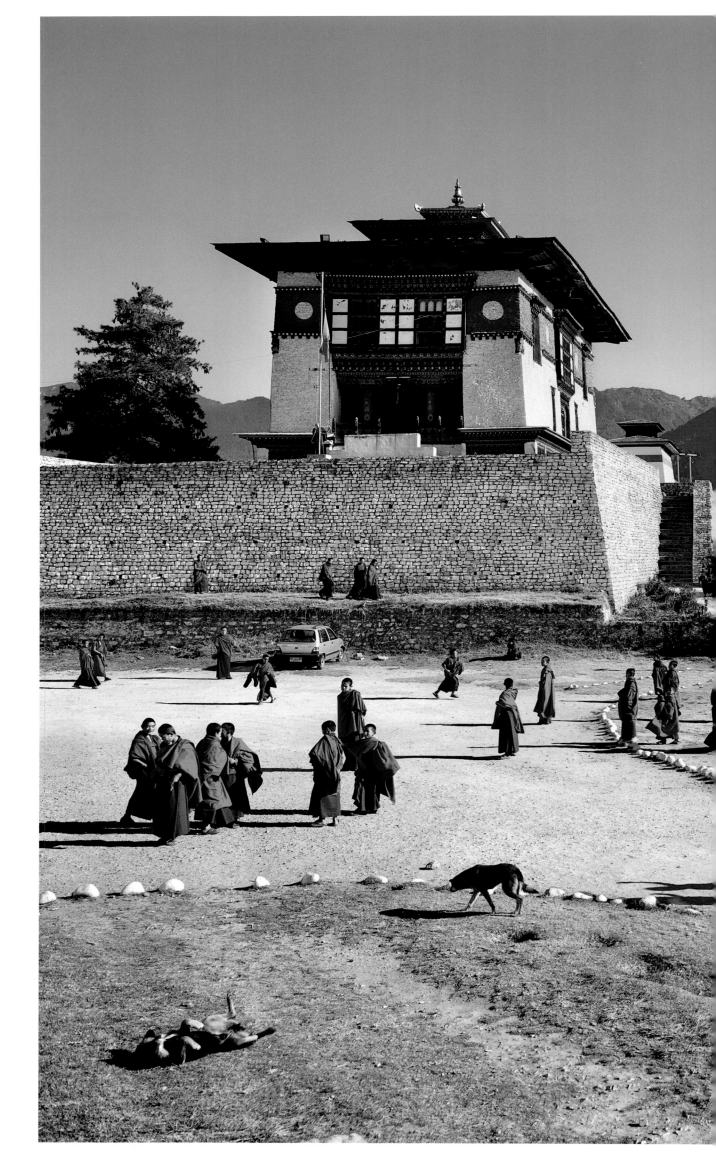

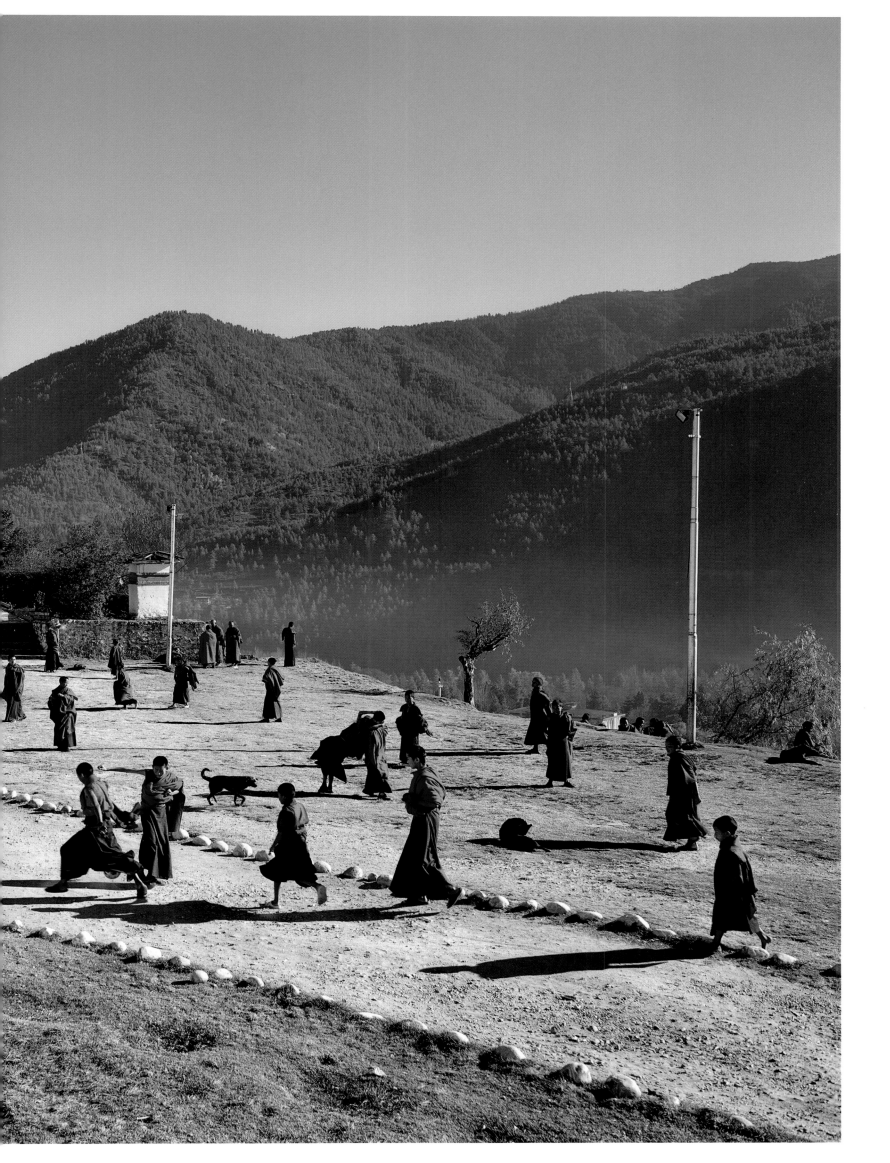

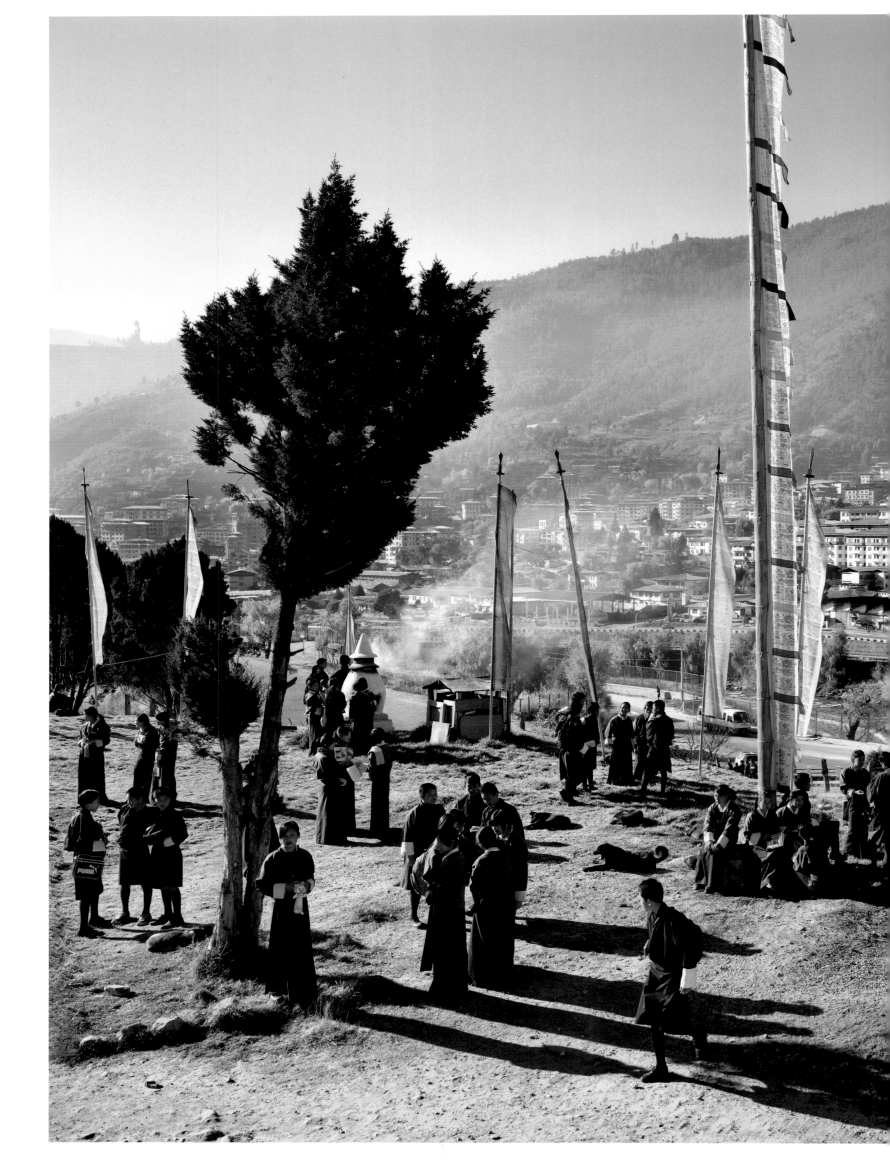

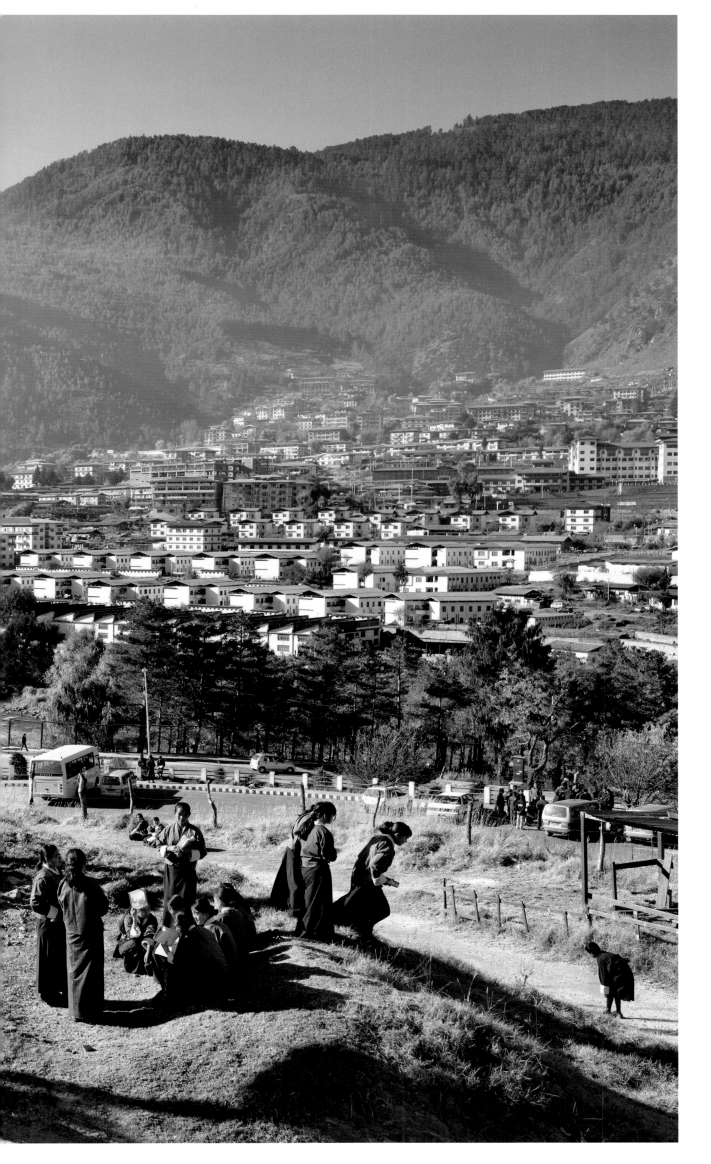

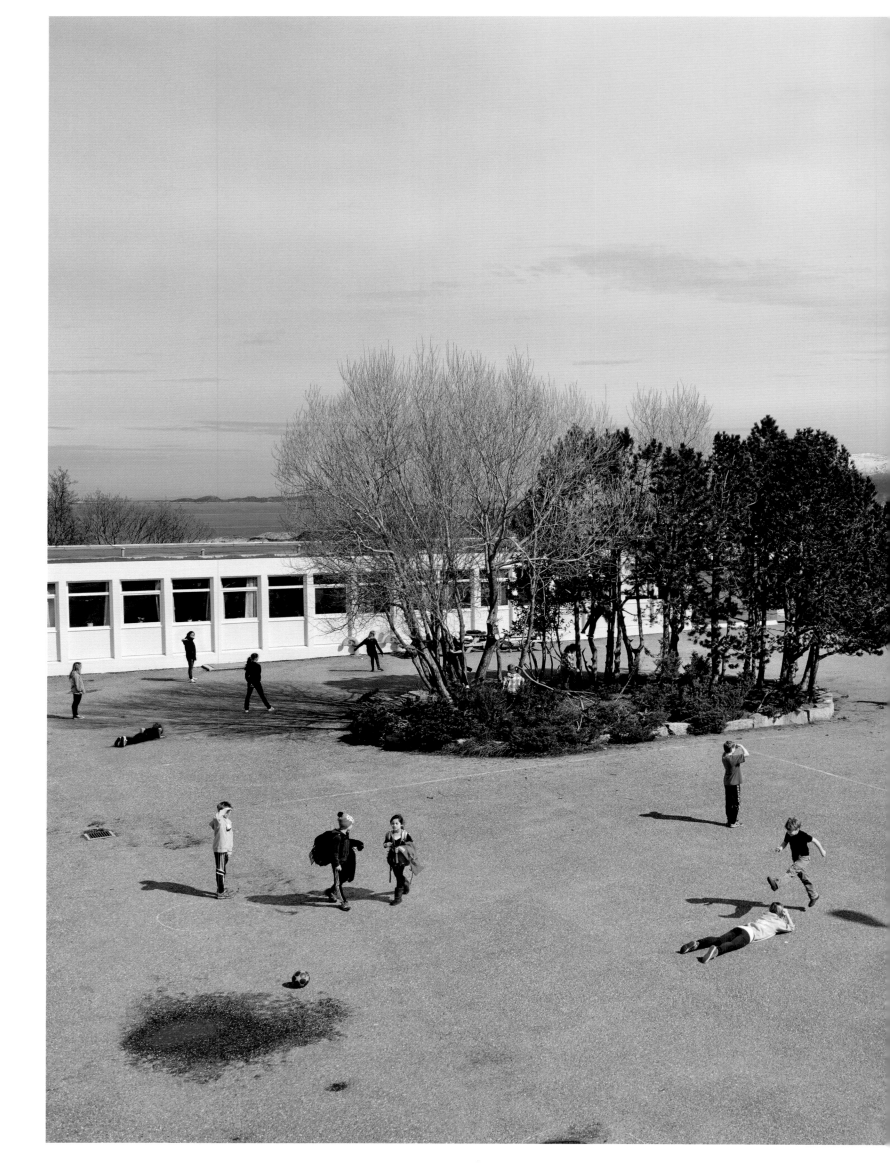

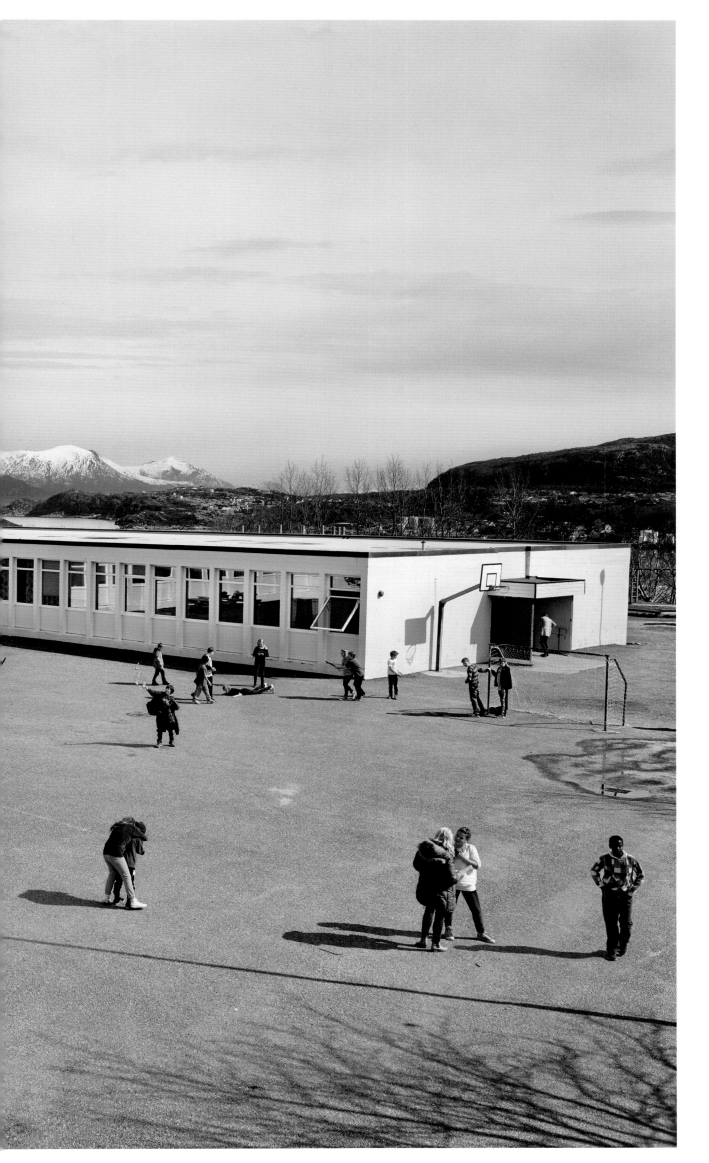

Gomalandet Skole,
Kristiansund,
Norway

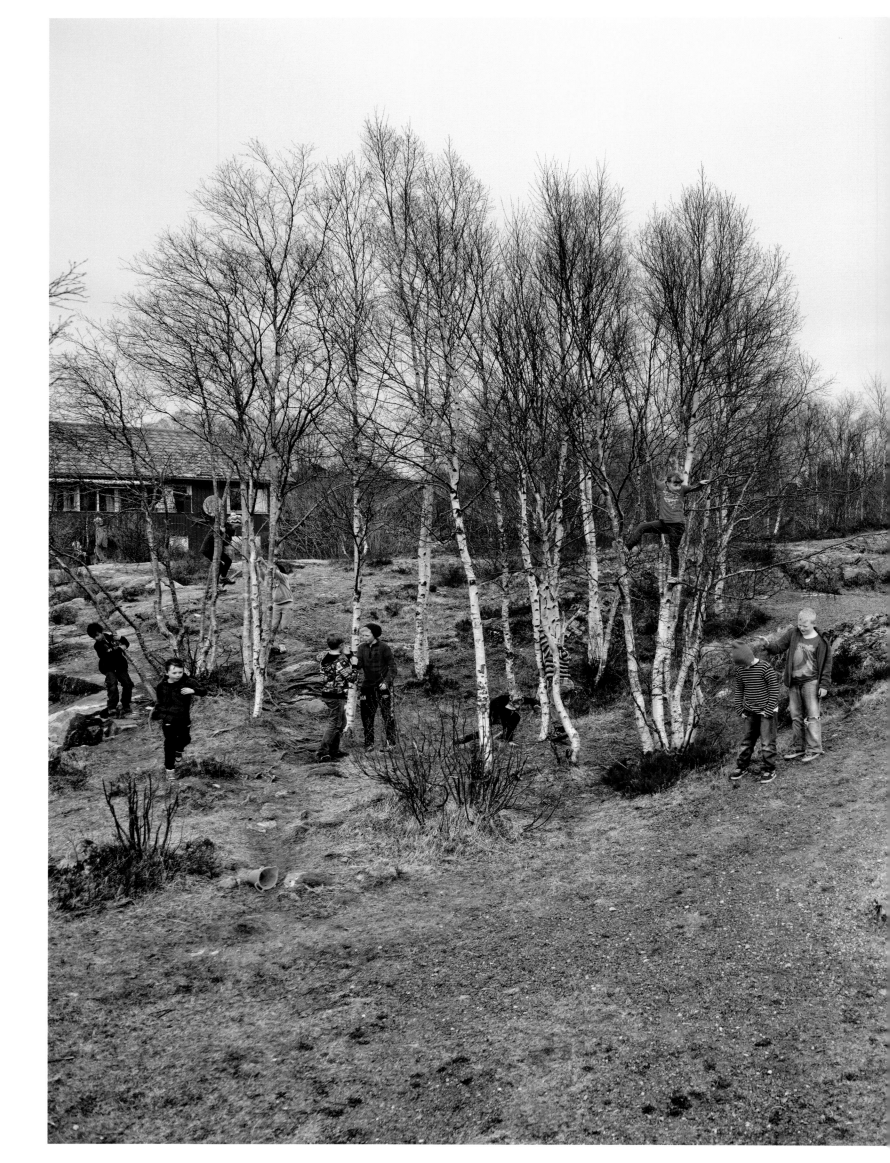

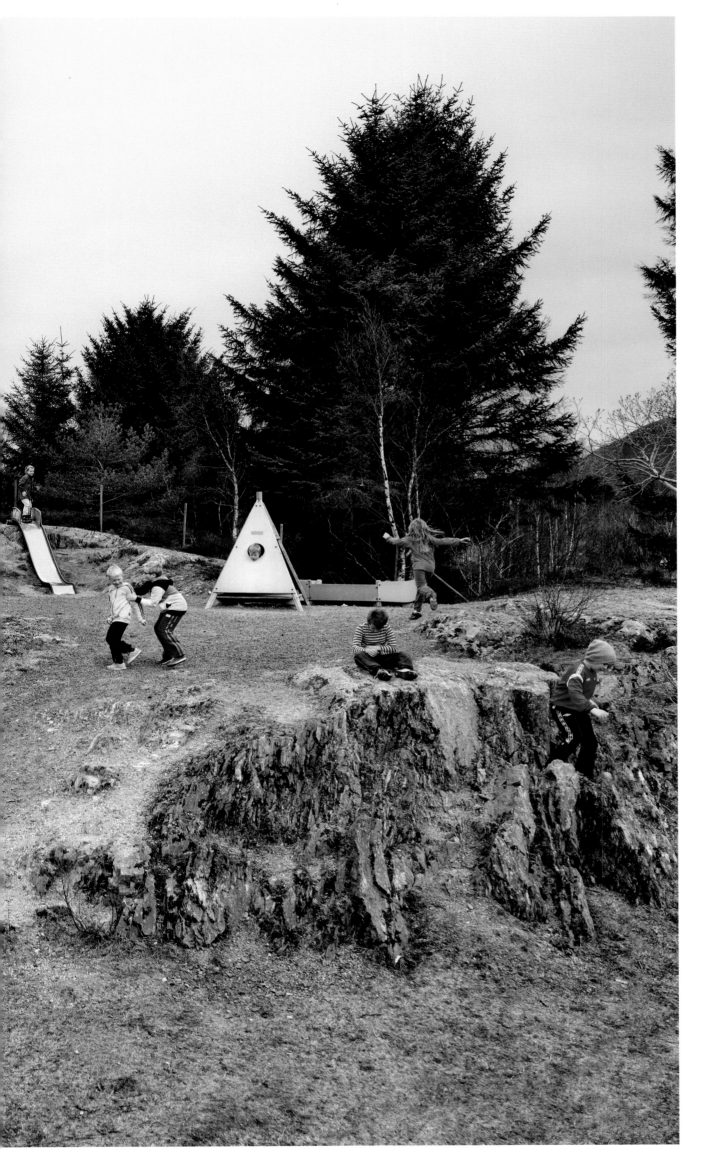

Paso Payita,
Aramasi,
Chuquisaca,
Bolivia

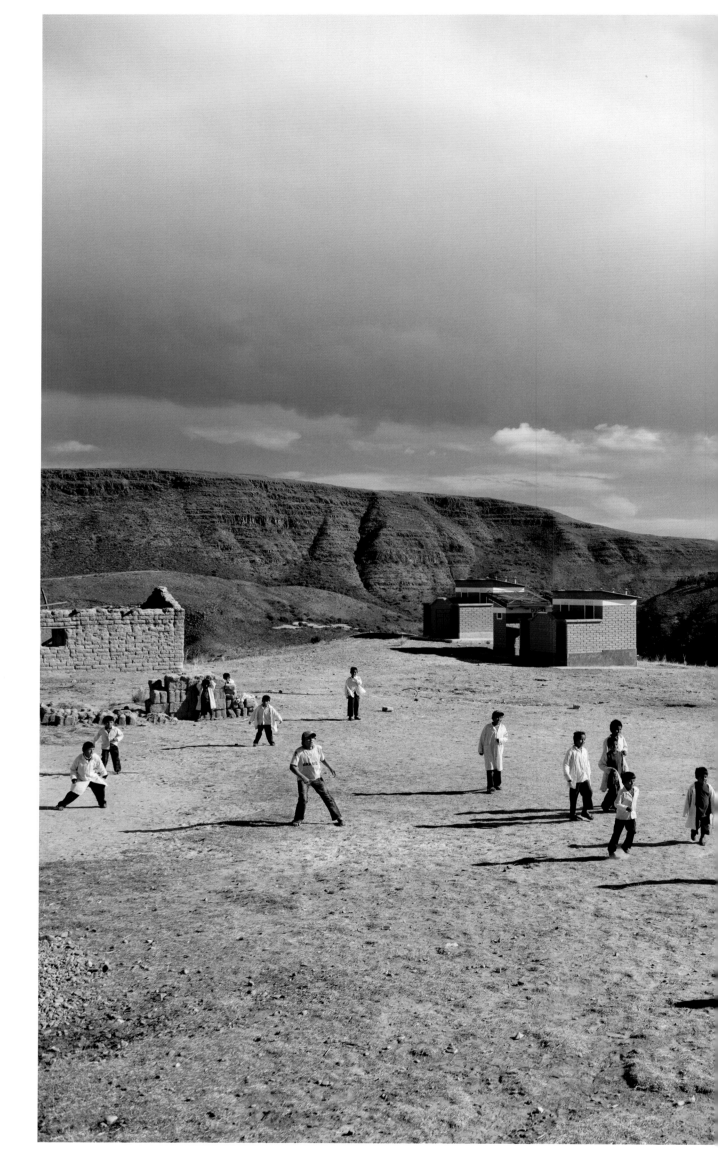

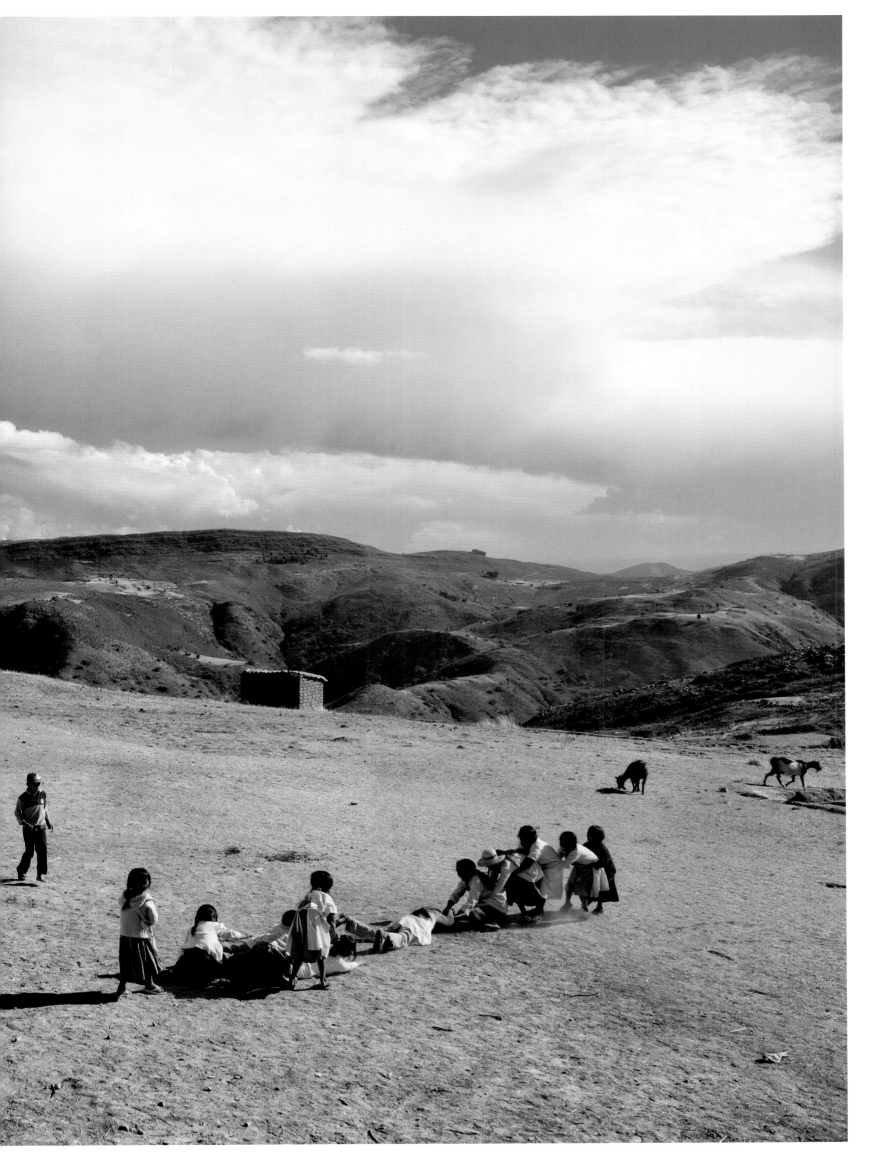

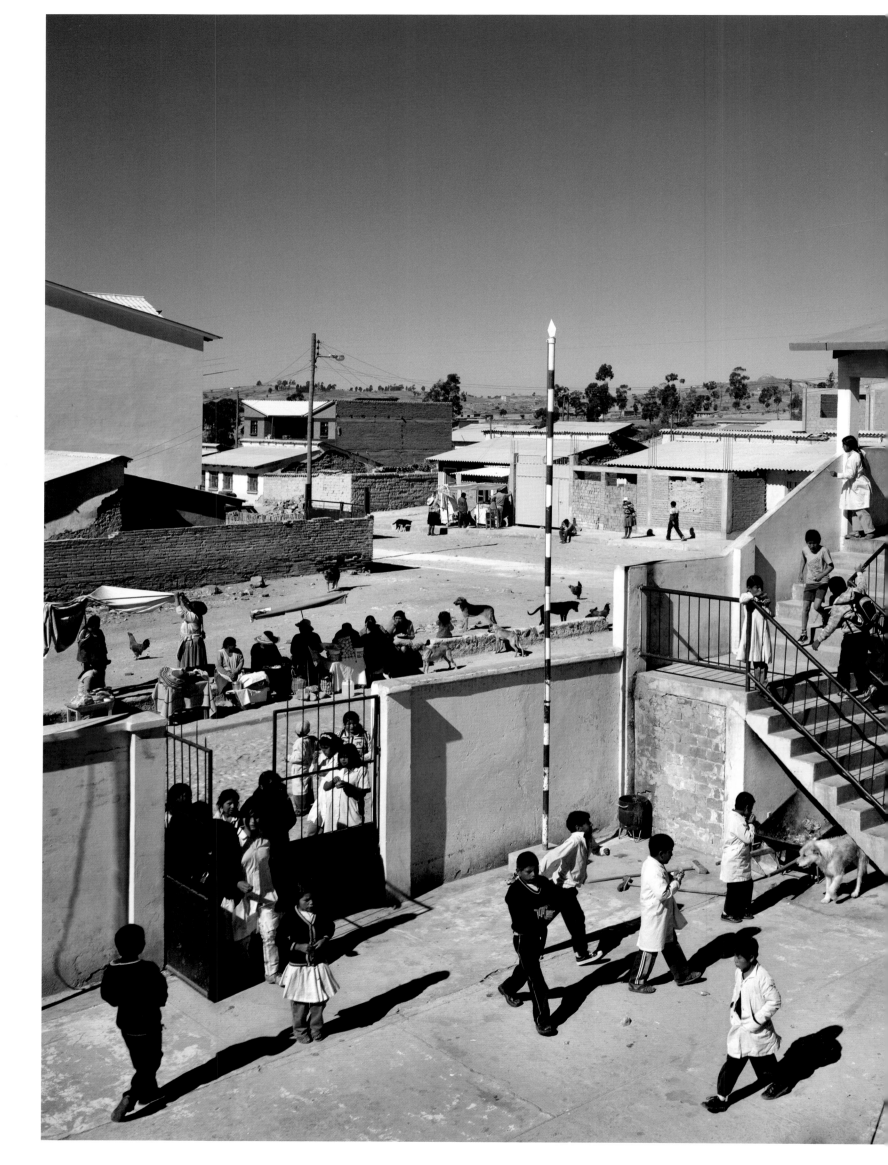

Thako Pampa
School, Sucre,
Bolivia

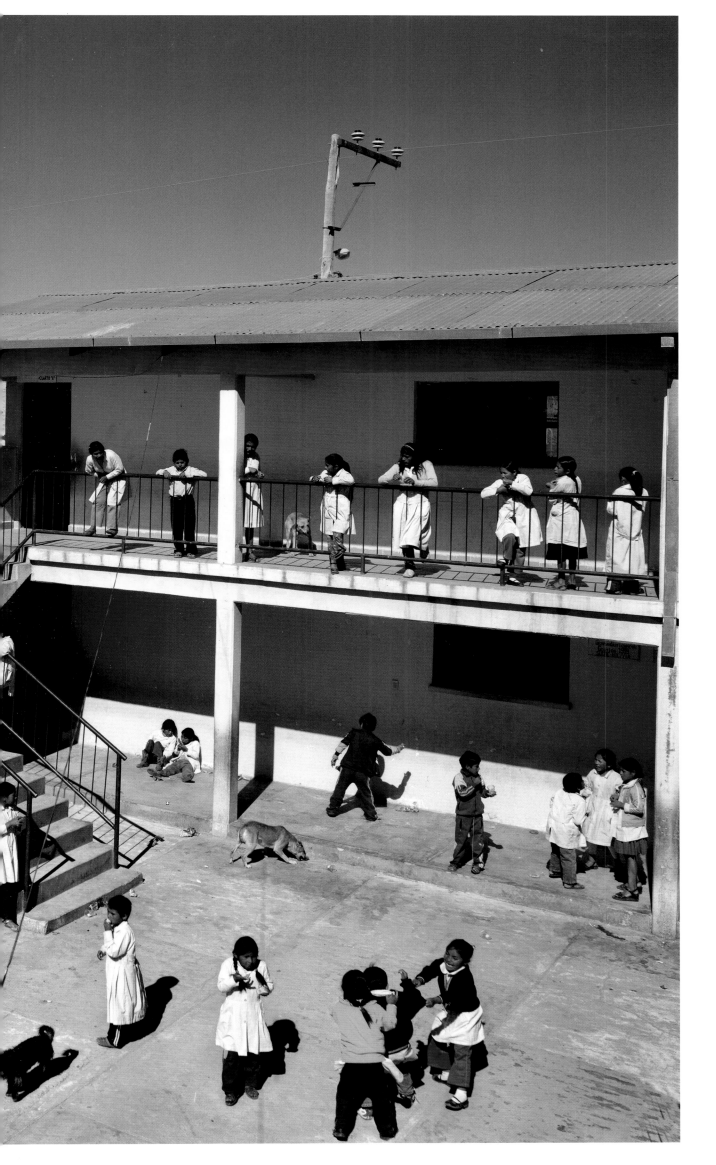

Colegio Gregorio
Reynolds, La Paz,
Bolivia

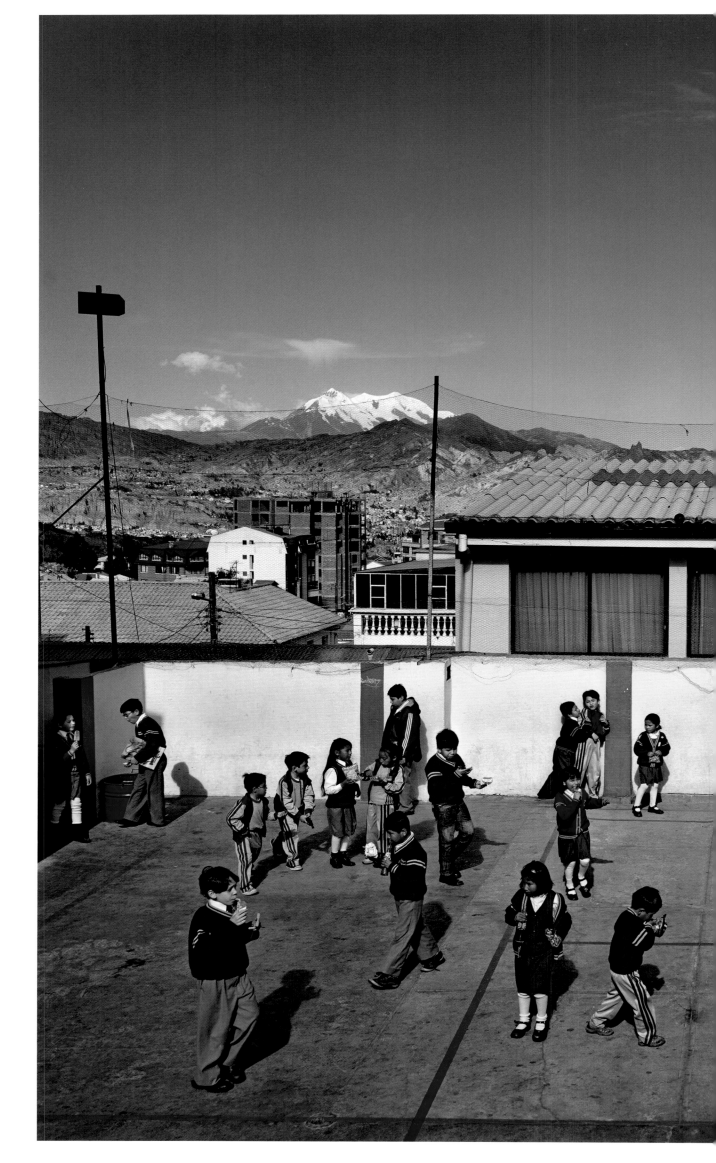

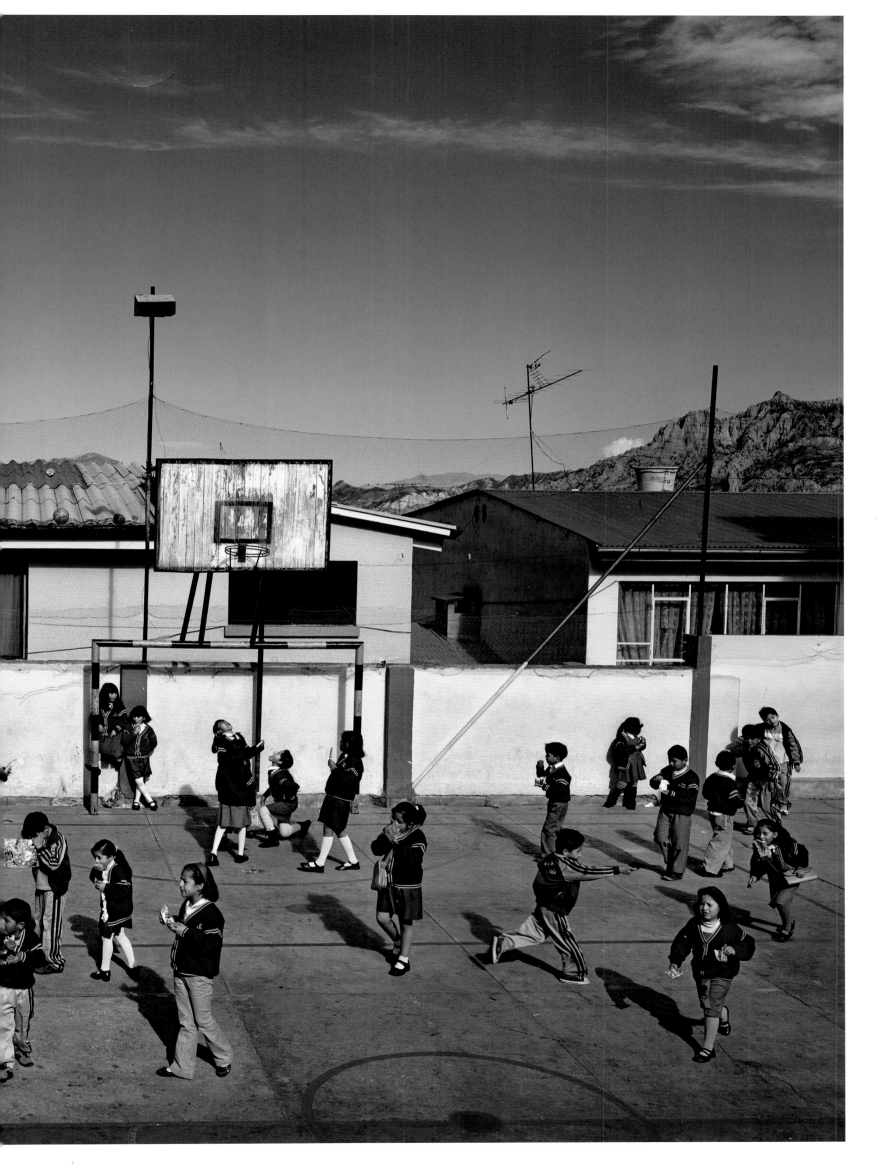

Open Day
Primary School,
Kathmandu, Nepal

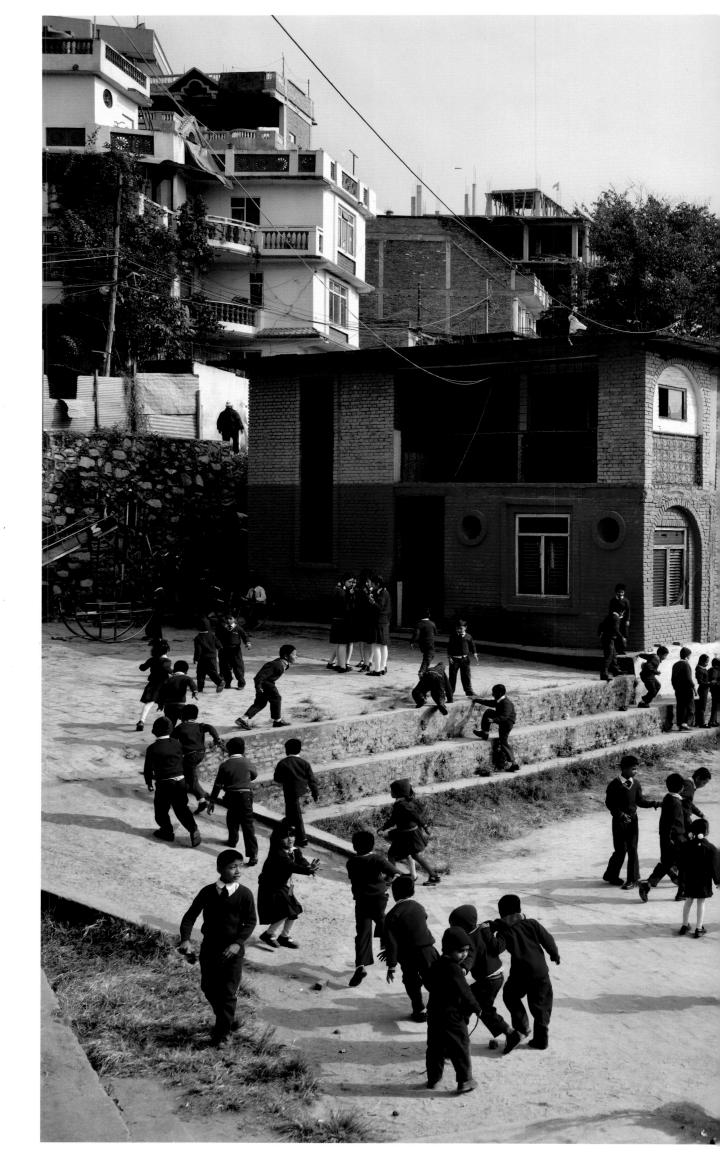

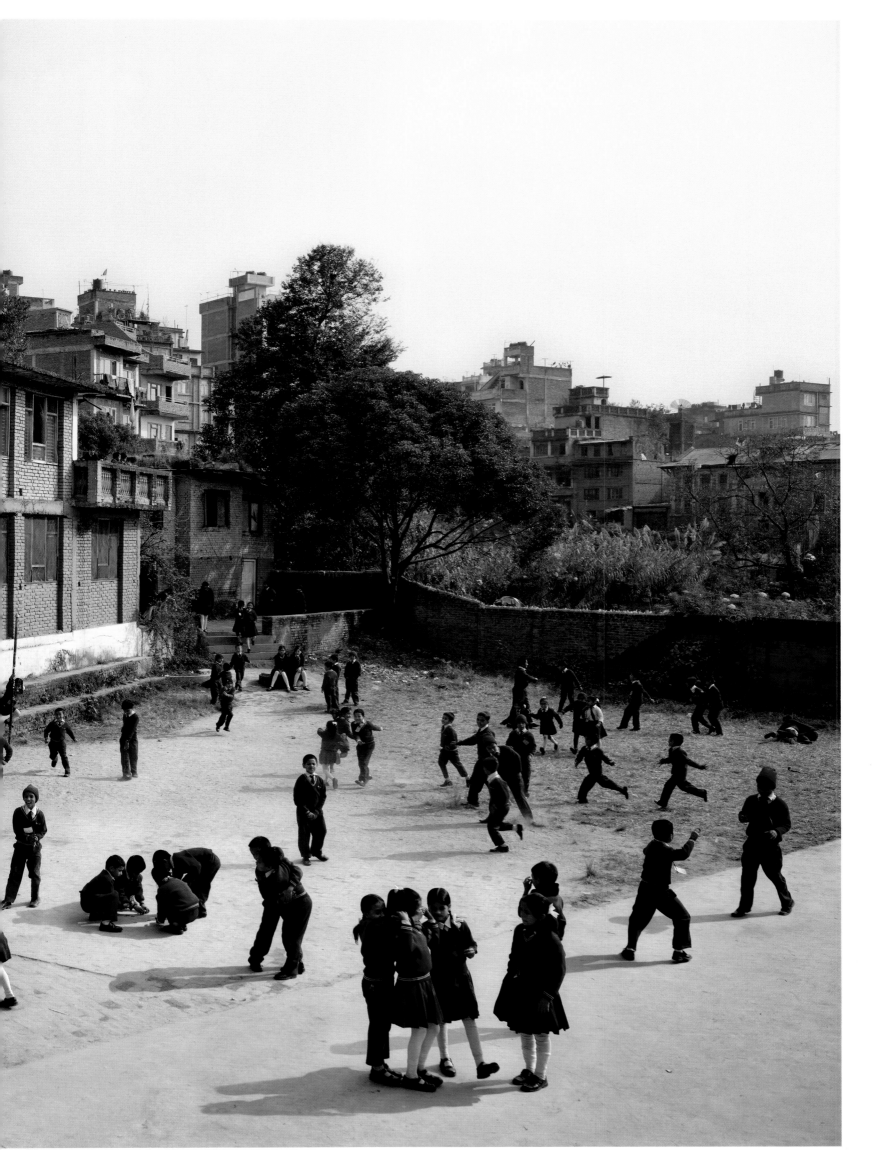

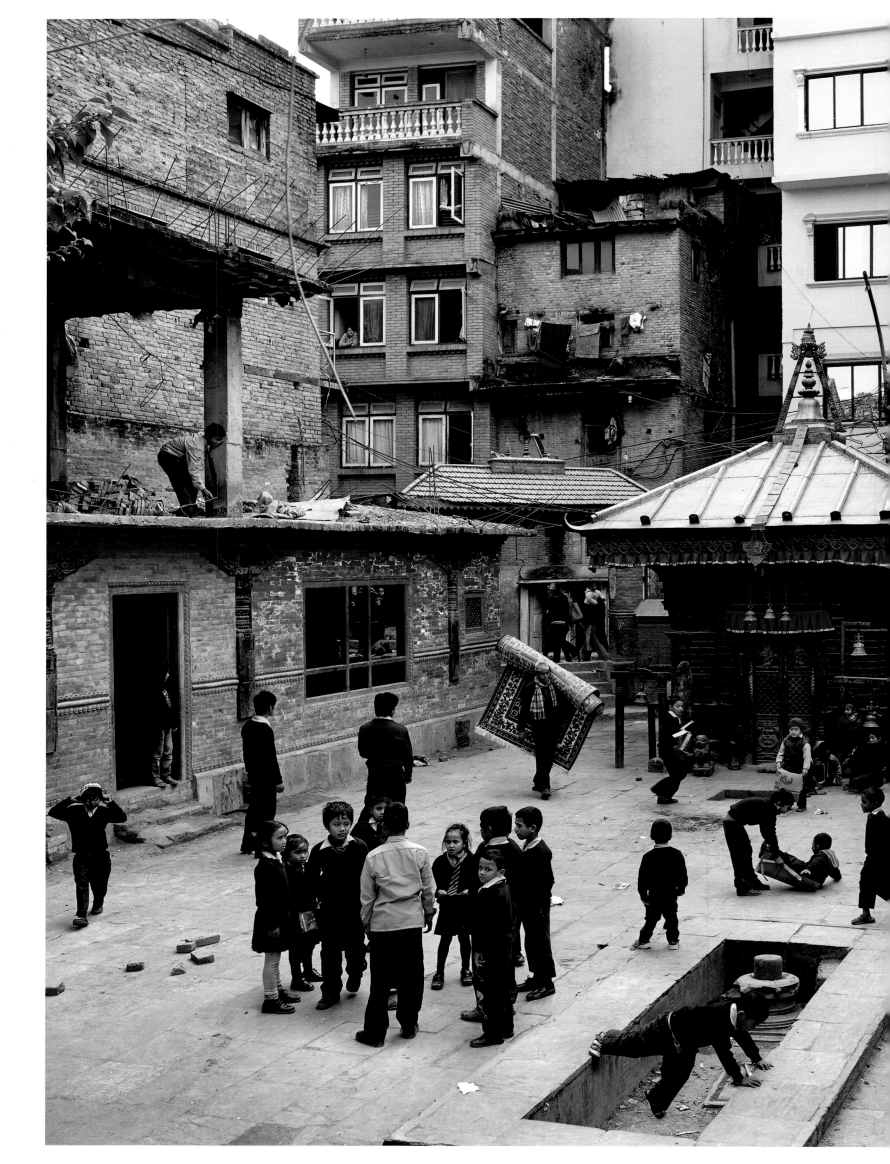

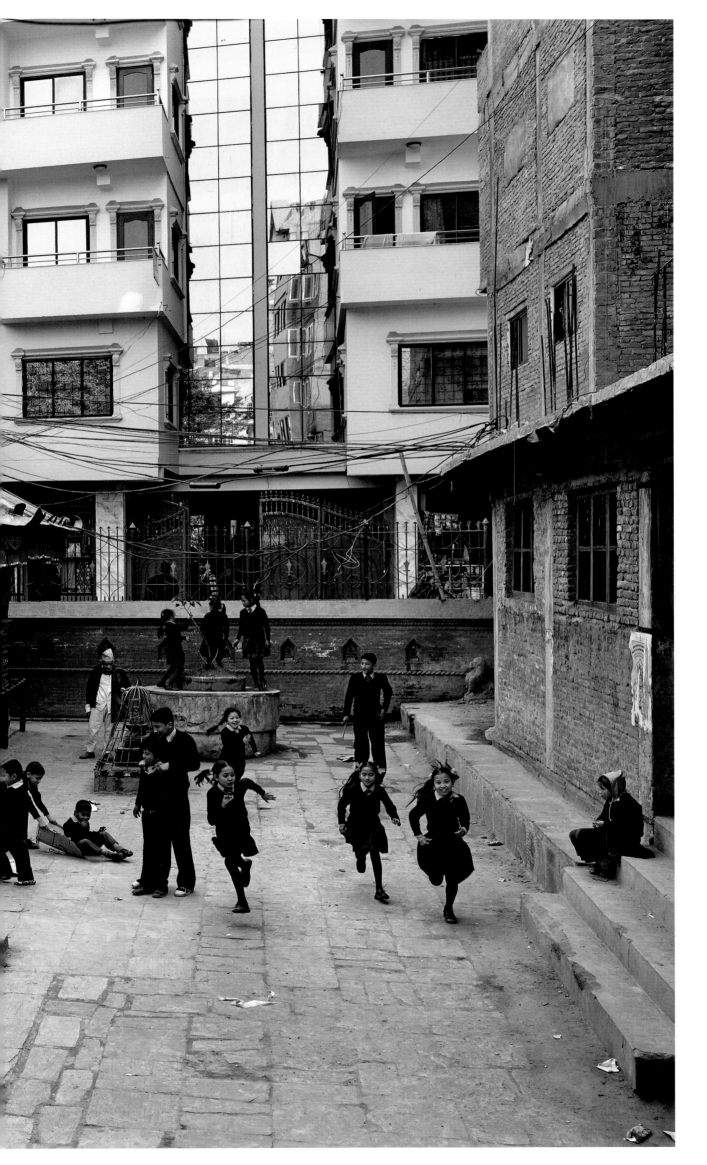

Bhakta Vidyashram,
Kathmandu, Nepal

Adolescent safe space, Site 5 District 12, Zaatari Refugee Camp, Jordan

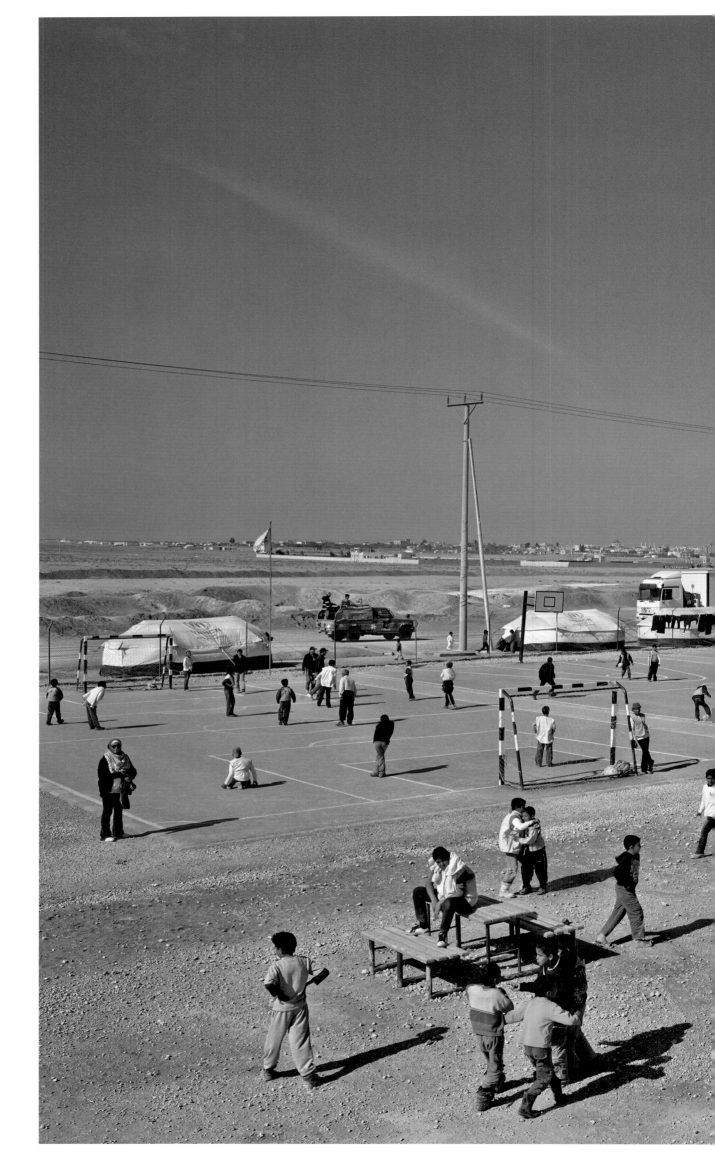

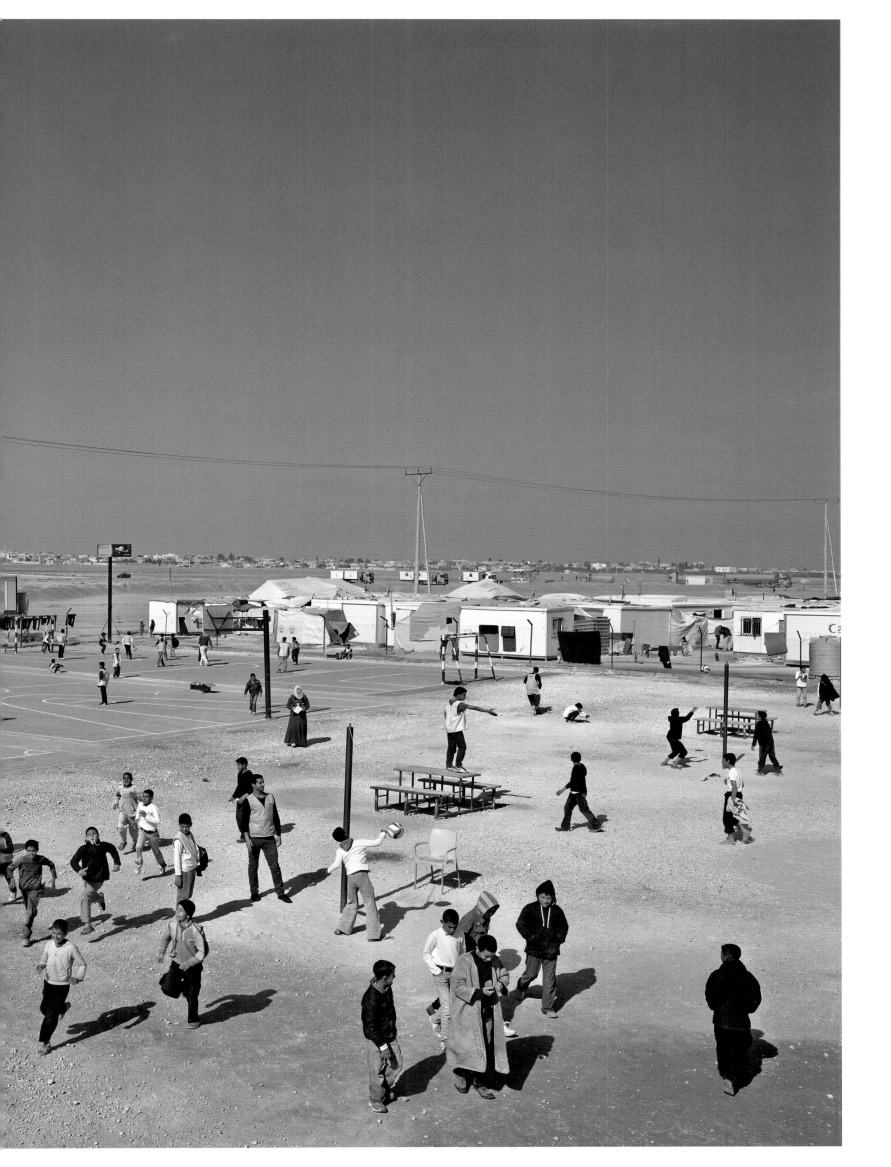

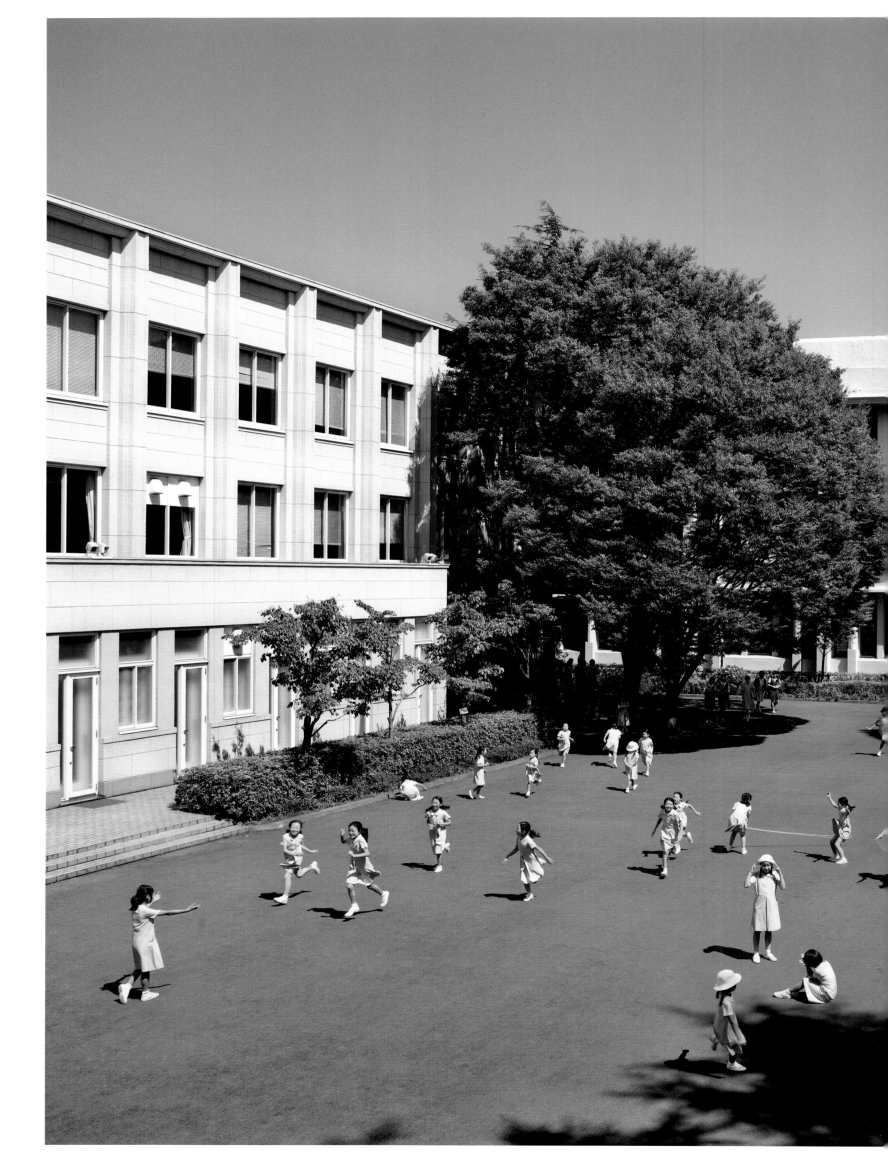

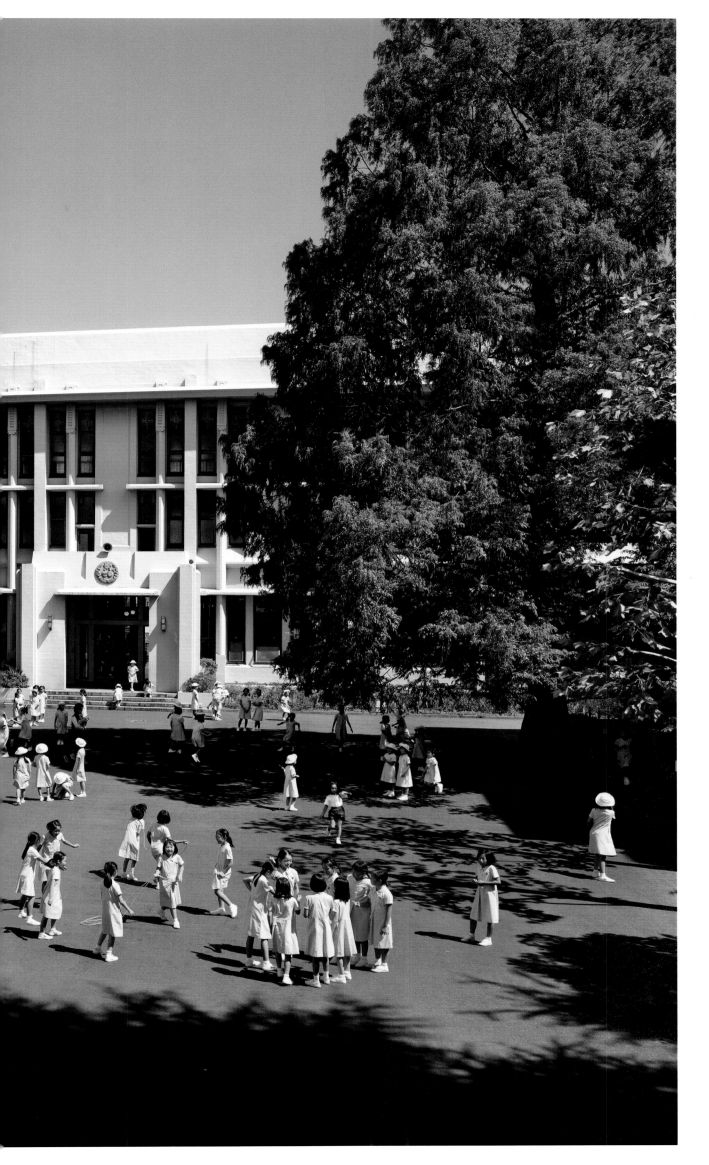

Seishin Joshi Gakuin
School, Tokyo

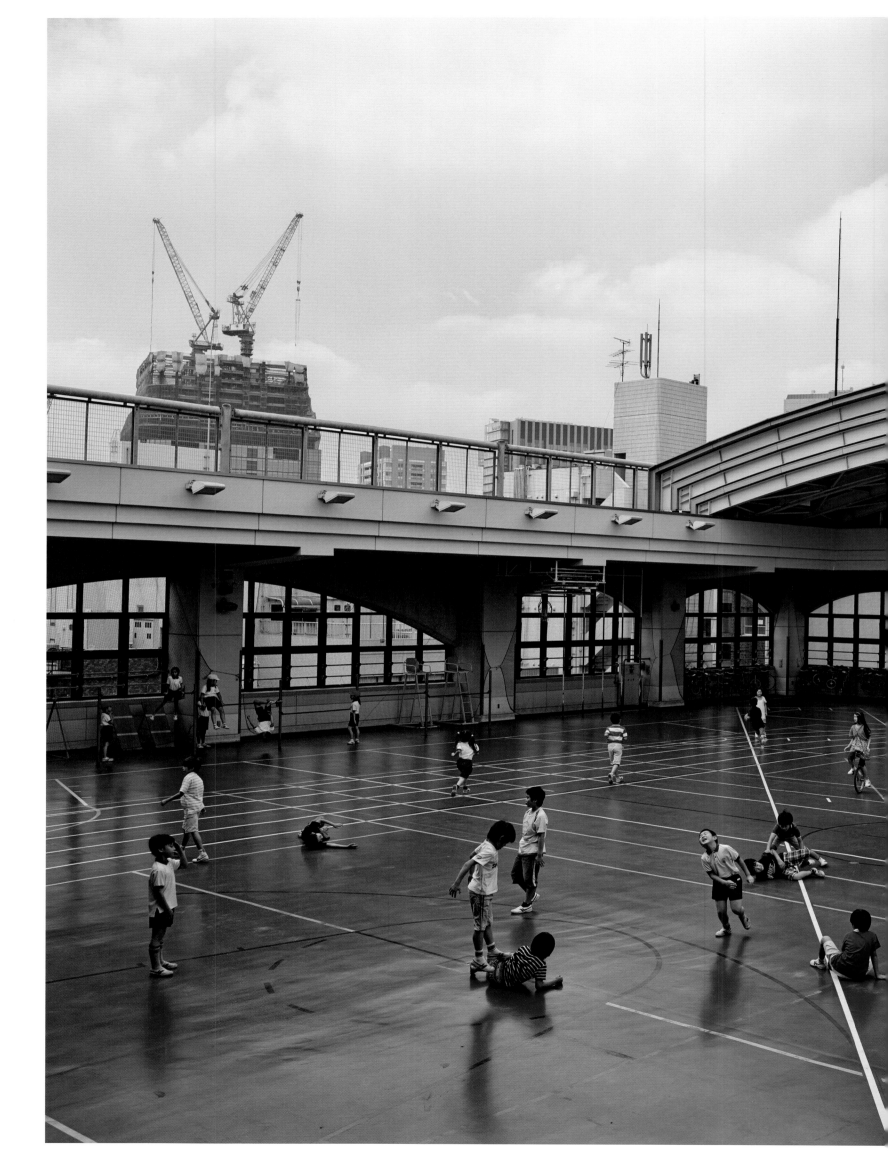

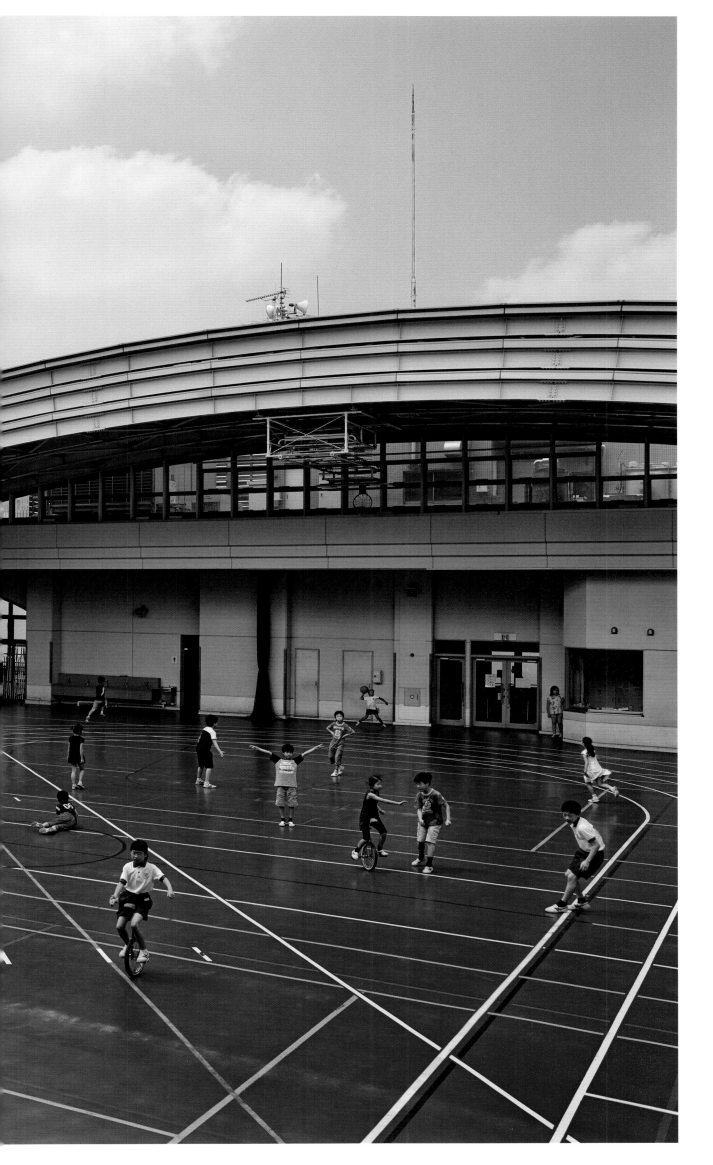

Sei Gakuin
Elementary School,
Tokyo

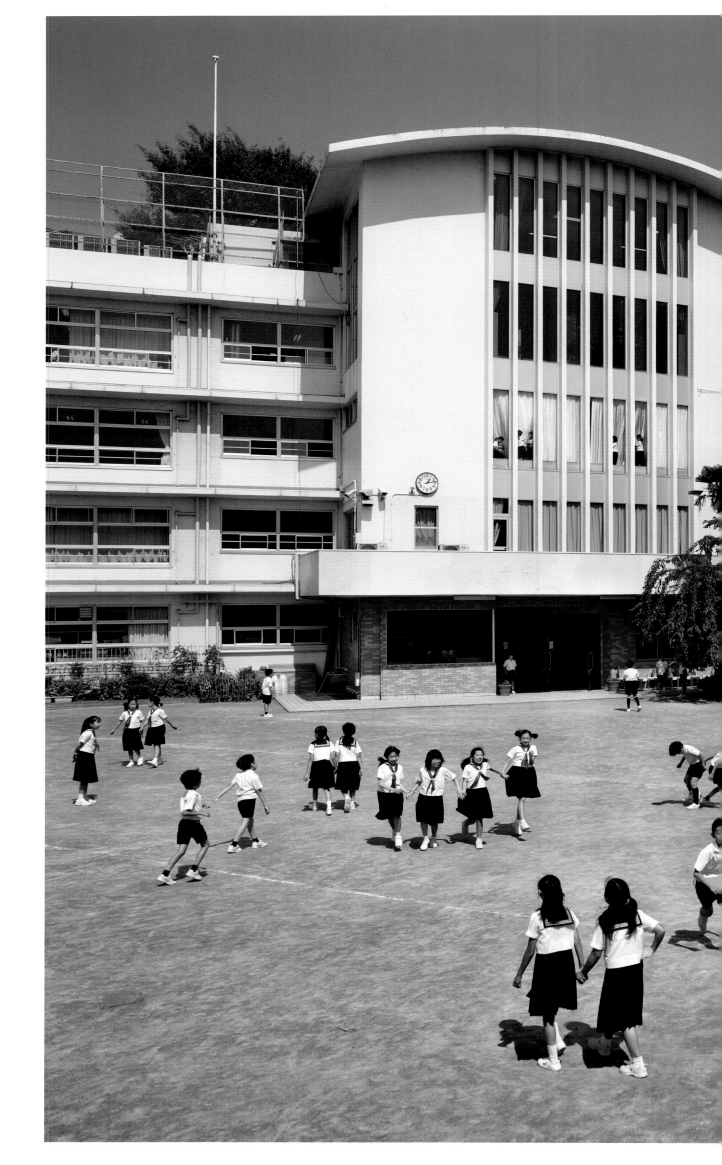

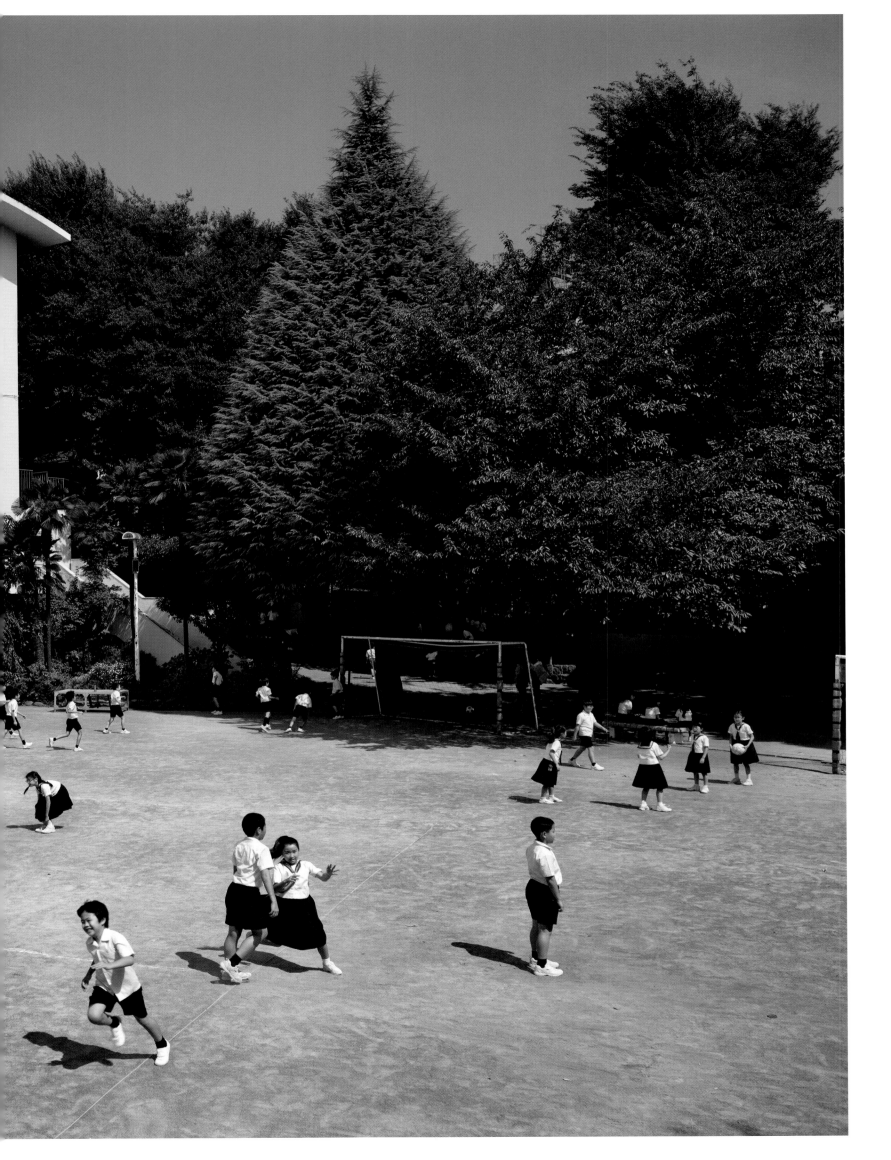

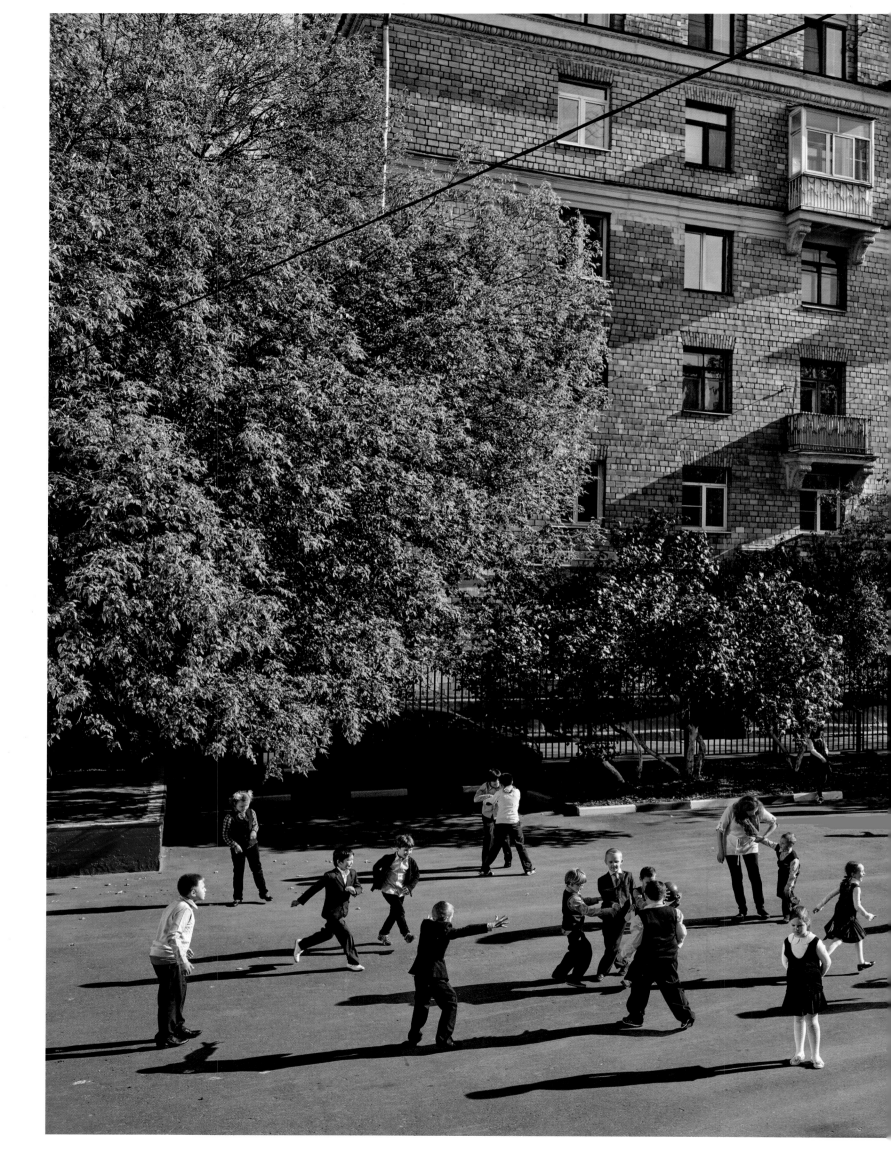

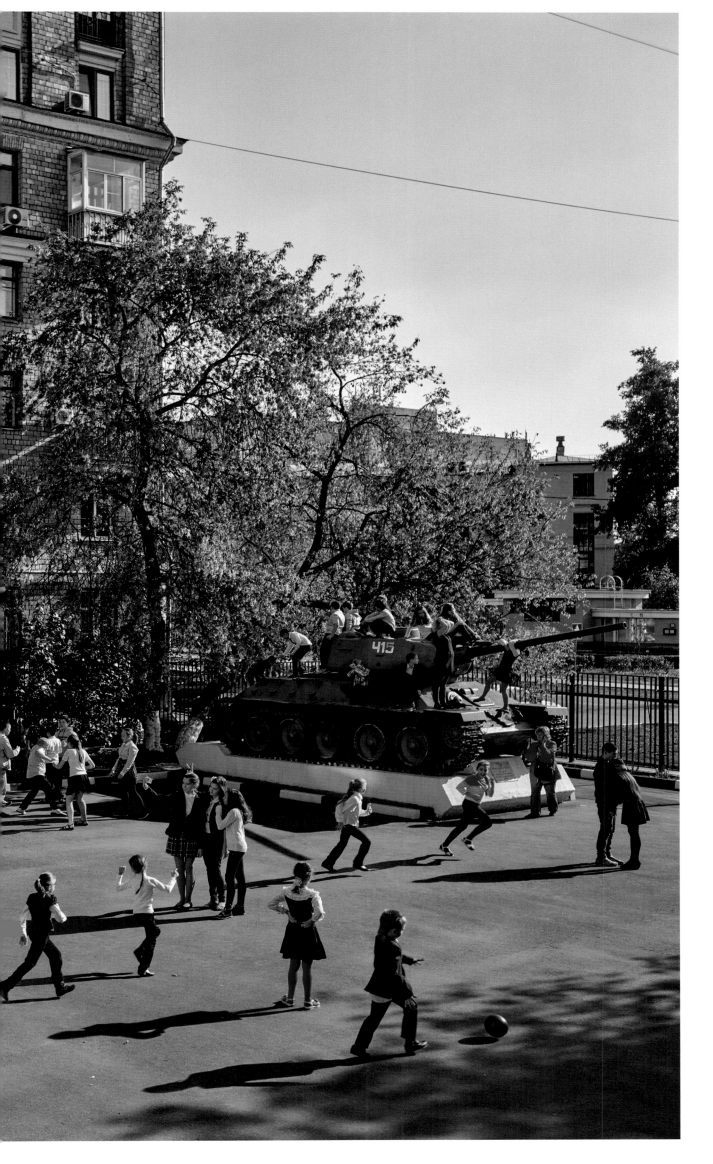

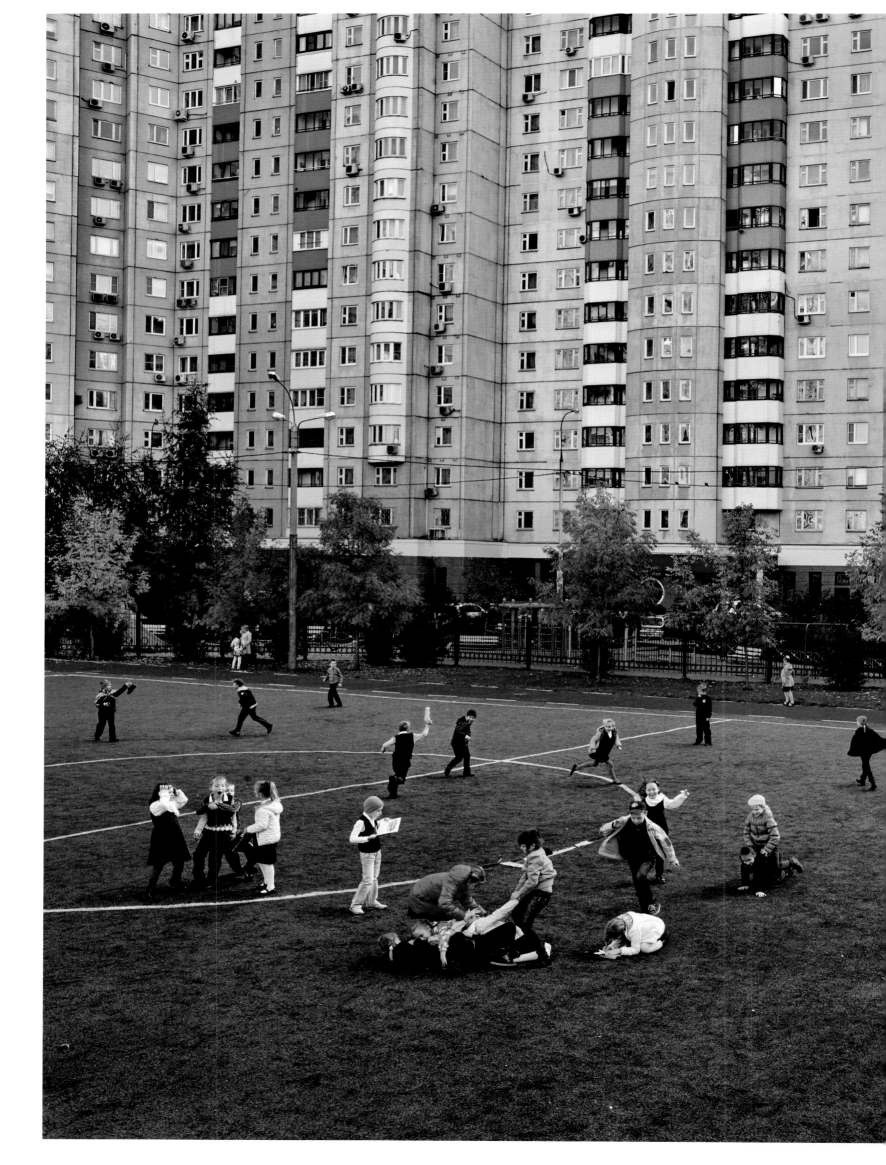

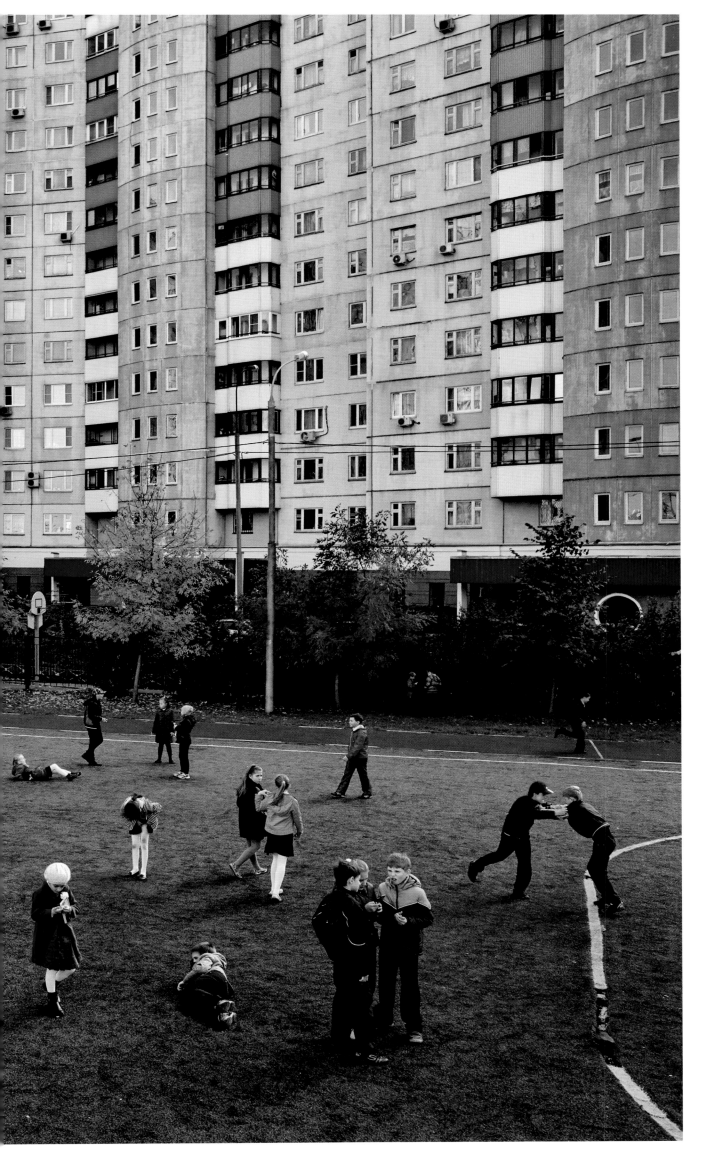

Cadet School of the
Heroes of Space,
Moscow

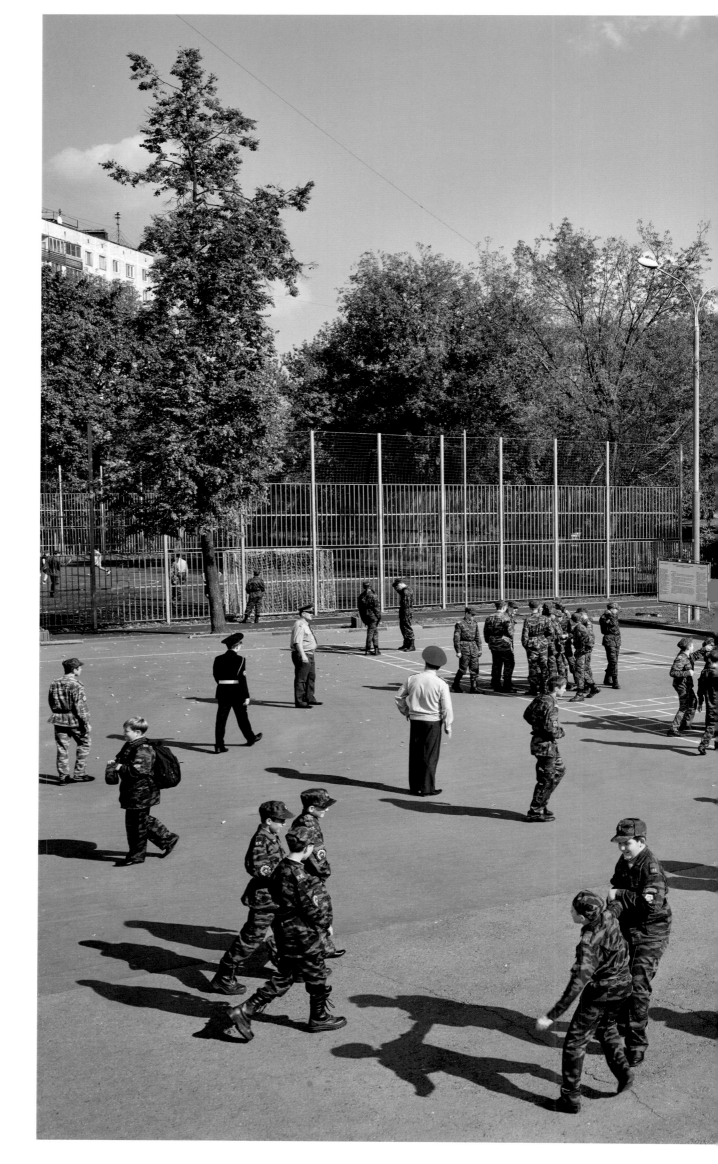

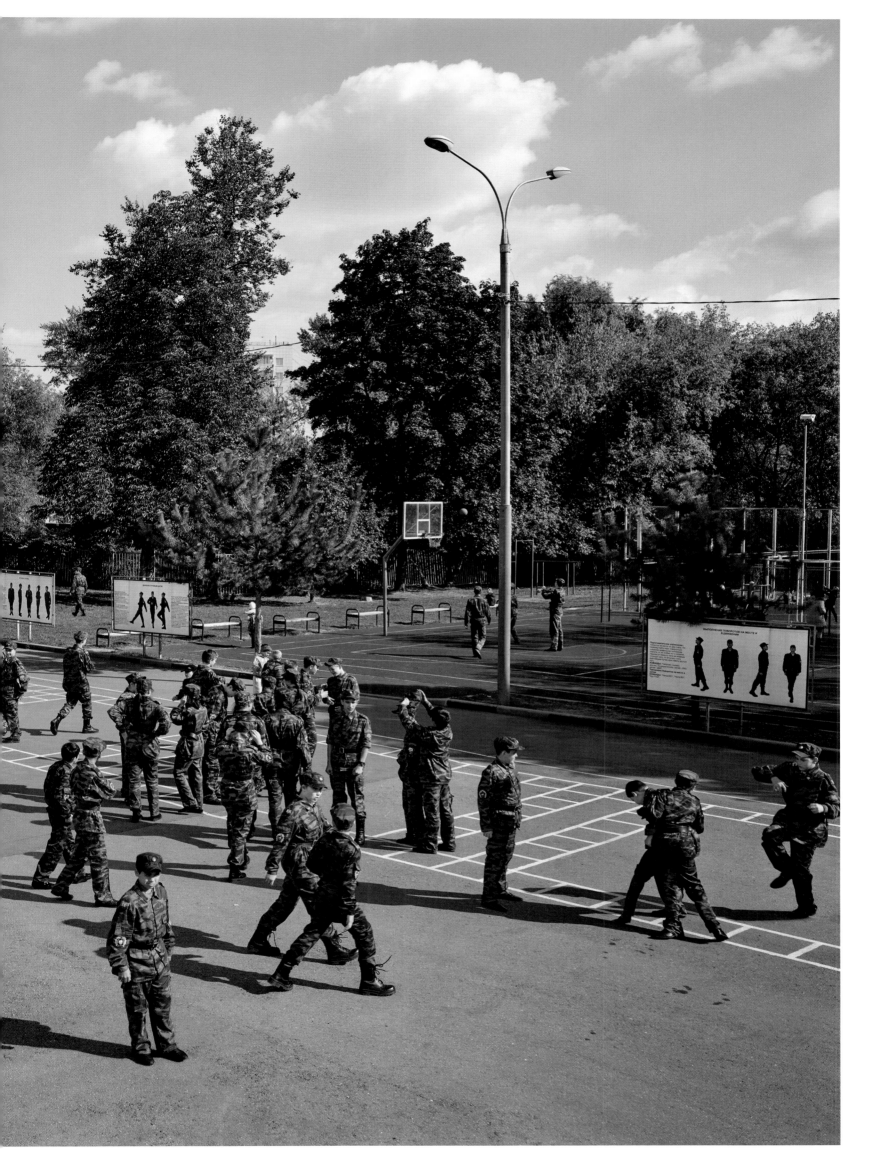

Nativity School,
Los Angeles

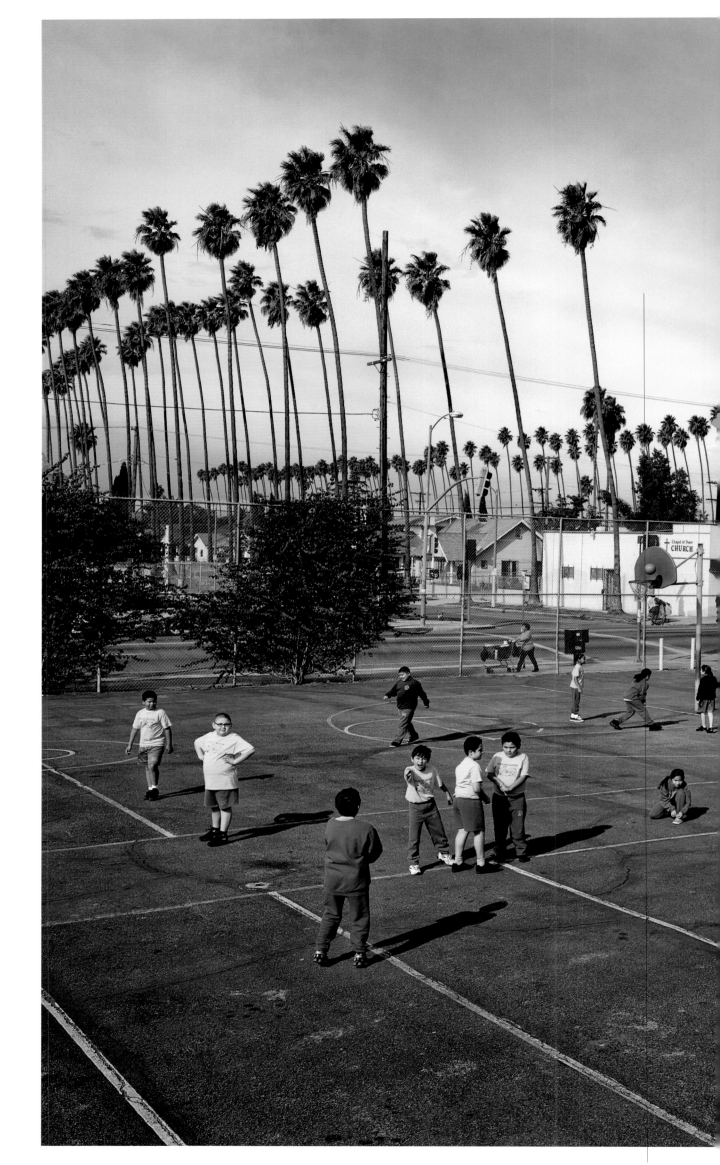

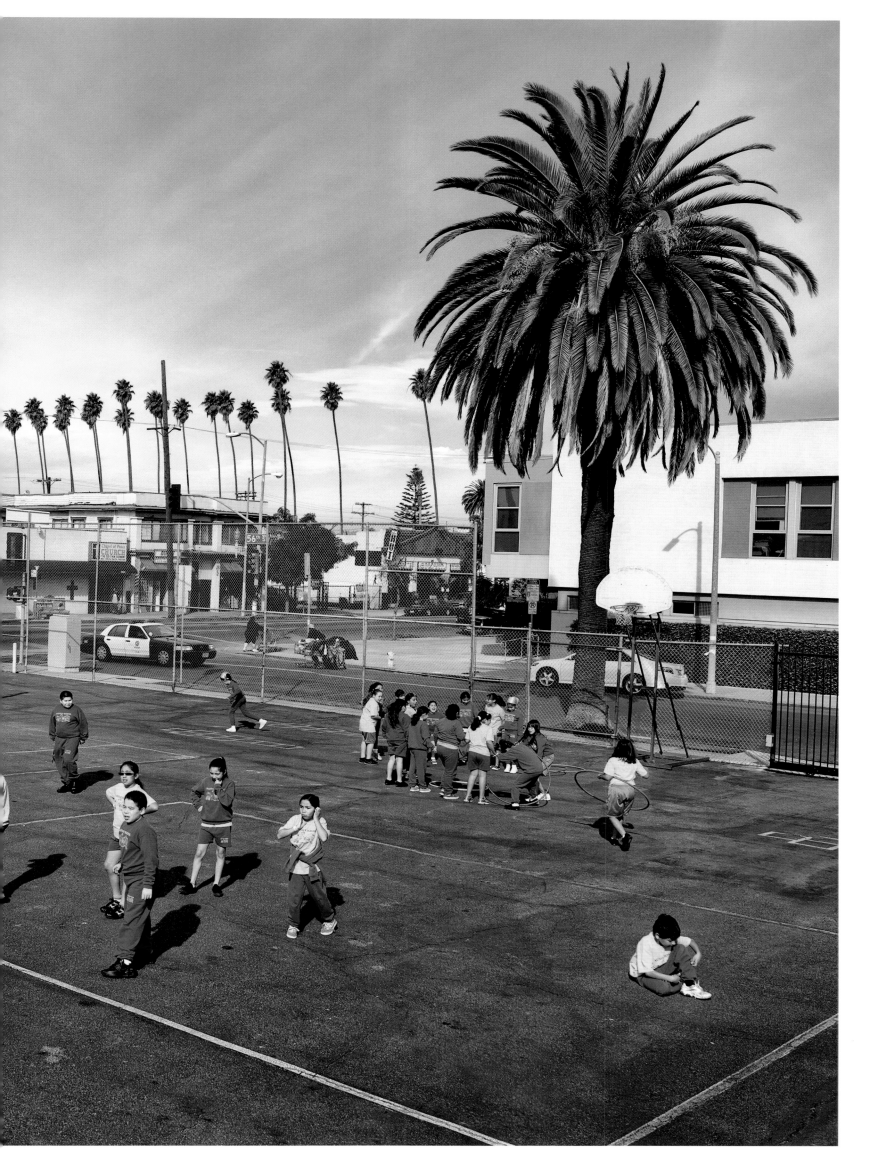

Warren Lane
Elementary,
Inglewood,
California

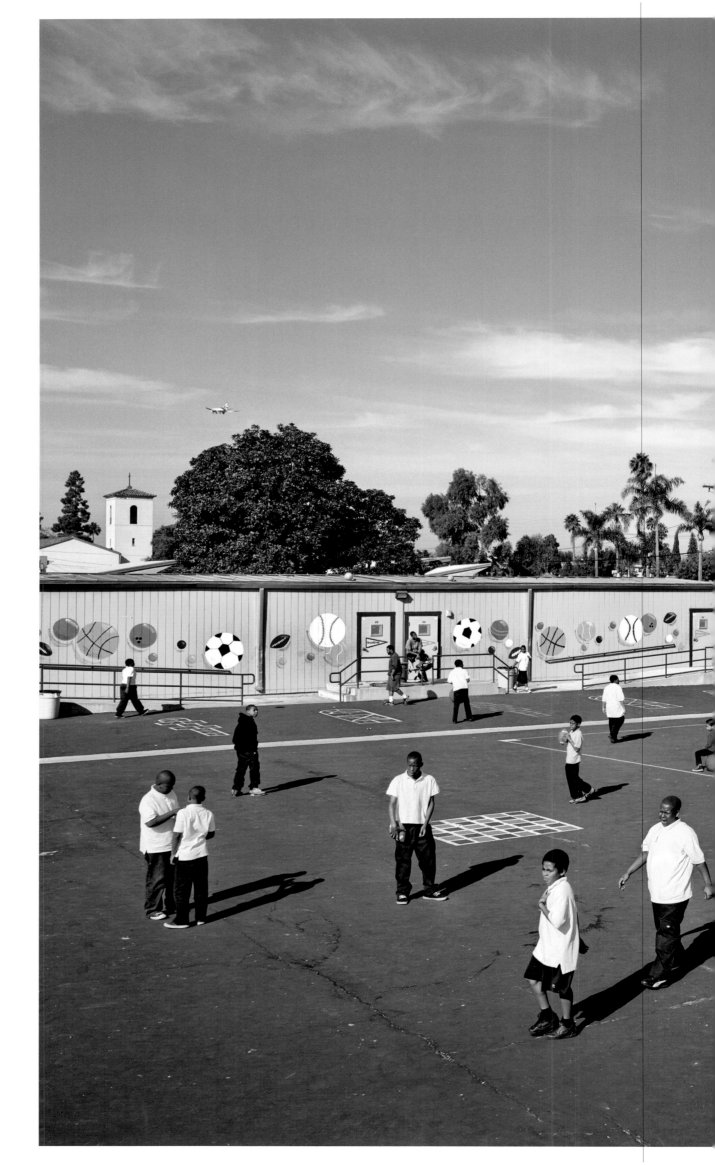

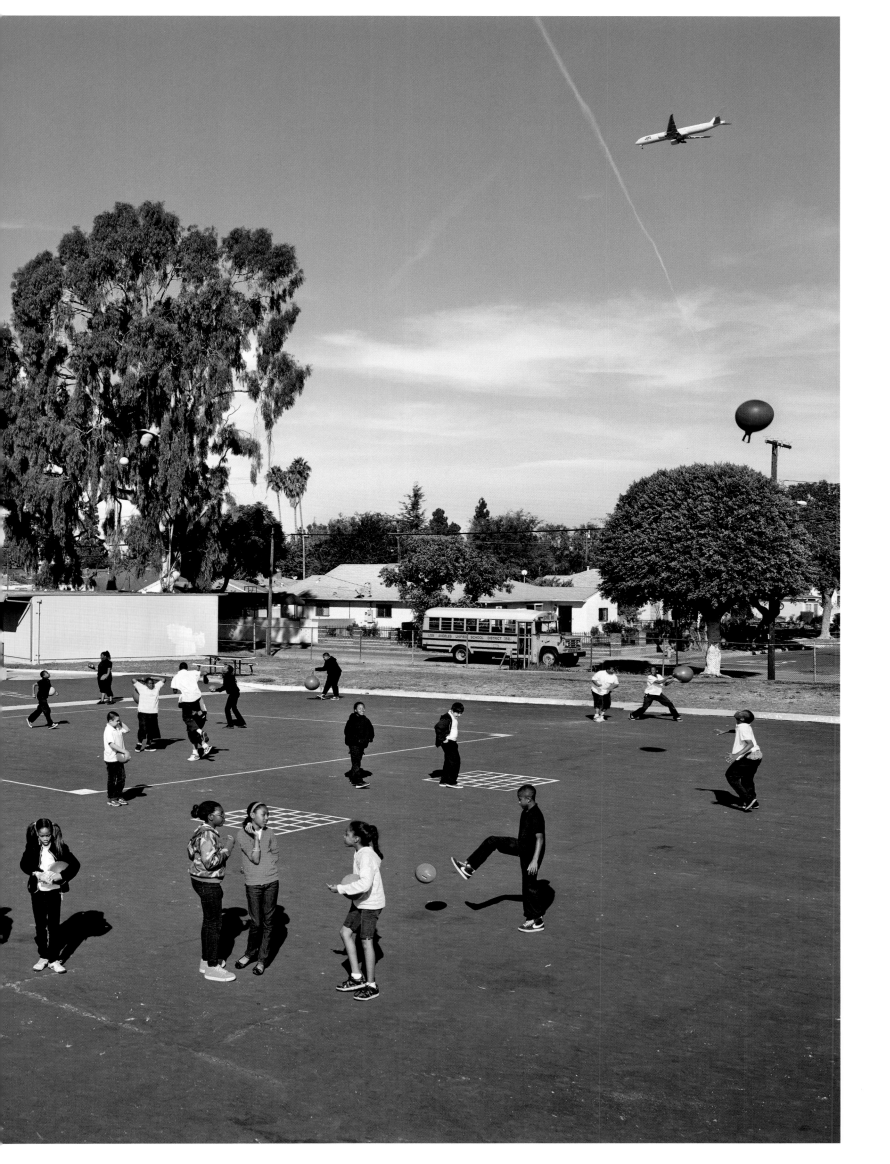

Inglewood
High School,
Inglewood,
California

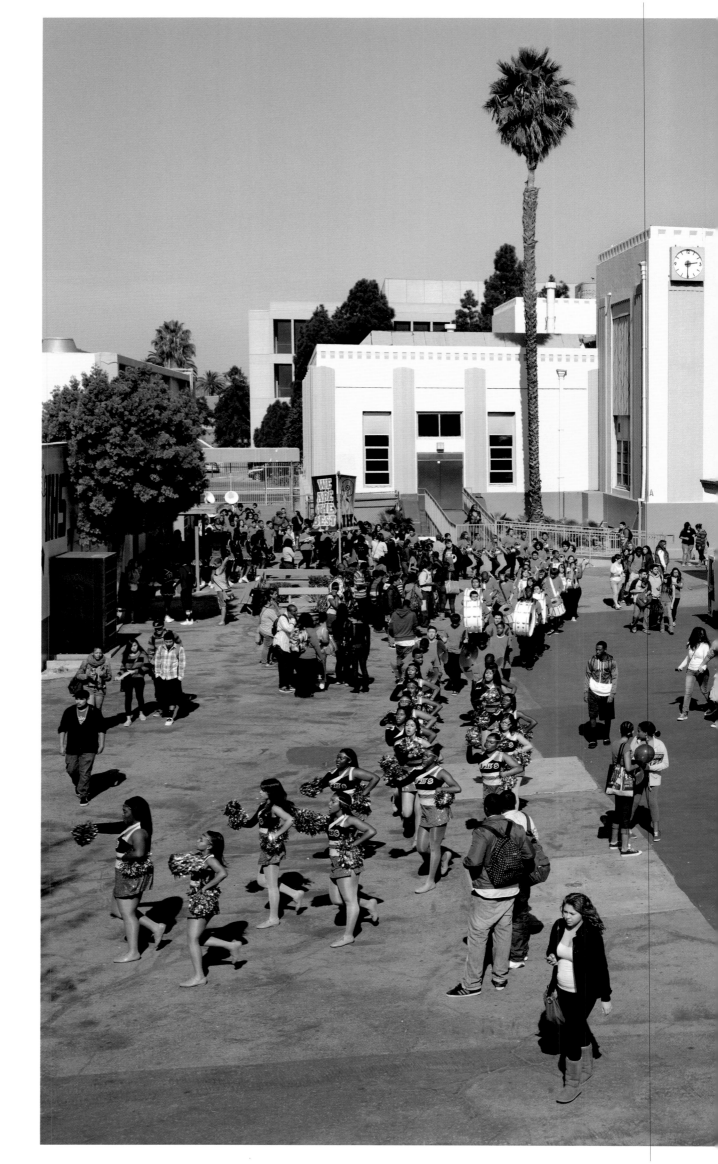

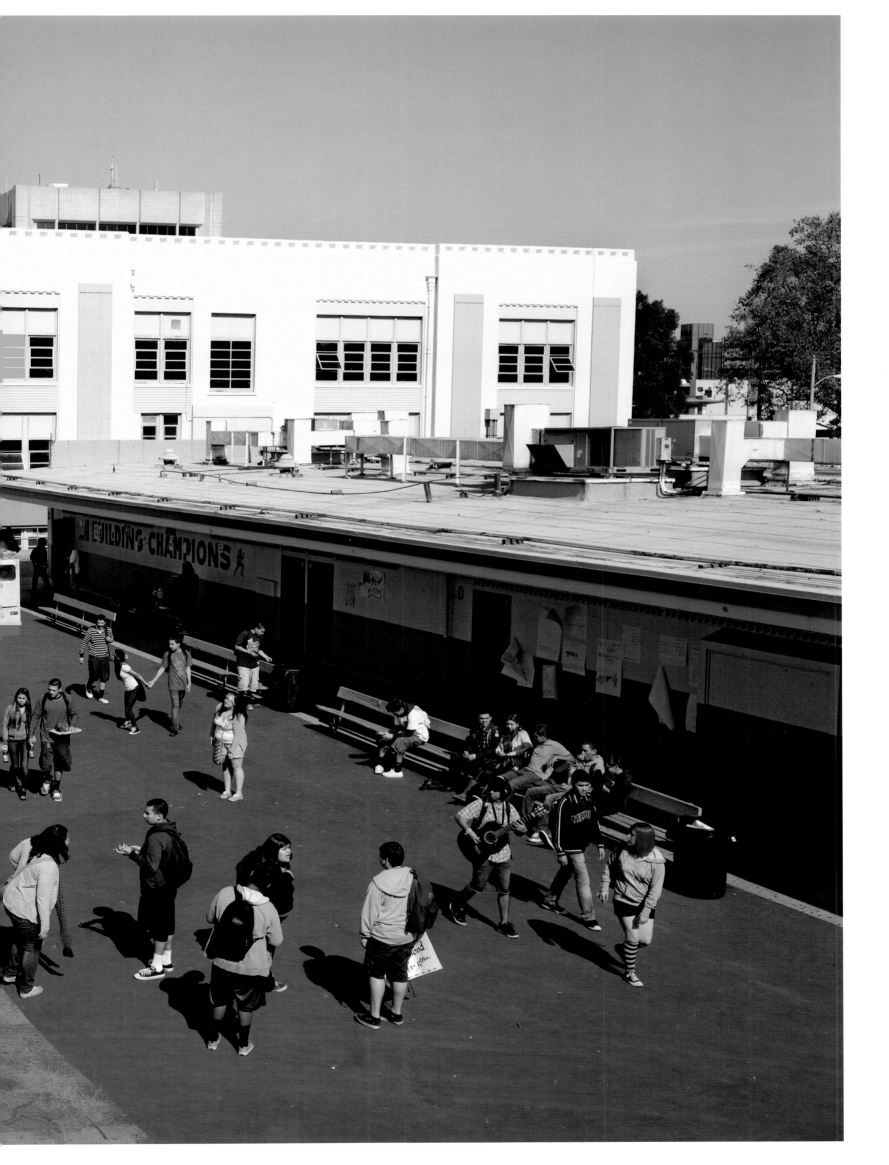

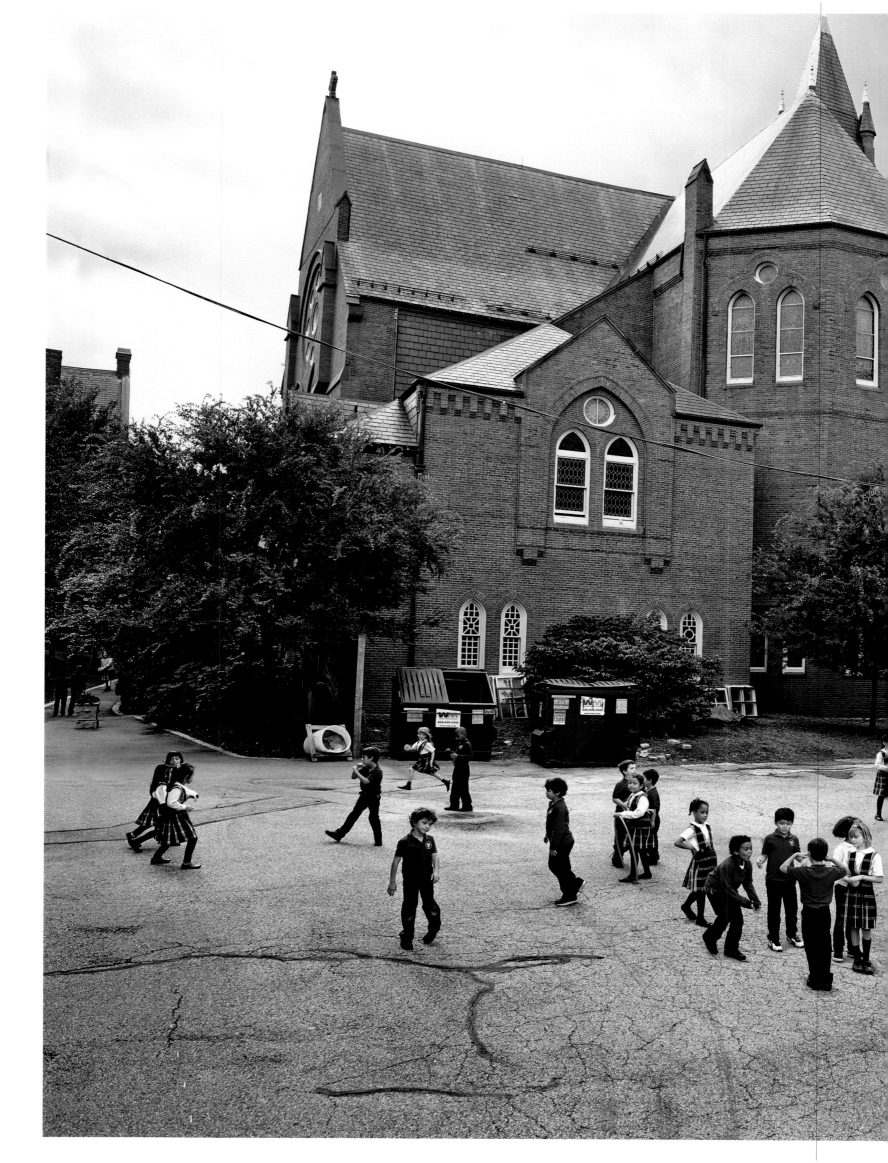

St. Mary of the
Assumption
Elementary School,
Brookline,
Massachusetts

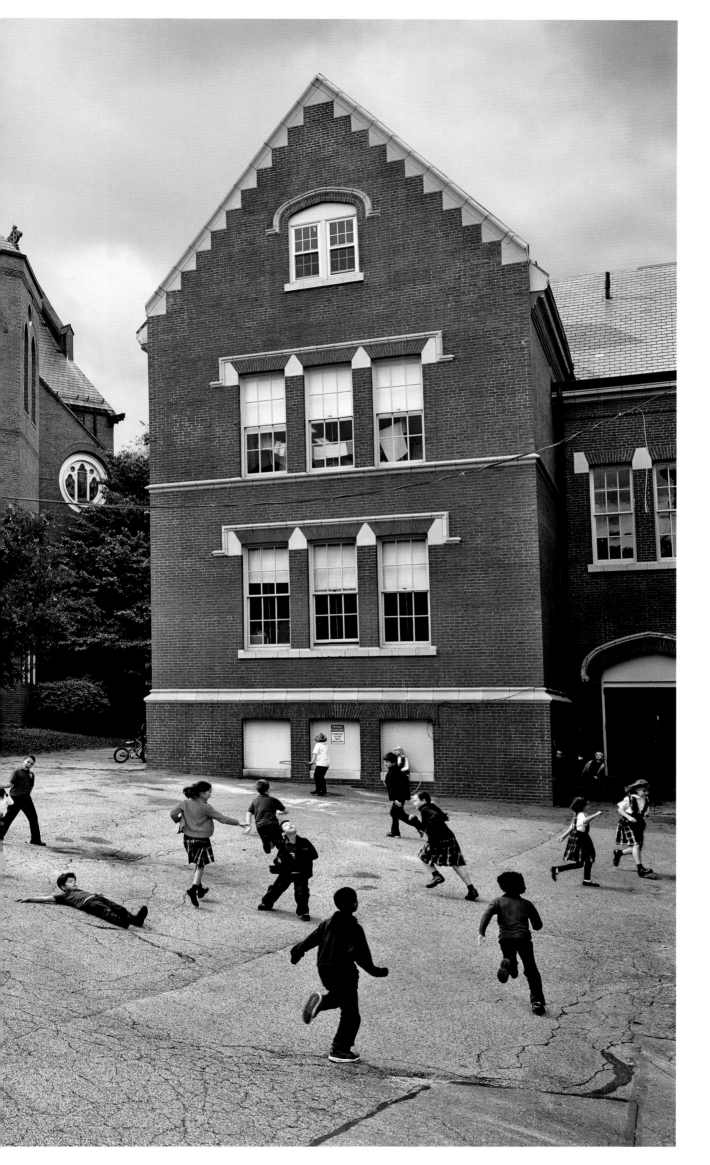

Emiliano Zapata
Elementary School,
Pachuca de Soto,
Hidalgo, Mexico

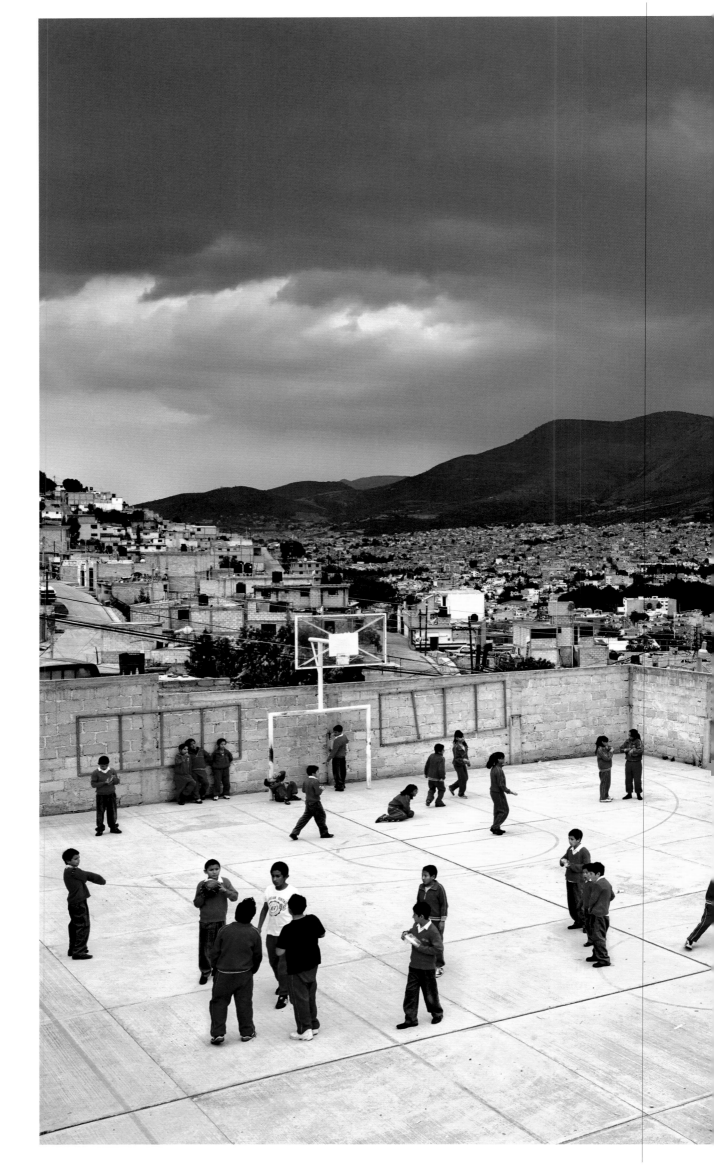

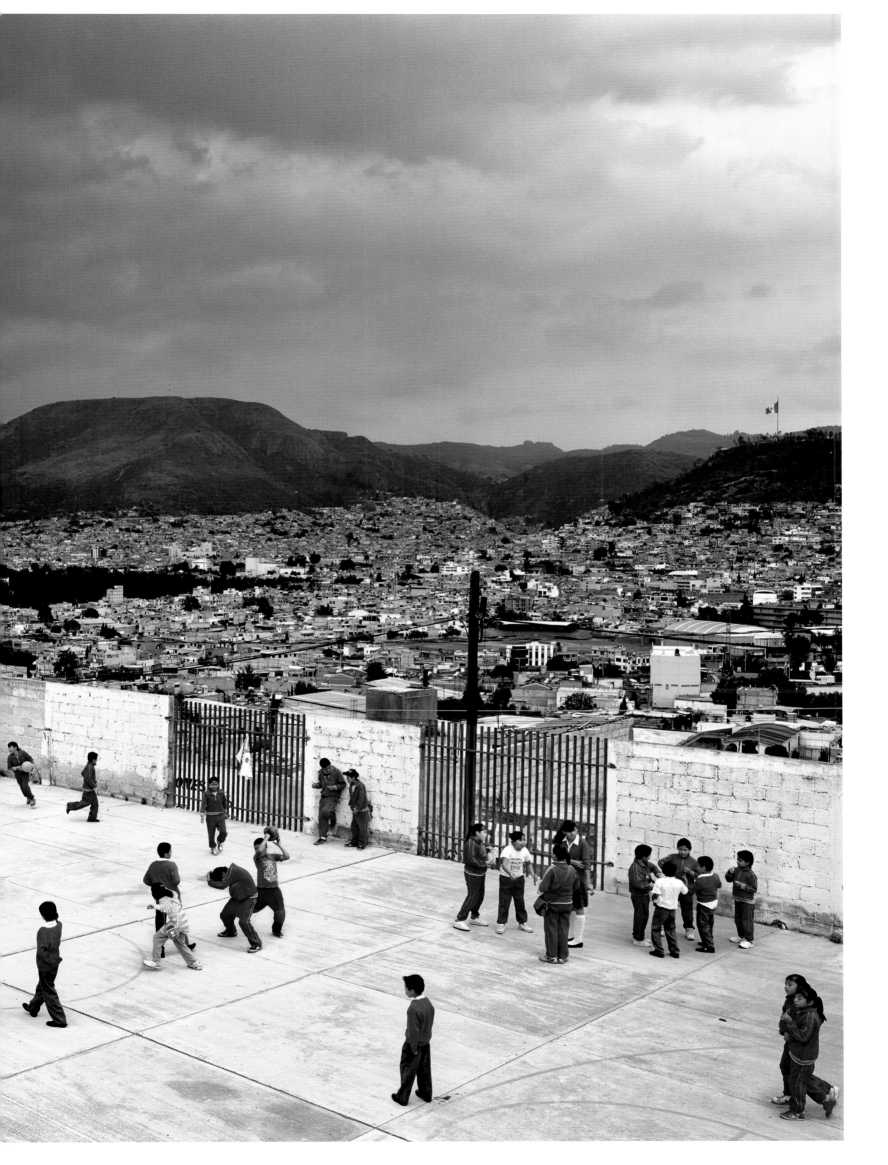

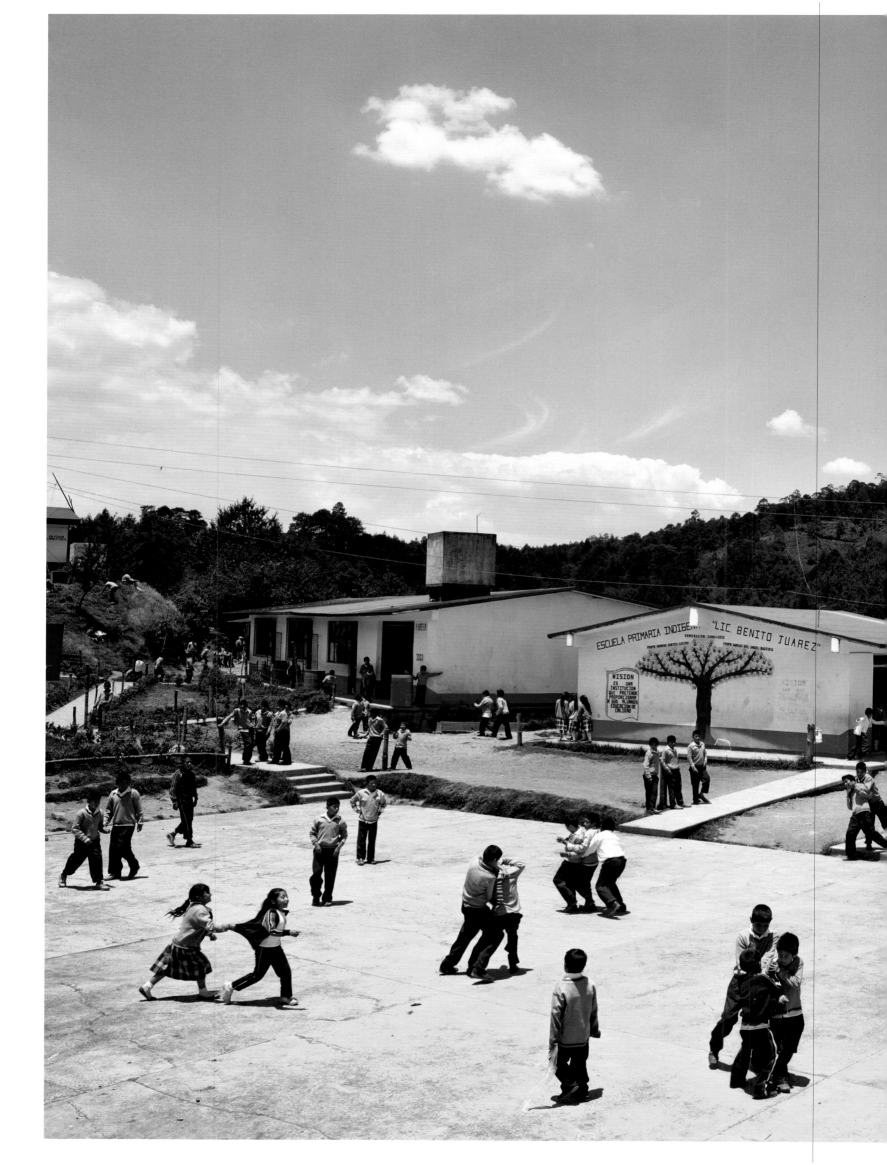

Benito Juárez
Indigenous
Elementary School,
Acaxochitlán,
Hidalgo, Mexico

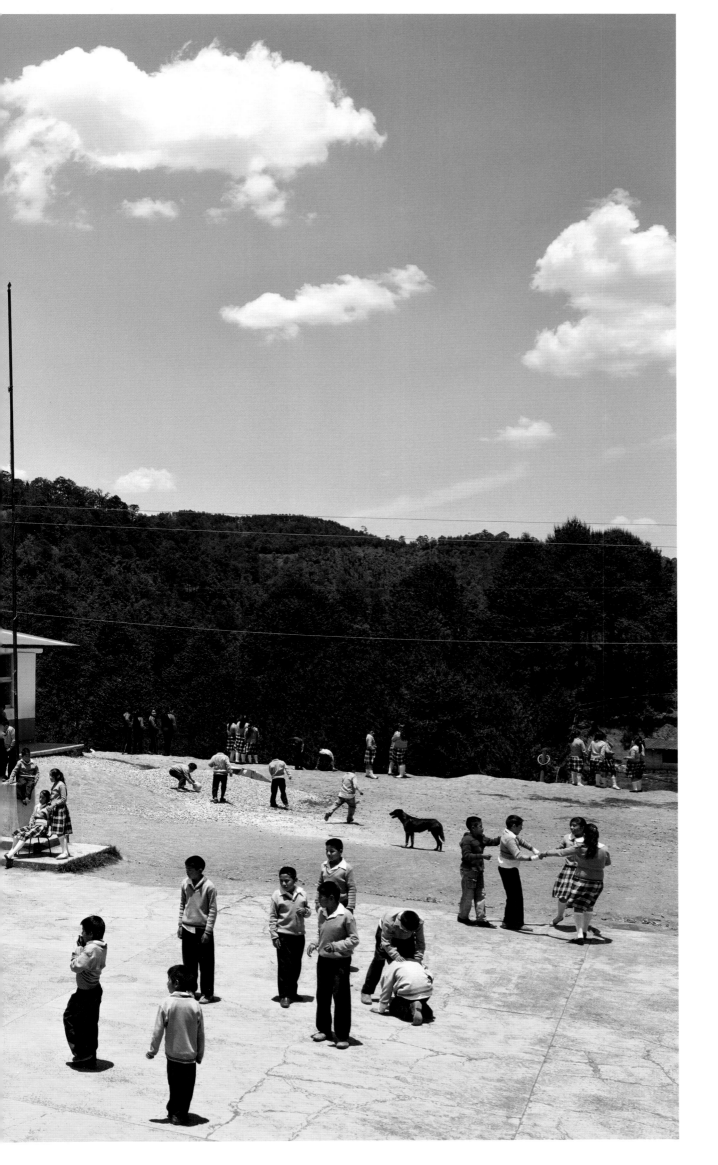

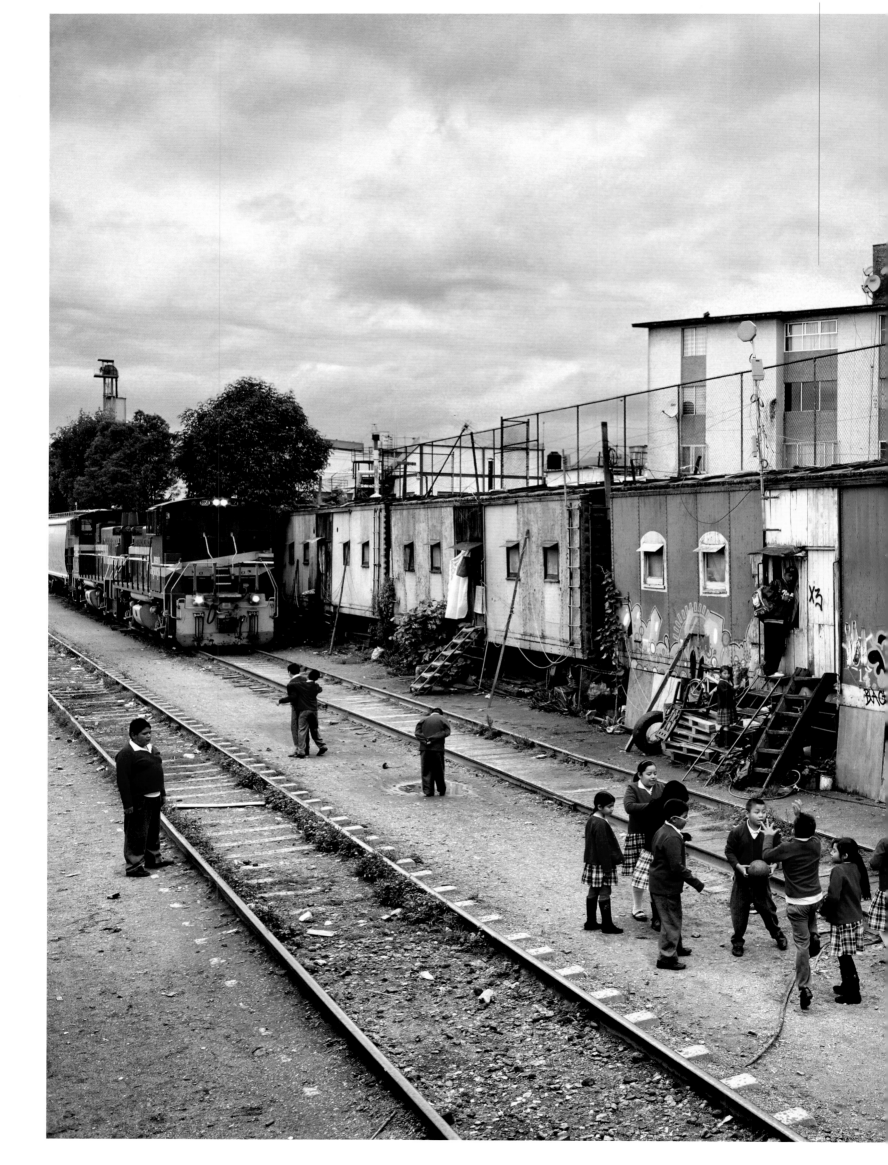

Adolfo López
Mateos Primary
School, Mexico City

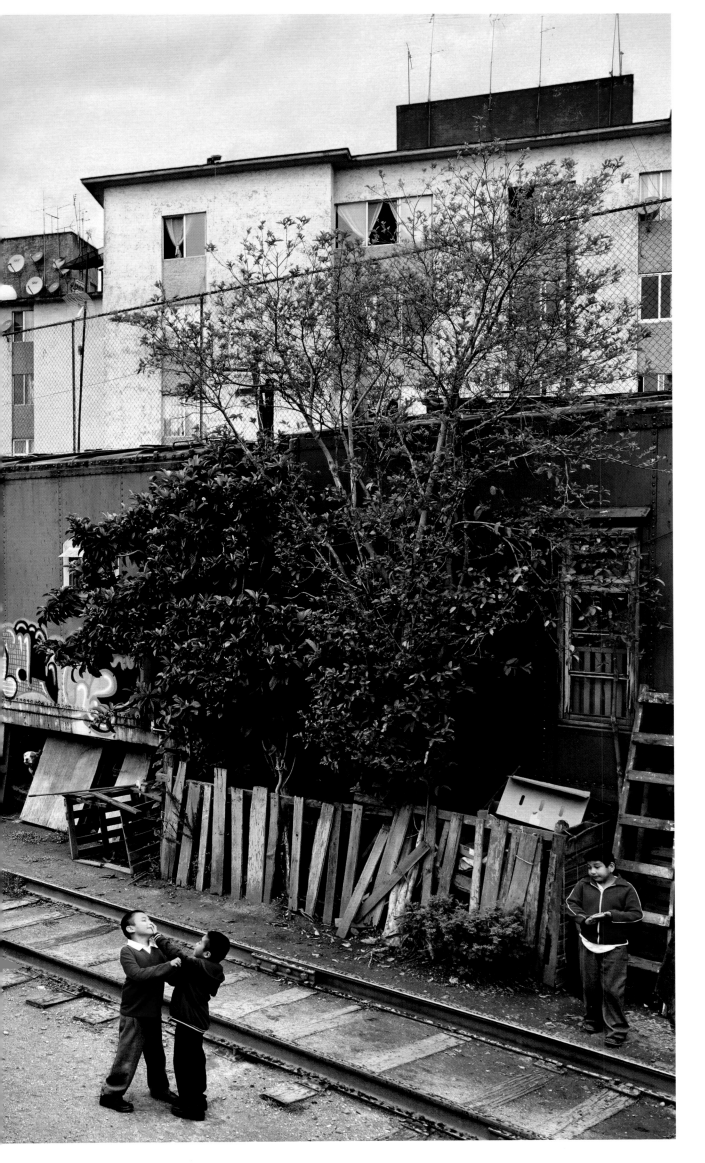

Kroo Bay Primary,
Freetown,
Sierra Leone

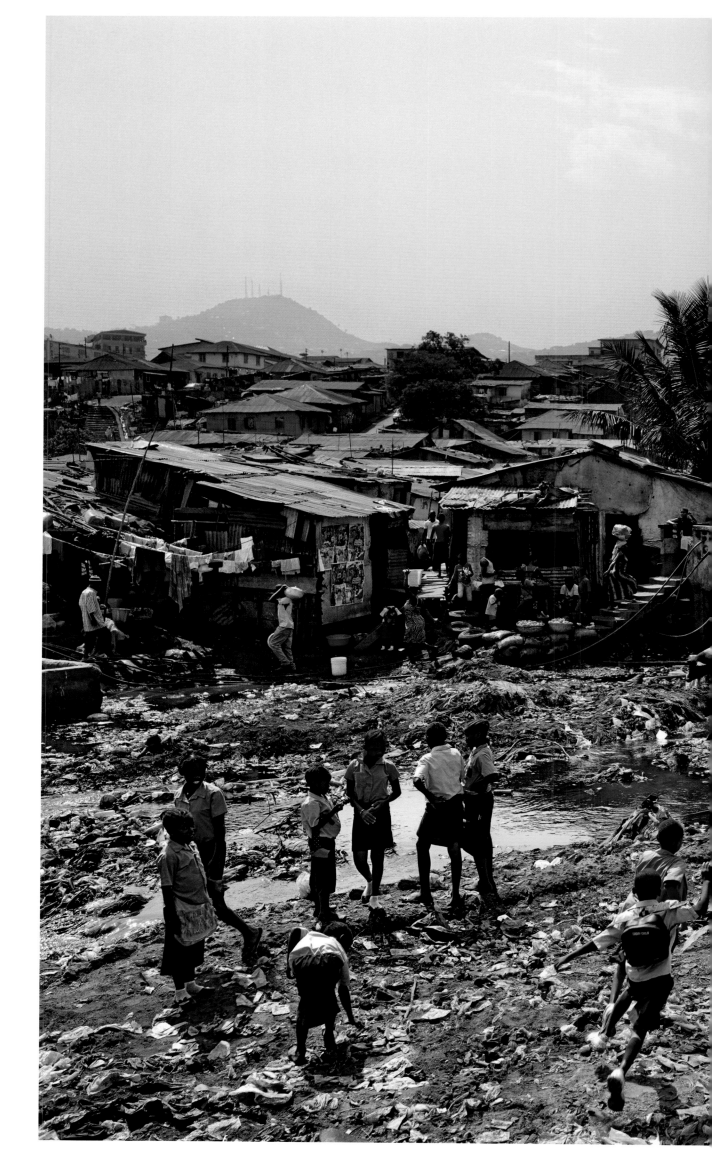

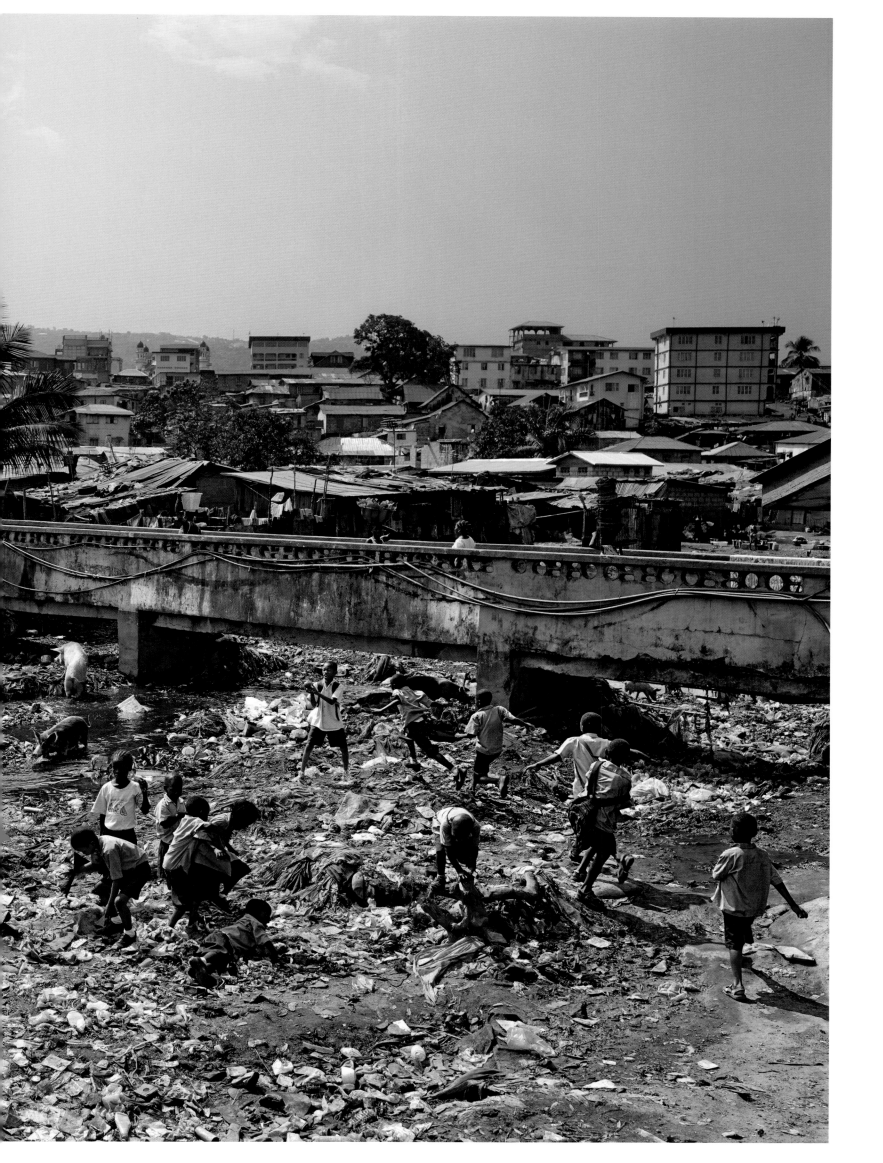

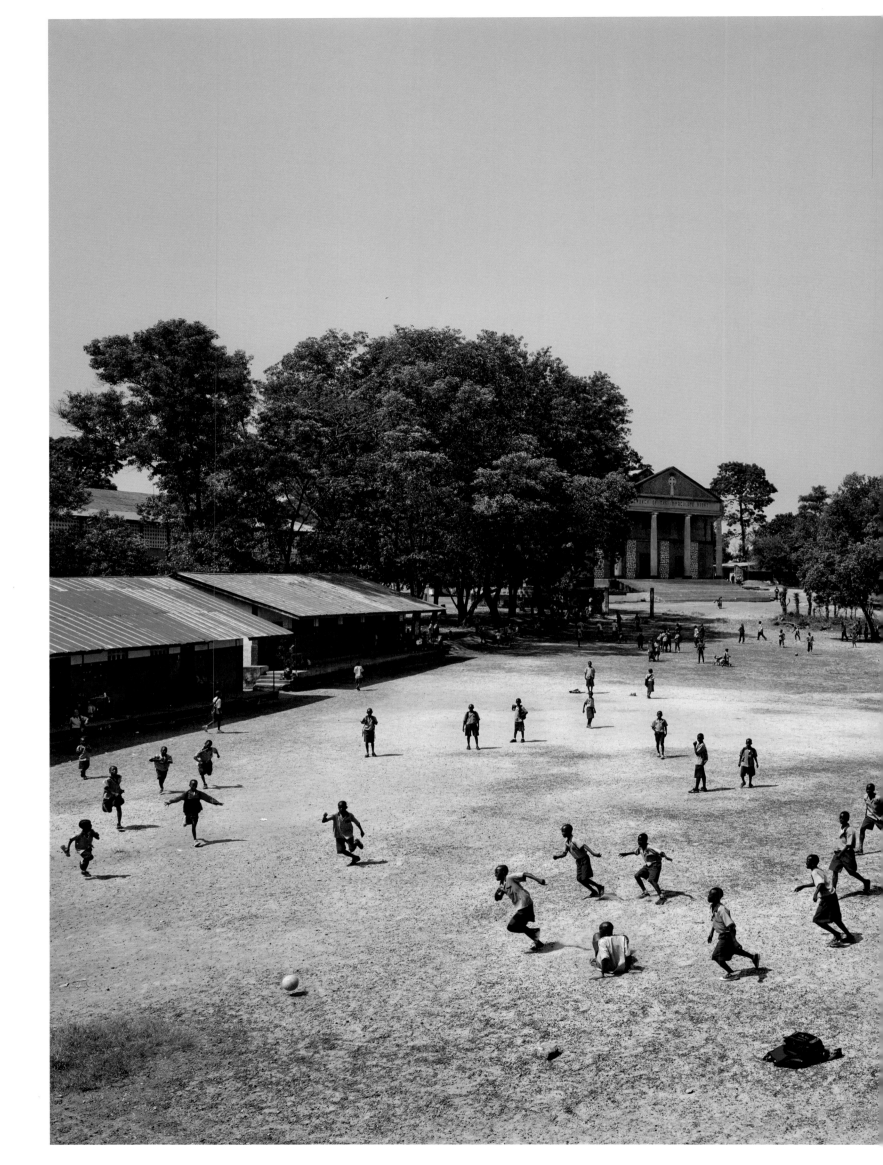

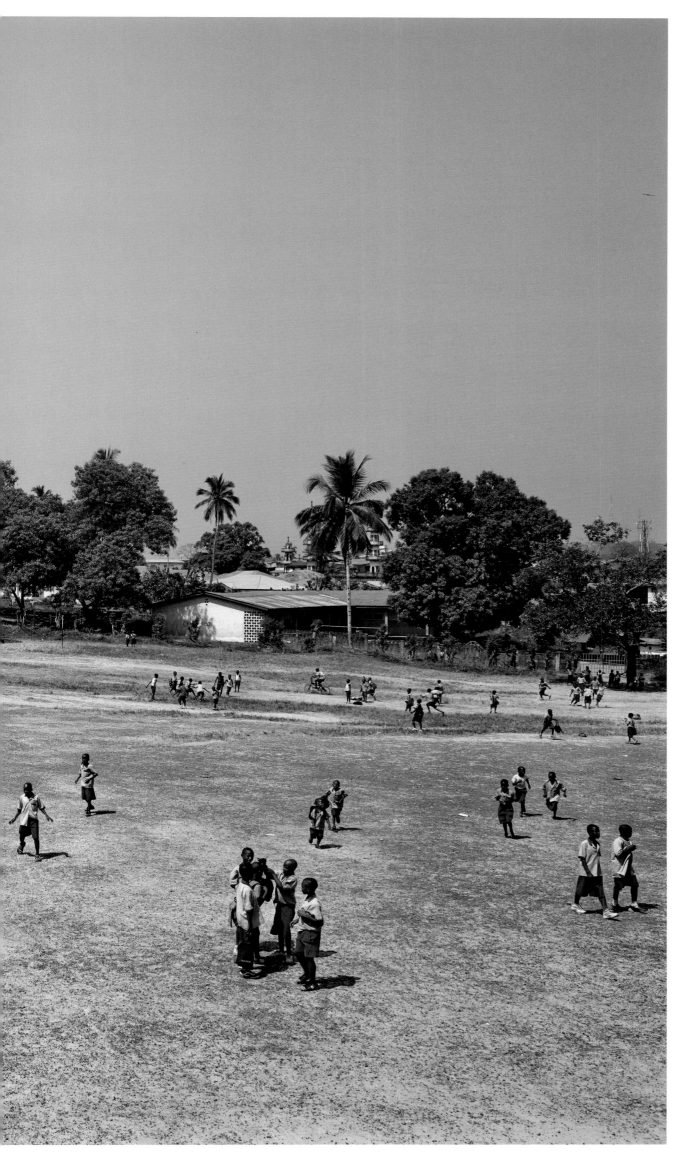

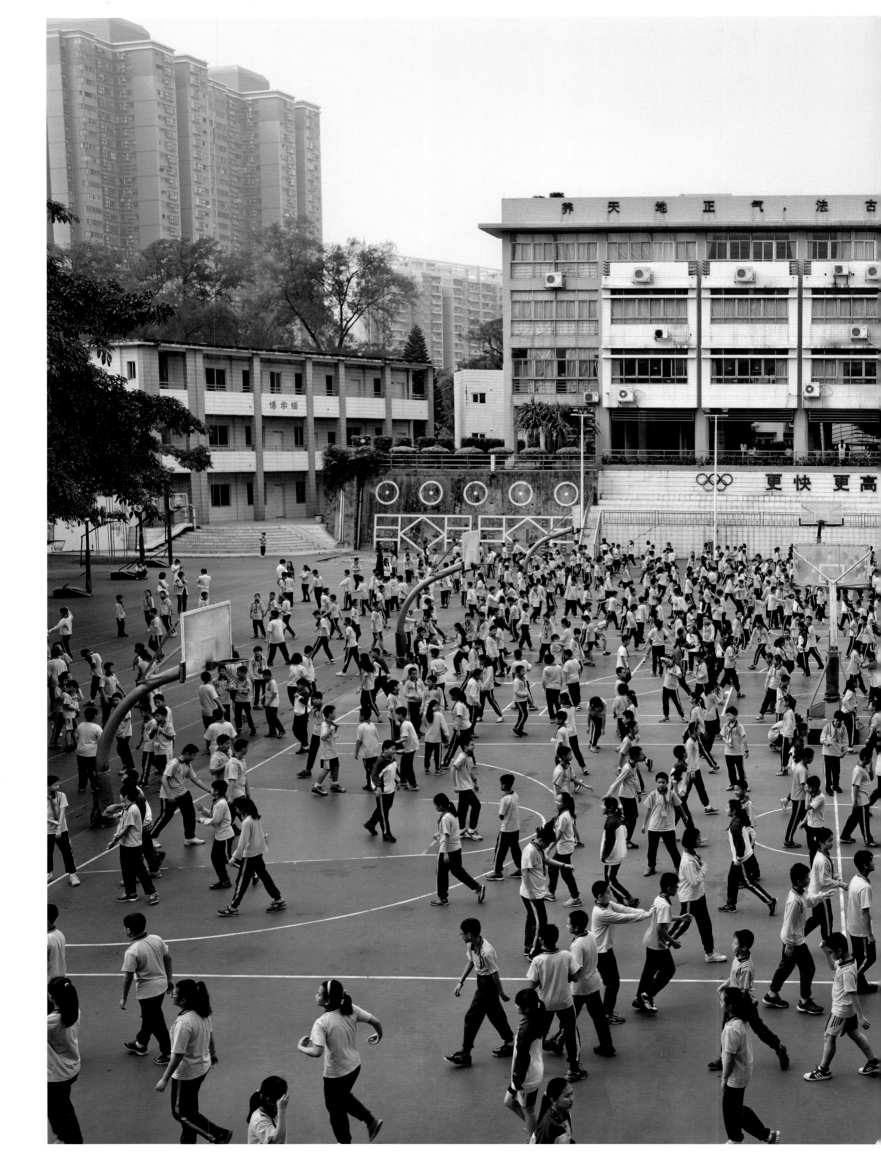

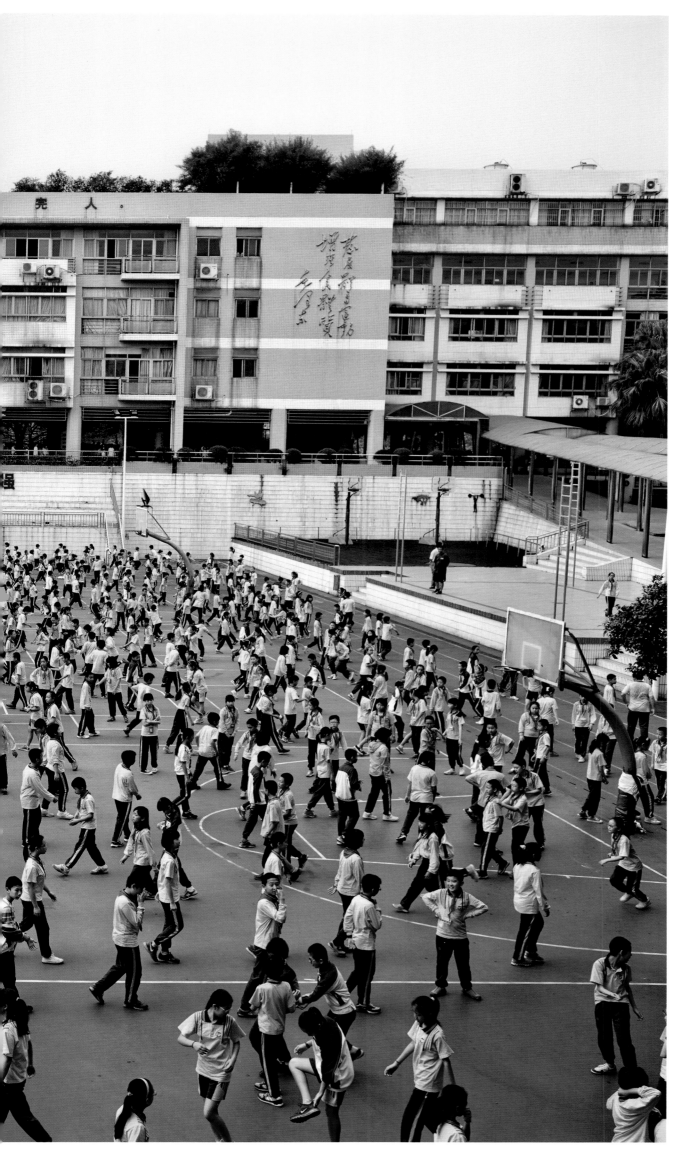

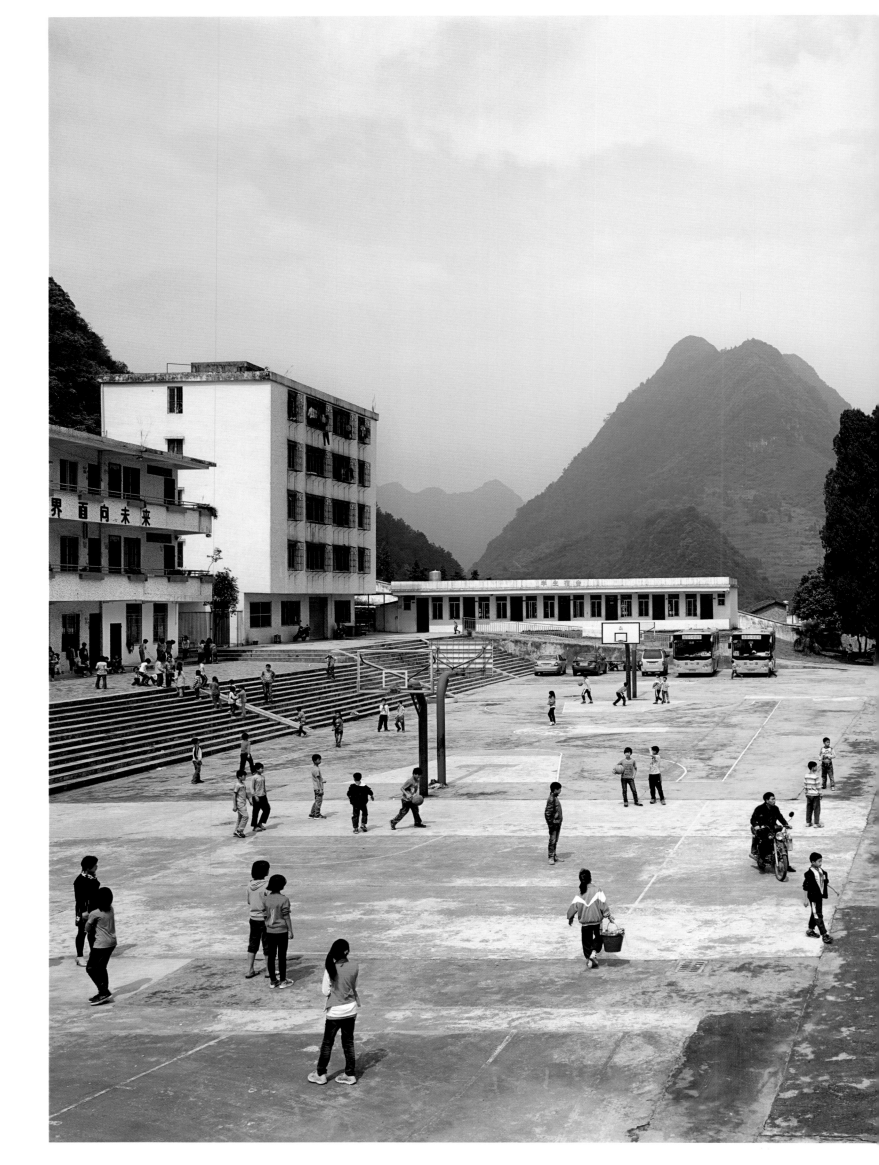

Pei Qiao Central
Middle School,
Qingyuan, China

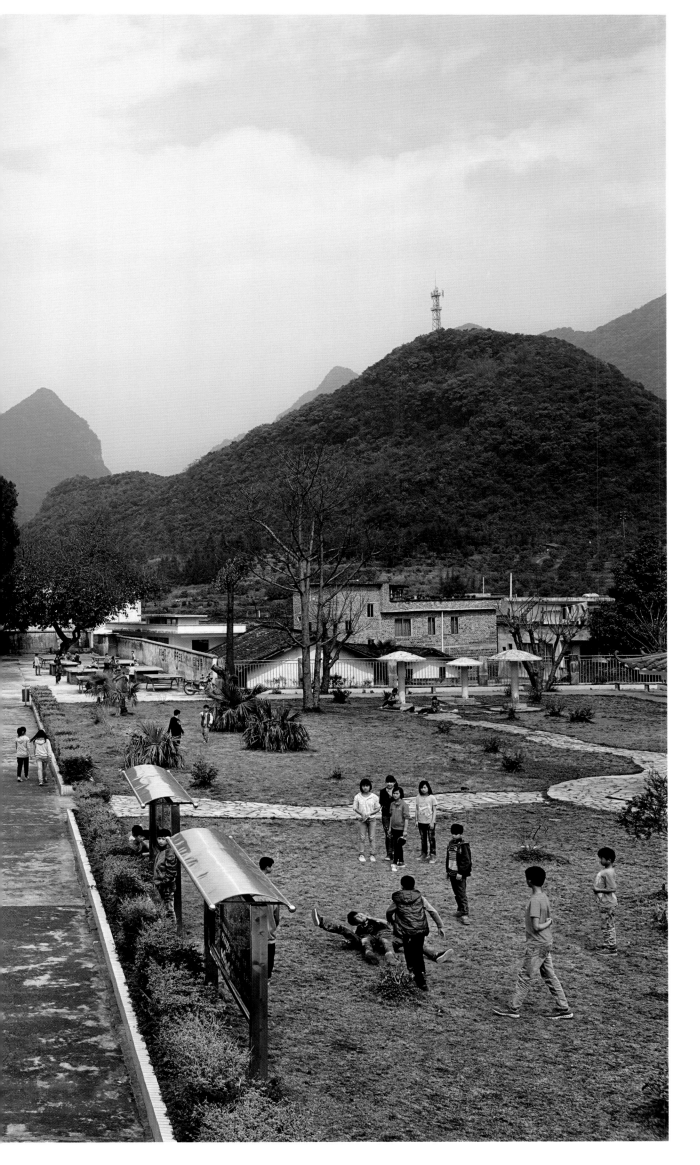

Wen Chong Primary
School, Qingyuan,
China

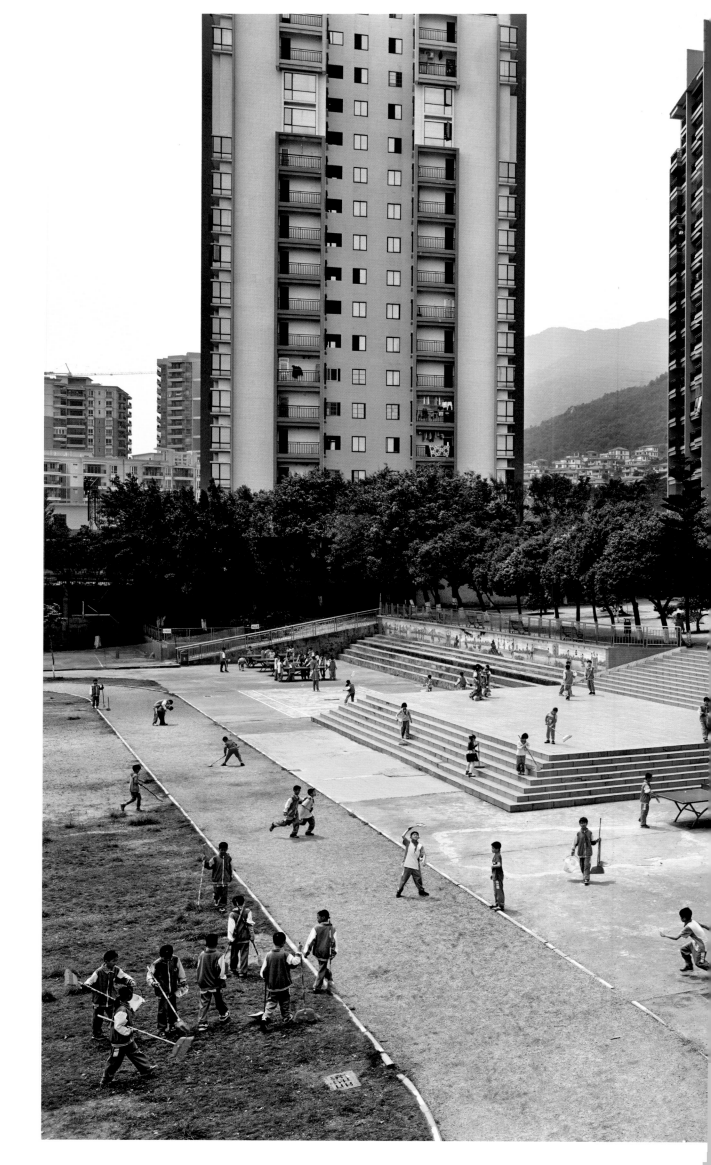

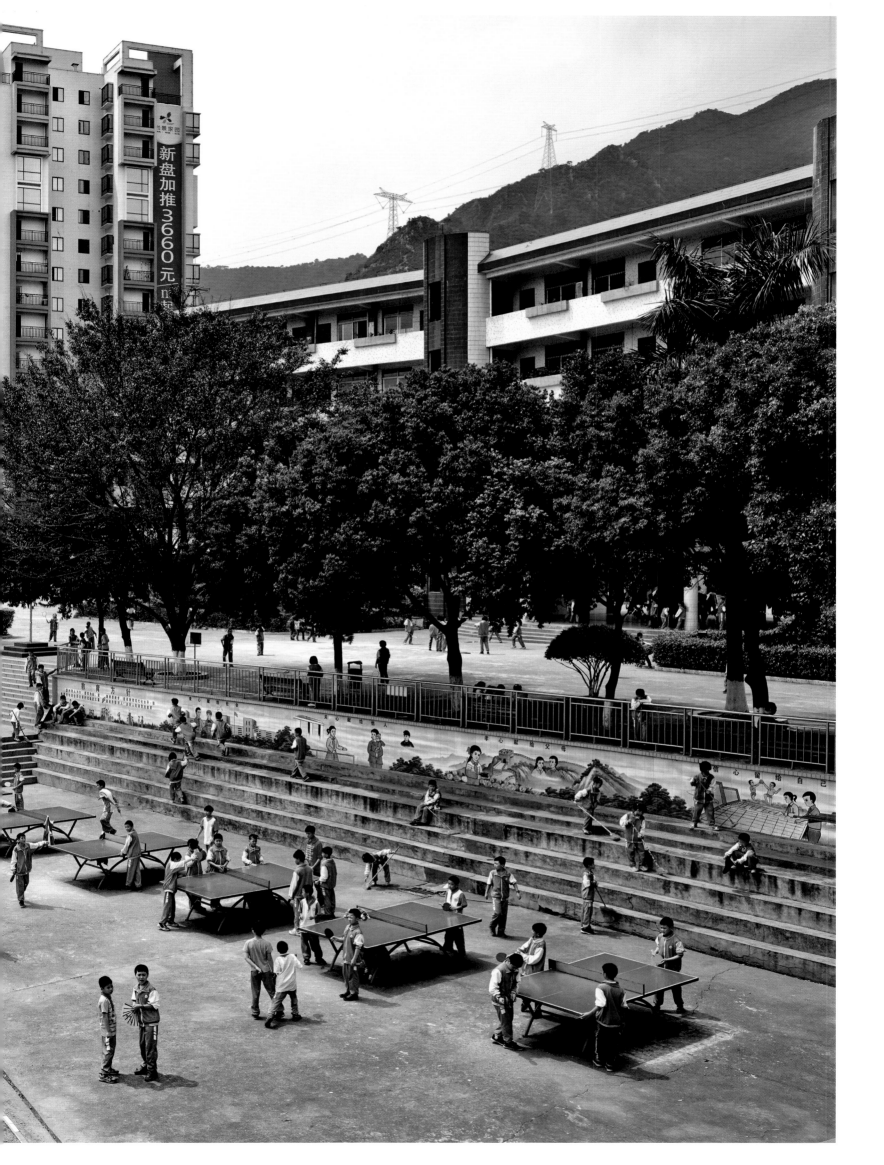

He Huang Yu Xiang
Middle School,
Qingyuan, China

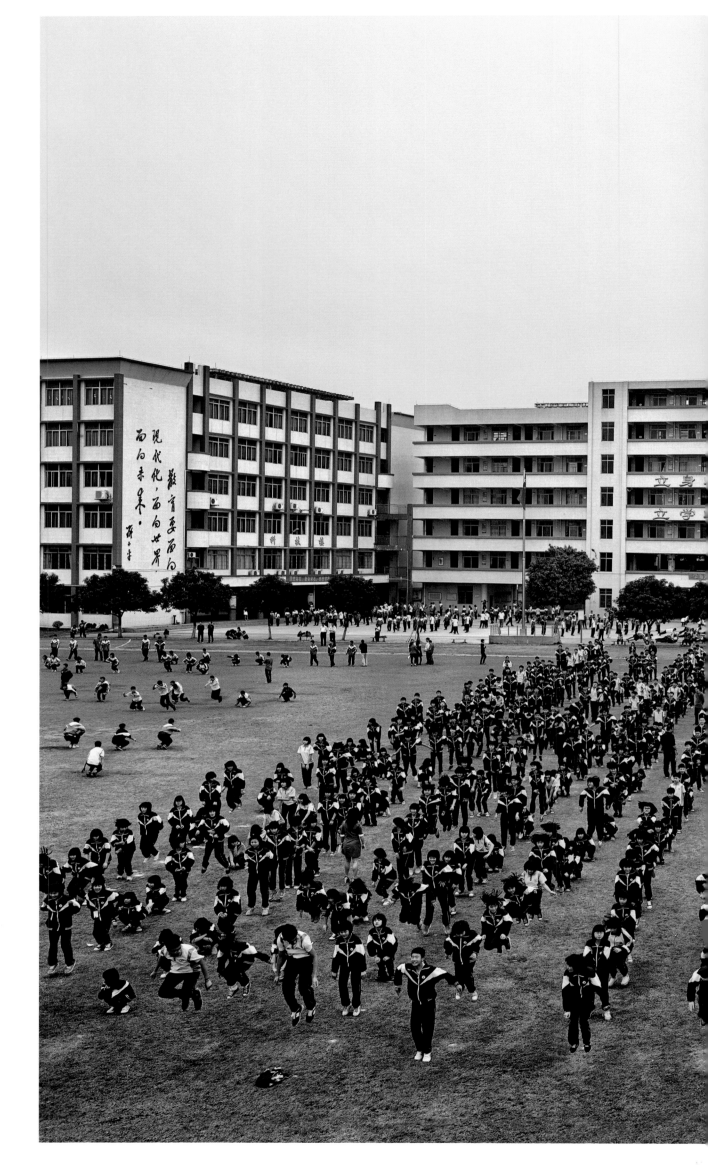

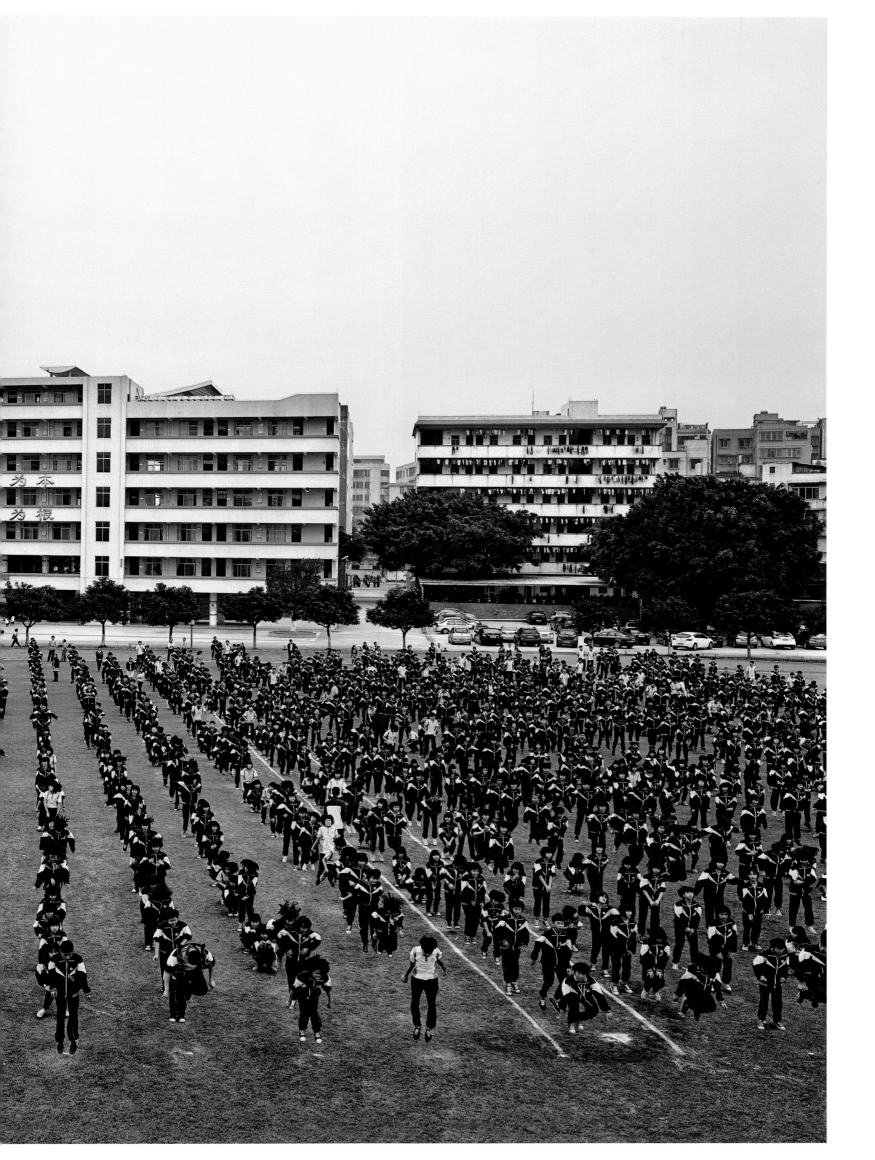

When I conceived this series of pictures, I was thinking about my time at school. I realized that most of my memories were from the playground. It had been a space of excitement, games, bullying, laughing, tears, teasing, fun, and fear. It seemed an interesting place to go back and explore in photographs.

I started the project in the UK, revisiting my school (the surface of the playground featured on the inside cover was recorded there) and some of the other schools nearby. I became fascinated by the diversity of children's experiences, depending on their school. The contrasts between British schools made me curious to know what schools were like in other countries.

Most of the images from the series are composites of moments that happened during a single break time—a kind of time-lapse photography. I have often chosen to feature details that relate to my own memories of the playground. Although the schools I photographed were very diverse, I was struck by the similarities between children's behavior and the games they played.

James Mollison

Pilgrims School
Winchester, UK
March 15, 2010 p10

The choristers of Winchester Cathedral have been educated in the Cathedral Close since Saxon times, in the seventh century. The school hall was a resting place for pilgrims visiting the cathedral. Today, the school continues a long tradition of educating choristers for the Winchester College chapel choir, known as "quiristers." The color of a boy's sweater indicates whether he is an ordinary chorister, a Winchester College quirister, or a "commoner." There are about two hundred boys educated at the school, aged four to thirteen, eighty of whom are boarders. Like other private English prep schools, its fees are expensive. Two boys had accidentally collided running around the playground. Another group played at locking some boys in the building on the left: the boys inside would attempt to get up the stairs and come out of another door before those outside could block their way.

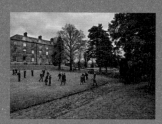

Stonyhurst College
Lancashire, UK
November 11, 2009 p12

A Jesuit priest founded Stonyhurst College, an independent Catholic school in St. Omer, France, in 1593. At the time, Catholic institutions were banned in England. The school moved to Stonyhurst Hall in 1794. It provides boarding and day education for about 450 students aged thirteen through eighteen, and still adheres to Jesuit principles. Among Stonyhurst College's alumni are saints, archbishops, presidents, and prime ministers. Sir Arthur Conan Doyle is also an alum; the writer used Stonyhurst Hall as a model for Baskerville Hall, and named his villain, Moriarty, after one of his classmates.

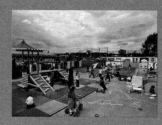

Al Furqan School
Birmingham, UK
May 26, 2010 p14

This school was founded in 1989 as the Muslim Study Group, with just four children aged three through four. It proved popular with Muslim parents and grew rapidly. In 1998 Al Furqan was approved for government funding and obtained grant-maintained status, becoming the first state-funded Islamic school in England. It moved to its present site in 2002. In recent years, the school has come under fire for its educational practices. In November 2012 England's Office for Standards in Education, Children's Services and Skills (Ofsted) rated the achievement of pupils, quality of teaching, and leadership and management as inadequate. However, the report also noted that the pupils' spiritual, cultural, and social development was good. Older female students at the school wear headscarves (and can't be photographed), as do all the female teachers; some teachers wear the *niqab*.

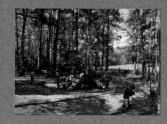

Eagle House School
Sandhurst, UK
May 10, 2012 p16

Eagle House is a prep school originally for boys, which became fully coeducational in 2005. It now serves 352 pupils aged three through thirteen. There are 201 boys and 151 girls. The school has many games fields, an adventure playground, an athletics track, and a thatched Tudor house built by staff and pupils. The school's imaginative Golden Eagle program teaches children responsibility, initiative, and team-building through activities like first aid, camping skills, and wilderness skills. When I visited, grade one children on the adventure playground had a brilliant time building camps, playing hide-and-seek, and squabbling.

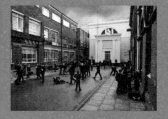

Hull Trinity House School
Hull, UK
November 16, 2009 p18

This school was founded in 1787 to educate boys for seafaring careers. Before sending its pupils out into the world, the brethren of Hull Trinity House would provide them with a special dinner as well as two oranges, to help protect against scurvy. Today, students no longer go from school to sea, but the Dinner Day tradition survives. In 2012, the school became an academy and, as its old buildings were deemed "dilapidated and inadequate to provide a modern education," it moved to larger, updated facilities. The nearly three hundred pupils mostly come from white, working-class backgrounds; on the playground, they are tough and boisterous. The cluster of boys on the right were giving the blond boy a "wedgy": grabbing the top of the victim's underpants and jerking them upward.

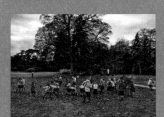

Thornton College Convent of Jesus and Mary
Thornton, UK
November 6, 2009 p20

Thornton College is an independent day and boarding school for more than 370 girls aged four through sixteen. The school occupies a former manor house within twenty-five acres of beautiful parkland, and has a medieval church on its grounds. There are also several modern buildings. The headmistress believes that it is better to educate girls separately from boys, as girls are sensitive about their bodies, and boys tend to tease and can be nasty. The school was founded by the Sisters of Jesus and Mary in 1917. It is a Catholic school, though it welcomes girls from other Christian denominations and other faiths. The fees for a senior termly boarder are £20,520 per year and for a senior day pupil £12,525 per year. There was a lovely atmosphere at the school the day I visited. The students amused themselves collecting leaves, making a huge pile for a joyful leaf fight.

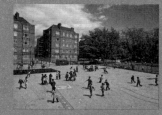

Sebright Primary School
London
May 17, 2010 p22

This is a large inner-city state primary school, serving 438 children, aged three through eleven. Pupils come from a wide range of ethnic backgrounds. The largest group is Bangladeshi. Two-thirds of students are not native English speakers. The proportion of pupils with special needs, especially dyslexia or social, emotional, or behavioral difficulties, is above average. There are also a number of students on the autism spectrum. The most recent Ofsted inspectors' report says: "Sebright School is a good school that reaches out successfully to its community and where pupils thoroughly enjoy learning. The high levels of pastoral care that pupils receive help them to develop very positive personal skills and qualities. As a result, their spiritual, moral, social and cultural awareness is outstanding."

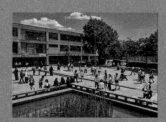

Hampstead School
London
May 24, 2010 p24

Students at Hampstead School, a large comprehensive school with about 1,300 pupils, aged eleven through nineteen, come from a wide range of socioeconomic, ethnic, religious, and cultural backgrounds. Many speak English as a second language. The school's debating society meets every Friday. In national competitions it has a record of success unrivalled by any comprehensive school in history. In February 2013 a small group of students set up a satirical blog called The Hampstead Trash. The blog routinely comments on school cultural issues and critiques school policy. In 2013, in an episode known as Trashgate one of blog's founders was banned from school premises by Hampstead's head teacher, who worried that he had become "enchanted by antiestablishment ways of thinking."

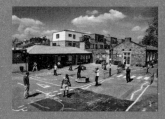

Spa School
London
May 19, 2010 p26

This is a school for students aged eleven through nineteen who have autism or Asperger's syndrome. There are one hundred pupils and over seventy staff members. Just out-of-shot, to the left, is the school's landscaped garden with flowers, vegetables, and an artificial stream. The headmistress says that the garden has a direct influence on the mood and behavior of her pupils, helping to soothe those who can be anxious or confused. In this playground there was none of the normal buzz of interaction. Pupils moved around the playground in their own worlds, often repeating actions and seldom communicating with others. When they did, it would often end in an altercation, and one of the many staff members would quickly arrive to defuse the situation.

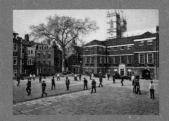

Westminster School
London
March 17, 2010 p28

A small school attached to Westminster Abbey was set up in 1179 and eventually granted a royal charter by Queen Elizabeth I in 1560. It is a school principally for boys, aged thirteen to eighteen, though girls aged sixteen to eighteen have been accepted since 1973. There are around 750 pupils, about a quarter of whom are boarders. Nearly half of the students are accepted by Oxford or Cambridge universities, a higher proportion than for any other school. Among the school's graduates are Ben Jonson, Christopher Wren, John Dryden, John Locke, Edward Gibbon, A. A. Milne, Michael Flanders, Donald Swann, Peter Ustinov, and Andrew Lloyd Webber. This is a view across Little Dean's Yard, the heart of the school, where a few boys played cricket, but most just used the break to chat.

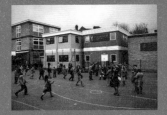

Sacred Heart Catholic Secondary School
London
March 19, 2010 p30

Since my visit this school has converted to academy status and moved to a new site. The school is in a rough area, and regularly falls in the top five percent of all secondary schools in the UK on Academic Value Added tables. Eighty percent of the pupils are of African heritage. Ofsted assessments both before and after the changes rated the school as outstanding and praised the pupils' behavior. "Students conduct themselves with impressive courtesy, generosity towards others and commitment to achieving the very best. Students feel completely safe within the school," inspectors noted. That was not the impression that I had: the school was one of the most boisterous that I visited, and I saw several students being bullied, as well as a fight that captivated the whole school.

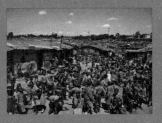

Valley View School
Mathare, Nairobi, Kenya
January 19, 2011 p32

Valley View, a school of 815 pupils and twenty-three teachers, primarily serves the population of the Mathare slum. This encampment of three square miles is home to six hundred thousand people. A typical house is just ten square feet. Valley View's classrooms are thirteen-by-twenty-foot concrete blocks with corrugated metal roofs. When it rains the classes stop because the roofs leak. The classrooms are so cramped that pupils have to climb over desks to get out. The school has a very small kitchen and no library. There are just eight toilets. Pupils have to fetch water every morning. Attendance has greatly improved since the World Food Programme started providing meals for students in 2005. Children are allowed to carry food home to share with their parents. The WFP is also providing funds for a new school building, big enough for 1,200 pupils.

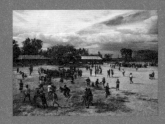

Manera Primary School
Naivasha, Kenya
January 18, 2011 p34

There are 458 girls, 412 boys, and fourteen teachers at Manera Primary School. Some classes have over one hundred pupils. There was a surge in enrollment when the Kenyan government introduced free education in 2002. Many of the students' parents are employed by the flower-exporting businesses on the shores of Lake Naivasha. This is temporary work and they may move on when the flower season ends. Others are unemployed and cannot afford to buy uniforms, which pupils must have in order to attend school. One-parent families are the norm and there are many parents who struggle to feed their children. The school was badly hit in the violence that followed Kenya's disputed 2007 election. The majority Kikuyus chased away members of the Kalenjin and Luo tribes. The head said that this did not stop the children of different tribes from playing together.

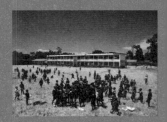

Kaloleni School
Nairobi, Kenya
January 20, 2011 p36

Kaloleni estate was built by Italian prisoners of war at the end of World War II, and the bungalows were given to African soldiers who had fought in the British army. There are 1,049 pupils and twenty-three teachers. Fifty percent of the children are orphans or have only one parent. Many parents lost their jobs when Kenya Railways downsized in 2000. Most of the school's roofs leak and one of them has been blown off. There is no running water. The school keeps chickens for the workers and grows a few vegetables for the pupils. Teachers are not allowed to hit the children. The head told us, "The children are chaotic. We cannot control them." When I visited, the girls played a game called "urr-up," which involves throwing one another into the air. They broke out laughing when one girl's knickers were exposed.

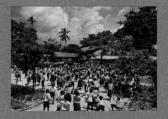

Freretown Community Primary School
Mombasa, Kenya
March 23, 2011 p38

Freretown was established in 1875 as a place for the settlement of freed slaves. The bell that was rung to warn residents of the approach of slave-trading vessels can still be seen nearby. The average class size at this school was thirty-five in the 1960s and has grown to eighty-five. Because of a shortage of desks and chairs, the younger classes sit on the cement floors, which are full of potholes. Many of the children are AIDS orphans and are allowed a fifty-percent discount on school equipment. The boys often drop out of school to become "beach boys," begging or stealing from tourists, the girls may enter the sex trade. The headmistress blames political corruption for the school's poor state. She also believes it is important for African men to drop their opposition to family planning. There are several local families with over ten children.

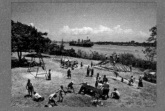

Likoni School for the Blind
Mombasa, Kenya
March 25, 2011 p40

The school has 166 students, most of them blind. Many are albino, a condition that often leads to visual impairment. Some albino students who are not blind also attend the school to protect them from being kidnapped by the agents of witch doctors in Tanzania, where many people believe that albino body parts can make them rich. The school tries to allow students to move at their own pace and does not force them to leave when they reach a certain age. Despite their blindness the boys played fairly rowdy games: holding hands in pairs and trying to pull each other over; spinning the merry-go-round as fast as they could to fling people off it; and feeling their way around the climbing frames.

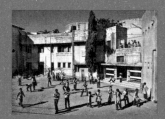

Virani Deaf and Dumb School
Rajkot, Gujarat, India
November 27, 2012 p42

This school was named "the best working institute for the welfare of handicapped people" by the Gujarati government. Most deaf children in India are not taught sign language, which means that their language development, cognition, and social skills are impaired. Particularly in rural areas, they are often thought to have intellectual disabilities and are treated as outcasts. But at Virani, the teachers take a one-year course to learn sign language, and parents can come to the school to learn to sign as well. There are classes in sewing, knitting, screen printing, handicrafts, drawing, painting, and gardening. Girls can also do vocational beautician training and learn henna drawing. When I visited, there was an eerie quiet on the playground, as the boys played a catching game over the volleyball net and the girls chatted to each other in sign language.

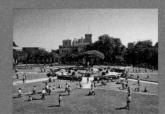

Rajkumar College
Rajkot, Gujarat, India
November 28, 2012 p44

Situated on twenty-five acres in the heart of Rajkot, the school was built for the princes of Saurashtra in 1869. Eight boarders now share each room formerly occupied by one prince. A portrait of Queen Victoria still hangs in the impressive assembly hall. The first seven headmasters were British and the last British head left in 1985. There are about 1,400 students, boarding and nonboarding, one third of them girls. Girls have been accepted since 2000 and have their own facilities in a secluded corner of the grounds. Boarders come from all over India and some children are sent from Dubai, Malaysia, and the United States, as their parents want to protect them from the corrupting influences of their home environments and believe they will be better disciplined at Rajkumar College. Yoga is compulsory from kindergarten through grade eight.

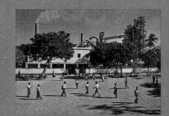

SDCCL Public School
Sikka, Gujarat, India
November 26, 2012 p46

Shree Digvijay Cement Company Limited founded this school in 1962 for the children of its workers. It is a government-controlled primary school for needy children with fees of just two hundred rupees, or less than four U.S. dollars, per month. There are about three hundred boys and girls in attendance. The company has also set up a high school at which the children can continue their lessons. Many students will eventually get jobs in the cement factory. Those who are able and fortunate may get jobs in the IT sector. There are eleven computers for the children to use. Extra curricular activities include dance, debates, school council, and managing assemblies. Water is delivered on alternate days and is only available for one hour a day. Daily consumption by staff and students is five hundred liters. There are three toilets in the school.

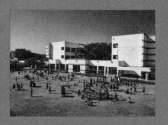

KD Ambani School
Jamnagar, Gujarat, India
November 27, 2012　p48

The school is part of a complex that houses workers at the nearby Reliance refinery, where the children's parents work. It is the largest refinery in the world and Reliance Industries is India's second-biggest company. The school is named after Kokilaben Dhirubhai Ambani, the wife of the company's founder. The present owner is one of her sons, the richest man in India. The school was founded in 1998, two years after the refinery was moved to this sparsely populated and dry area. Water comes from a desalinization plant. There are 3,045 students, 210 teachers, fifty classrooms, and six science labs. Lunch breaks are staggered. During my visit, the children sat in neat circles on the field eating from packed lunch boxes before getting up to play.

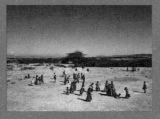

Gram Panchayat School
Ludiya, Kutch, Gujarat, India
November 30, 2012　p50

In January 2001 a devastating earthquake hit Gujarat, killing about twenty thousand people and destroying four hundred thousand homes. Ludiya was severely damaged, and the town's inhabitants thought that a less crowded environment would be safer. So the Hindus migrated two kilometers north, while the Muslims remained. The population of the new Hindu village is just two hundred. This school is on the edge of the new village. There are about thirty-five children in grades one through five, taught in a single classroom. Little can be grown in this harsh land and vegetables have to be imported. A well was provided by an NGO and more recently the government has paid for a water pipeline. The school has no toilet and there are only five toilets in the village, all without running water.

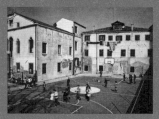

Ugo Foscolo Elementary School
Murano, Venice
March 21, 2014　p52

The Romans first settled Murano, an island in the Venetian Lagoon, in the sixth century. It has been a center of glassmaking since 1291, when glassmakers moved there after being expelled from Venice because of the fire risk posed by their furnaces. Murano glass is still famous and the parents of many of these students are involved in glassmaking. The school occupies the seventeenth-century Palazzo Soranzo. In 2013 the government slashed its budgets and can no longer pay for school cleaners. The school has sixty-four pupils, in grades two through five. There were not enough children to make a grade one class viable and the school is gradually closing down. When I visited, a team of boys in one year group played soccer against boys from the year below. When the older boys went 4-0 down, they began to take out their frustration on the younger boys.

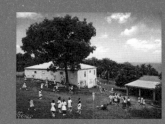

St. Augustine Roman Catholic School
Palm Loop, Montserrat
May 18, 2012　p54

Montserrat is an island in the Caribbean, twelve miles long, with a population of just over five thousand people, mainly of African-Irish descent. Since its foundation in 1875, the Catholic St. Augustine School has been rebuilt four times. The school building was destroyed by hurricanes, in 1899 and 1928. After Hurricane Hugo caused extensive damage in 1989, a major fund-raising effort resulted in the building of a new multi-storied building that was consecrated in 1991. However, the eruption of the island's Soufriere Hills volcano in 1995 destroyed Plymouth entirely, including the school. Evacuated without loss of life, the school relocated to a private house in the island's "safe" zone, away from the volcano, to which new buildings and playgrounds have since been added. Now one of three primary schools on the island, it is attended by 135 pupils.

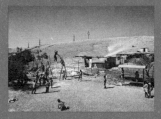

Al Khan Al Ahmar Primary School
Area C, Jericho, West Bank
September 17, 2013　p56

The school is in a Jahalin Bedouin village situated in the scorched desert hills between Jerusalem and the Dead Sea. It was built in 2009. Previously, pupils attended school in Jericho, but after three students were killed by cars while waiting on the highway for the school bus to arrive, parents stopped sending their kids to school there. Getting planning permission for construction was impossible as the Israelis deem the settlement illegal; so with a limited budget and the help of an Italian architect, the school was built from old car tires filled with earth, then plastered in mud. The rubber tires keep out the heat in summer and the cold in winter. The Jahalin Bedouins were originally from the Negev desert, but were deported after the 1967 war. They were nomadic but now the West Bank Barrier stops them from migrating as they used to.

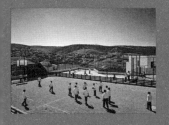

Tiferet-Menachem Chabad School
Beitar Illit, West Bank
September 10, 2013　p58

This school, serving 270 boys aged six through thirteen, is part of the Jewish settlement of Beitar Illit, founded in 1984. The playground looks out across the Palestinian village of Nahalin. The settlement is home to more than forty-five thousand Haredi Jews. It has the fastest growing population of any West Bank settlement. Nearly two-thirds of the inhabitants are under the age of eighteen, and twenty thousand are at school. Some families have as many as five boys enrolled in the school. Sixty percent of lessons are religious. Pupils also study math, Hebrew, and science. Parents who want this type of religious education also send their children to the school from Jerusalem. Although there are no physical education lessons, the boys played soccer during their break with evident enjoyment. Television is banned from the whole settlement, although computers with "kosher" Internet are allowed.

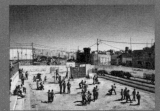

Aida Boys School
Bethlehem, West Bank
September 8, 2013　p60

The Aida Refugee camp, just outside Bethlehem, was set up in 1950 by the United Nations Relief Agency for Palestinians displaced from villages within Israel, and the school was built shortly afterward. The front line between Israelis and Palestinians during the First Intifada (1987–91) fell close to the school, and its walls were thickened to protect its students against bullets. In 2004, the Israelis completed construction of its security wall, just outside the entrance to the school, which the headmaster describes as "a humiliation in front of [the pupils] every day, a kind of restriction on their future." The third and fourth graders watch the towers to see if the soldiers are looking, and, if not, they throw stones at them. Whenever hostilities flare up with the Israelis, the air fills with tear gas and the headmaster sends everyone home.

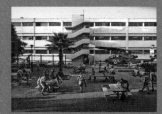

Holtz High School
Tel Aviv, Israel
September 12, 2013　p62

This high school is also a technical college and is affiliated with the Israeli air force. Nearly all of the pupils will be drafted into the air force as computer engineers, electronics specialists, and mechanics. The 850 students come from all over the country because they want a military career or because their parents believe that it will make them well disciplined. In addition to tables for chess and ping-pong, there are a few old military aircraft spread around the campus. This photo was taken after the students had been practicing marching and military drills and while they were waiting for their parents to arrive to watch their end-of-term parade. The school belongs to the Amal group, established in 1928, a network of 120 institutions that concentrate on technological education to ensure that Israel will have the well-trained young people that it needs.

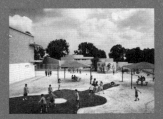

Shikim Maoz School
Sderot, Israel
September 9, 2013　p64

This is a secular, government-funded primary school focused on art, music, and dance. There are 274 pupils and thirty teachers. Sderot is the nearest Israeli town to the Gaza border which is just two kilometers away. The school was founded in 2009 and was designed to withstand bomb attacks, with reinforced walls and windows. The brightly colored building in the middle of the playground is a bomb shelter to which the students run if the alarm sounds. On June 29, 2012, seven rockets were fired on Sderot from Gaza; one hit the school. Luckily it was a Saturday and school was out. The school has left the damage unrepaired as a reminder of the danger. Everyone in Sderot has family or friends who have been affected by the rockets, and the students and teachers are traumatized by the threat.

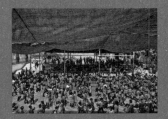

Maamounia Elementary
Rhimal Area, Gaza City, Gaza
September 15, 2013　p66

This school is funded by the United Nations Relief and Works Agency. The facilities are used by two separate schools. The morning school has 976 girls and boys, and the afternoon school has 945 boys. A huge piece of fabric hangs over the playground to protect the children from the sun. Overcrowding is a big problem at Maamounia. The school had to make new classrooms in shipping containers, which get very hot in summer. None of the teachers want to teach in these classrooms, so they take turns. Because of the blockade of Gaza, over forty percent of students' parents are unemployed. The closing of the tunnels has hit the economy hard, and the shops are empty. The school was used as a shelter during the summer 2014 conflict, which claimed the lives of 138 students attending UNRWA schools.

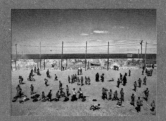

Deir al-Balah Boys' Elementary
Middle Area, Gaza
September 16, 2013 p68

Deir al-Bahar Camp houses thirty thousand people in an area of one square kilometer. The school is funded by the United Nations Relief and Works Agency. Two separate schools use the facilities; this photo was taken during the break between the switching of schools. The boys had begun to lay out their bags in the places where they would soon line up for the afternoon school assembly. Many students' parents are unemployed and cannot afford to pay for their children's notebooks and pens. Some of them are fishermen who used to go twenty kilometers out to sea, but are now restricted to three kilometers by the Israeli authorities. Many people had their houses destroyed by the Israeli army's Operation Cast Lead, which was launched in 2008 in response to missiles fired from the Deir al-Bahar Camp area.

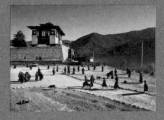

Dechen Phodrang
Thimphu, Bhutan
November 24, 2011 p70

Situated on a dramatic ridge overlooking Thimphu, the capital of the Kingdom of Bhutan, the ancient Dechen Phodrang Monastery (literally, the "Palace of Great Bliss") has 450 students and fifteen teachers. Students wake up at 5:00 a.m., and start the day with one hour of praying before their first classes at 6:30 a.m. At 8:00 a.m. students have breakfast and a short break before resuming classes until noon. Living conditions at the monastery are rudimentary; the children sleep on mats on the floors of the drafty study rooms. Respiratory infections, lice, and scabies are common, and the monastery struggles to provide basic sanitation facilities and adequate food for the boys. Many boys are sent to the monastery because their families cannot afford to feed them; most come aged seven, and stay eight years before transferring to the Monastic College.

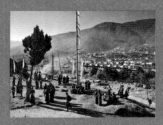

Lungten Zampa
Thimphu, Bhutan
November 26, 2011 p72

This high school with 1,200 students and fifty-one teachers was one of the first schools to be set up in Bhutan, in 1972. That year, the seventeen-year-old fourth Dragon King of Bhutan remarked that "Gross National Happiness is more important than Gross National Product." Subsequently this idea has become the official basis of Bhutan's government policy. GNH lessons are part of the curriculum in all Bhutanese schools. The national dress code, comprised of traditional garments, used to be compulsory for everyone, and still is for all hotel and restaurant staff and taxi drivers, who have to be licensed by the government. School uniforms must also conform to the code, and those of individual schools are differentiated by their color schemes. Smoke issuing from the little shrine toward the left of the frame is from incense that has been lit to bring good luck.

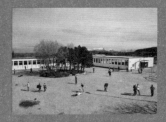

Gomalandet Skole
Kristiansund, Norway
April 26, 2012 p74

This school was originally intended for children with disabilities, but in the 1980s the Norwegian government decided that children with special needs should be incorporated into standard schools. Many of the pupils are immigrants from Somalia. They are given intensive courses in Norwegian before being integrated into normal classes. One teacher told us that this helps on the playground, "as children who can't express themselves properly are more likely to lash out." Children who have problems with certain subjects are grouped together so that they do not hold back the others. Because it did not freeze over during the last Ice Age, Kristiansund is thought to be the first area of Norway to be settled, around the eighth millennium BC. In recent years it has become a major hub of the oil and gas industry.

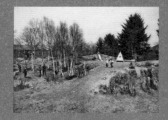

Utheim Skole
Kårvåg, Averøy, Norway
April 25, 2012 p76

This small island school serves a community of five hundred and caters to children aged five through thirteen. There are eighty-eight pupils and nine teachers. The nearest secondary school is fifteen kilometers away. The school makes a point of getting parents involved in their children's schoolwork. Most of the parents have been to university; many of them work on oil rigs or in the boat-building industry. Many children walk or cycle to school, even in winter, and they are encouraged to play outside. There are areas where they can climb trees or build camps from sticks and stones. Three years ago a tunnel was built connecting the island to the mainland and since then more people have moved to Kårvåg.

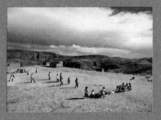

Paso Payita
Aramasi, Chuquisaca, Bolivia
August 9, 2011 p78

Situated in a remote area on rough terrain nearly ten thousand feet above sea level, this school has two teachers and thirty-one students aged six through twelve. Many students live in the surrounding hills and have to walk for several miles to get to school. Most people are indigenous Quechua peasant farmers who keep sheep, goats, pigs, and guinea pigs. The sheep's fleeces are dyed with local wildflowers, spun, and woven into the beautiful fabrics for which the local women have become famous. Half of these students go on to secondary school; of those, fifty percent then go to university in the departmental capital, Santa Cruz. The entire school, except for the few pupils who were ill when I visited, is pictured here. The boys played soccer while the girls played a rough game of tug-of-war without a rope.

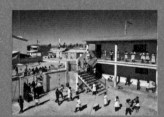

Thako Pampa School
Sucre, Bolivia
August 10, 2011 p80

The school is on the outskirts of the Spanish colonial town of Sucre and serves many families who have emigrated from the countryside. There are 649 students from four through eighteen years old. To accommodate them all the school operates two shifts, one in the morning and another in the afternoon. The headmaster told us that the majority of students live with just their mothers or with no parents at all. Those without parents are left to their own devices and find it difficult to study or do their homework. Children will often work to earn money outside school hours, and this also affects their concentration. During their break students run to buy snacks from the row of women seated just outside the gates. Dogs eagerly clear up any dropped morsels of food.

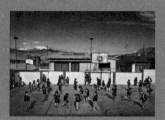

Colegio Gregorio Reynolds
La Paz, Bolivia
August 12, 2011 p82

This school serves eight hundred students, aged four through seventeen. Five hundred of them attend in the morning and three hundred in the afternoon. La Paz is surrounded by high mountains and varies in elevation. Although this is a private school, it is not attended by the children of the truly affluent, who live in the city's lower-elevation neighborhoods. In 2013 a law came into effect that requires Bolivian schools to teach students the indigenous language most commonly spoken in their locality. Now all children in La Paz are taught Aymara. Pupils also learn Spanish and one foreign language, usually English. When we visited, the children arrived at the playground with various snacks bought from the tuck shop. A group of girls spent the break throwing sweets up into the air and catching them in their mouths. Boys played *policías y ladrones*.

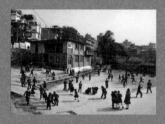

Open Day Primary School
Kathmandu, Nepal
December 5, 2011 p84

The Kathmandu Valley has a population of 2.5 million and is expanding at the rate of four percent per year. This makes it one of the fastest growing metropolitan areas in South Asia, and the first region in Nepal to face the challenges of rapid urbanization and modernization. Unplanned development has created many problems and substandard buildings have left Kathmandu vulnerable to earthquakes. Open Day is a private school with five hundred pupils and thirty-five teachers. The land does not belong to the school and its rent is increasing as the city expands. Many parents opt for private schools over public, as public school teachers have low morale, and many of them fail to perform their duties. In spite of the region's growing population, public school enrollment is falling to such an extent that the government plans to merge many schools.

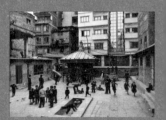

Bhakta Vidyashram
Kathmandu, Nepal
December 5, 2011 p86

Education in Nepal was traditionally based on home schooling for the country's elite, and in 1950 only five percent of the population were literate. Now sixty percent are literate, but many barriers to education remain, especially for families on the lower rungs of the traditional caste system. Bhakta Vidyashram school in downtown Kathmandu (Bhakta means "devotee" and Vidyashram means "house of education") caters to children from poorer families. Many of its one hundred students can't afford books or pencils, and the school relies on volunteer teachers and international donations. There are two basic classrooms. The kids were completely unsupervised at break time. Their playground outside the front of the school was actually a public square. A host of people walked through carrying carpets, TVs, and other goods.

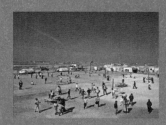

Adolescent safe space
Site 5 District 12, Zaatari
Refugee Camp, Jordan
January 23, 2014 p88

The children who use the safe play areas, run by UNICEF and the International Medical Corps, are refugees from the civil war in Syria. Many of them have lived under shellfire and seen their relatives and friends injured or killed. Though I visited during a school holiday, the safe play areas remained open, as the kids don't have much else to do. On the edge of the play area there are places where children can go and get psychological support. In Syria they may have had no opportunity to play or run around, so this safe space is very important to them. Fifty-five percent of the camp's ninety thousand inhabitants are under eighteen. Twenty thousand of the twenty-five thousand children of school age are registered to attend the camp's schools, although their capacity is only fifteen thousand.

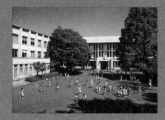

Seishin Joshi Gakuin School
Tokyo
September 7, 2011 p90

This is one of the most prestigious schools in Tokyo; the Empress of Japan was a student. The school was founded in 1908 by four nuns from Australia. Seishin Joshi Gakuin means "The Sacred Heart," and although the school is Catholic, only thirty percent of the students are Christian. Gaining a place is difficult, with four hundred girls applying for the ninety-six places in grade one. Discipline at this school is important. Student responsibilities include organizing committees, community service, and working in the library. Twice a week all students have to clean the classroom for ten to fifteen minutes and put on gloves to clean the toilets. At break time, the girls were exemplary, playing happily among themselves.

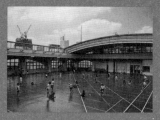

Shohei Elementary School
Tokyo
September 8, 2011 p92

Due to the scarcity and high cost of land in Tokyo, when this school was built fifteen years ago, its playground was constructed on the roof, above the sixth-floor classrooms. Only soft balls are allowed, to guard against injuring pedestrians on the streets below. There is a retractable roof that plays music when it closes. There is also a gym, swimming pool, and library. The school cost seven billion yen, or U.S. $60 million, to build. There are eighteen teachers and 270 students. Once every two days the students clean up the stairs and classrooms. The government provides cleaners for the school, but the principal feels that it is important that children learn to clean up after themselves. They must take off their shoes before entering their classrooms.

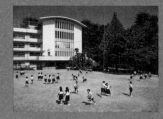

Sei Gakuin Elementary School
Tokyo
September 8, 2011 p94

This is a private Protestant school with four hundred pupils and twenty full-time teachers. The average class size is forty. Students do not have to come from Protestant families but they do have to pass an entrance exam. Sei Gakuin high school and junior high were founded in 1905 and the elementary school was added in 1960. The annual fee is about U.S. $5,000. Fewer than one percent of Japanese schools are private. Some parents are willing to pay for private schools because they are good at preparing pupils to get into the most prestigious universities, which greatly increases their chances of getting good jobs. Although they were unsupervised, the children played for the entire break without any arguing or fighting.

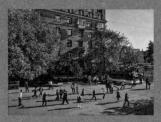

School #415
Moscow
September 18, 2014 p96

The five-story school block was built in 1956, during the Cold War. The building's underground bomb shelter is now a museum containing weapons and cultural artifacts from the region. The T34 tank was installed in 2000 to mark the fifty-fifth anniversary of victory in the Second World War. The students are proud of it and like climbing on it. In winter the pupils have to stay inside because the ten-minute break between lessons is not long enough for them to change into jackets and boots. The children are taught the "facts" about Stalin, though I could not get them to tell me what those facts are. They just said that he is important because he ruled for thirty years and built Russia from nothing into a great country.

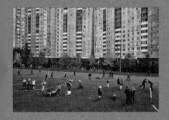

School #2013
Moscow
September 22, 2014 p98

Most schools in Moscow have numbers instead of names. Throughout the year 2013, this school had many problems with its number. The worst was when someone in another part of Russia uploaded a video to the Internet titled Girl Pole Dancing School 2013, which resulted in visits by the police and reporters. This is a lower-middle-class area, where twenty percent of the population has immigrated from former Soviet republics like Turkmenistan or Uzbekistan. In recent months there has been an influx of Ukrainian immigrants. The parents of these students must show they have legal papers for their children to be admitted. School #2013 has four security guards, who work in pairs. They take turns doing two-week shifts on residential duty. When entering and leaving the school pupils swipe a special badge that automatically sends a text message to their parents.

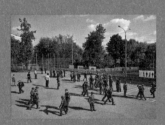

Cadet School of the Heroes of Space
Moscow
September 19, 2014 p100

This school is affiliated with the Russian air force. The older students begin training in flying and parachuting, and thirty percent of them join the air force or army when they graduate. Many others get government jobs. The school was founded in 1963. The front of the six-story building is covered with eight murals depicting events from the history of the Russian space program. These include portraits of the dogs Belka and Strelka, the first animals to go into orbit and return to Earth. The school playground has plaques with instructions on how to march, turn, and parade with a gun. Parade practice happens once a week, and more frequently prior to the annual November 7 parade with the Red Army in Red Square. This event commemorates the famous 1941 parade in preparation for the defense of Moscow against advancing Nazi troops.

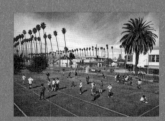

Nativity School
Los Angeles
November 10, 2011 p102

This Catholic school, founded by the Sisters of Loretto in 1924, has 330 students. It is situated in a low-income area with a high crime rate. There have been several drive-by shootings near the school, and once a stray bullet went through a school wall. Nativity is private and charges $210 a month in fees. Sixty-five percent of the students are unable to pay the full amount. The school struggles to pay its teachers. On the day I visited the school staff was selling nachos to raise money. The children wear two uniforms, one for classes and one for sports. During break-time they wore the latter and played dodgeball. I was happy to see it as I had read that it has been banned at many American schools for being too violent, along with other "human target" games, including tag.

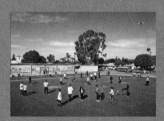

Warren Lane Elementary
Inglewood, California
November 10, 2011 p104

The 1960 census counted only twenty-nine African Americans among Inglewood's 63,390 residents. Back then, not a single black child attended the city's schools. Today, this school's pupils are seventy-eight percent African American, twenty percent Latino, and one percent Filipino. The average class size from kindergarten through grade three is twenty-eight, and in grades four through six it is twenty-four. Ninety-seven percent of Warren Lane's pupils are eligible for a free or reduced-price lunch. Eleven percent are classified as English learners, and nineteen percent have received special education within the past two years. The school is under the flight path to Los Angeles International Airport, one of the busiest in the world, where planes take off and land every few minutes. There is often a pause during class when a plane flies low overhead.

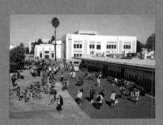

Inglewood High School
Inglewood, California
November 3, 2011 p106

Inglewood High is a public school in Los Angeles County that opened in 1905. The cheerleaders, in green, are on their way to the sports field, followed by the school band. This is part of a pep rally, which aims to hype up a team and its supporters in preparation for a game. Many of the school's recent notable alumni are professional athletes. In the U.S., often more tax dollars are spent on high-school athletes than on high-school math students. School staff members use an electric vehicle to patrol the grounds. Shortly before the photograph was taken a teacher drove up to one of the pupils and got out to speak to them before returning to the car to drive back to the school building.

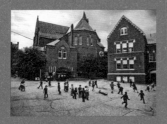

St. Mary of the Assumption Elementary School
Brookline, Massachusetts
September 26, 2012 p108

The pupils at this Catholic school receive religious instruction in addition to the standard curriculum. There are 230 students in pre-k through grade eight. The school was formerly run by nuns. Catholic schools in the United States were originally set up privately by people who worried that their children would lose their faith if they attended Protestant public schools. Since 2000, nearly two thousand U.S. Catholic schools have closed, often as a result of competition from publicly funded charter schools. The tuition at St. Mary's is $8,200 per year for pre-k through grade one and $5,250 for grades two through eight. The boy with his fingers in his ears above was being taunted. Almost half of U.S. elementary school teachers say that bullying, name calling, or harassment is a "very serious or somewhat serious problem" at their school.

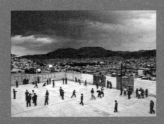

Emiliano Zapata Elementary School
Pachuca de Soto, Hidalgo, Mexico
May 7, 2014 p110

Pachuca is about sixty kilometers northeast of Mexico City. The headmistress told me that all her pupils come from poor families, the great majority of which are dysfunctional. The food subsidies that they used to receive have been withdrawn and the children often do not have enough to eat. Some of the older children work in the mornings, which means that they do not do their homework. Mexico has the poorest education results of any country in the Organization for Economic Co-operation and Development. The problems are widespread and entrenched. Teachers belonging to the powerful SNTE union refused for years to undergo even basic aptitude tests. They can sell their positions as public officials and even pass them on to their children. When I visited, some boys took turns hurling a ball at one another from as close a range as possible.

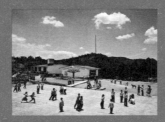

Benito Juárez Indigenous Elementary School
Acaxochitlán, Hidalgo, Mexico
May 6, 2014 p112

The 550 children who attend this school are of Nahua ethnicity. At least twenty percent do not speak Spanish. The teachers complain that the parents do not help their children study, that attendance is poor, and that most children are sent to school without any school materials and without breakfast. The Nahuas migrated south around 500 and became the dominant people in central Mexico, establishing the Toltec and Aztec cultures, among others. Several central Mexican ethnic groups have managed to retain their languages and much of their culture in spite of Spanish conquest. The total number of Nauhuatl speakers today is around 1.5 million. There seemed to be no supervision during the break here. The boys were particularly rough, wrestling, pinching, punching, and giving each other Chinese burns.

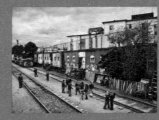

Adolfo López Mateos Primary School
Mexico City
May 8, 2014 p114

Twenty-one students in grades one through five are taught in a single classroom in a forty-foot-long train car. The car also contains the school office and library. Until 1994 the school used to travel with a service train that repaired the track. The children's parents were railway laborers and the children accompanied them as they worked. When the railroad discontinued the service train, it was parked, and the workers were allowed to live in the cars. The school's sole teacher, who has been in charge for thirty-seven years, also lives in one of the cars. A few of the children work after school as street-food vendors. They have poorer concentration than the students who do not work, and they do not do their homework. When I visited, the students played ball games and wrestled in front of the classroom. A chained guard dog barked throughout the break.

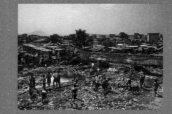

Kroo Bay Primary
Freetown, Sierra Leone
January 17, 2013 p116

Kroo Bay slum was populated in 1994 by people fleeing the conflict in eastern Sierra Leone. Several years later, when the fighting reached Freetown, rebels used the school as an army base. There is no sanitation or garbage collection. Since the construction of a nearby road and housing development in 2000, the school must close from July to September because the Crocodile River rises, floods the classrooms, sweeps away furniture, and damages buildings. Teachers are no longer paid regularly and rely on very small fees from parents to survive. There is no government support. During their break, some children played in alleyways and others on the land in front of the school. The children seemed completely oblivious to the trash, but I winced each time they fell, worried they would cut themselves on glass or a metal can.

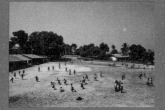

St. Francis Primary School
Bo, Sierra Leone
January 18, 2013 p118

This all-boys school was founded by Roman Catholic missionaries in 1933 and is now also supported by the government. There are 750 boys, aged six through eleven. Bo is the second-largest city in Sierra Leone. Many of the parents of these boys come from the countryside and stay with relatives in the city. Most boys walk to school. The school's main problems are a lack of teaching materials and disruptive behavior. Punishments include caning and not being allowed out at lunch breaks. The headmaster told me the boys prefer to be caned. Bo was hard hit by the 2014 Ebola outbreak, and in September all schools were closed for the rest of the year.

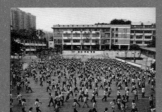

Affiliated Primary School of South China Normal University
Guangzhou, China
June 13, 2014 p120

This school is situated on the university campus and mainly serves the children of university teachers. There are 1,400 children, aged seven through twelve. Classes begin at 7:40 a.m. and the morning exercise break is at 9:30. During the break a sound system booms out instruction for stretching exercises, followed by ten minutes of running. At 10:25 there is an eye exercise break, in which the children move their eyes to music. These eye exercises are a feature of Chinese schools and are designed to counteract any ill effects of long hours of studying. The final year of high school is intensely focused on preparation for the university entrance exam. It isn't unusual for parents to quit their jobs to help their children study. This pressure has been linked to cases of depression and even suicide among Chinese teens.

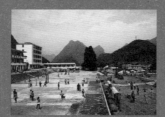

Pei Qiao Central Middle School
Qingyuan, China
April 8, 2014 p122

Pei Qiao was founded in 1927 to provide an education based on Confucian principles. Its original name was Tao Yuan, which is the title of a famous fifth-century fable describing a hidden paradise full of peach blossoms. Only one of the trees planted when the school was set up is still standing. It is now a government school. Qingyuan is in a rural area. Most of the people who are not farmers have to move to big cities to find work, leaving their children to be raised by grandparents. The headmaster said that the grandparents tend to spoil their grandchildren and not push them to do their homework. The children carrying buckets are on rubbish duty. There is a rotation to ensure that there are four students on duty at every break time.

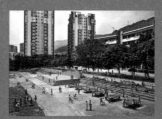

Wen Chong Primary School
Qingyuan, China
April 9, 2014 p124

The school was established in 1949, immediately after the communist revolution. There are around nine hundred pupils, aged seven through thirteen, who are taught in classes of forty to forty-five. There is no school cafeteria and children who cannot return home for lunch go to a private nursery where they are provided with a meal and a bed for their afternoon nap. The students are responsible for keeping the school clean and classes take turns performing this duty. The students' red scarves mark their affiliation with the Young Pioneers of China, a mass organization run by the Communist Youth League. They are a symbolic reminder of the blood shed by those who gave their lives to the cause of the Revolution and the children are taught to wear them with reverence.

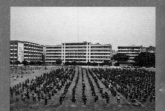

He Huang Yu Xiang Middle School
Qingyuan, China
April 9, 2014 p126

The school has four grades and 3,956 pupils, aged thirteen through sixteen. The day starts at 7:40 with a reading related to the curriculum; then there are classes of forty-five minutes each throughout the day. The pupils stay in the same classroom all day and the teachers rotate. They have an exercise break at 9:30 (when this photo was taken) and after lunch there is a compulsory nap. School finishes at 5:10. All students wear uniforms. The girls often adjust their baggy trousers to make them tighter. They are supposed to have short hair, though this regulation is not strictly enforced. The school does not want them to show off or compete to attract "bad boys."